Growing Up with Joey

Growing Up with **Joey**

*A mother's story of her son's disability
and her family's triumph*

by Sandy Papazian

FITHIAN PRESS · SANTA BARBARA, CALIFORNIA · 1997

Excerpts from *The Little Prince* by Antoine de Saint Exupéry, which appear as chapter epigraphs, copyright 1943 and renewed 1971 by Harcourt Brace & Company, reprinted by permission of the publisher.

The definition of cerebral palsy on page 81, from the *Better Homes and Gardens® Family Medical Guide*, is reprinted with the permission of Meredith Books.

"The Road Not Taken" by Robert Frost (page 214) is reprinted courtesy of Henry Holt and Company, Inc.

Published by Fithian Press
A division of Daniel and Daniel, Publishers, Inc.
Post Office Box 1525
Santa Barbara, CA 93102

Book design: Eric Larson

LIBRARY OF CONGRESS CATALOGING-IN-PUBLICATION DATA
Papazian, Sandy, (date).
 Growing up with Joey : a mother's story of her son's disability and her family's triumph / Sandy Papazian
 p. cm.
 ISBN 1-56474-184-2 cloth : alk. paper
 1. Papazian, Joey. 2. Cerebral palsied children—United States—Biography.
3. Epileptic children—United States—Biography. 4. Cerebral palsied children—
United States—Family relationships. 5. Epileptic children—United States—Family
relationships. 6. Papazian, Sandy (date). I. Title.
RJ496.C4P377 1997
362.1'9892836'0092—dc20
 [B] 96-18076
 CIP

To Robbie, Robert, Shawn, Marty, and Joey—
the forces that keep my world turning.

Contents

A section of photographs follows page 134

A meeting was held quite far from earth.
"It's time again for another birth,"
said the angels of the Lord above.
"This special child will need much love,
his progress may seem very slow;
accomplishments he may not show.
And he'll require much extra care
from all the folks he meets down there.
He may not laugh or run or play;
his thoughts may seem quite far away.
In many ways, he won't adapt,
and he'll be known as 'handicapped.'
So let's be careful where he's sent,
we want his life to be content.
Please, Lord, find the parents who
will do this special job for you.
They will not realize right away
the leading role they're asked to play,
but with the child from above
comes stronger faith and richer love.
And soon they'll know the privilege given
in caring for this gift from heaven—
Their precious child so meek and mild—
is 'Heaven's very special child.'"

Author Unknown

Growing Up with Joey

Chapter 1

Riding the Teeter-Totter

One day, from a seed blown from no one knew where, a new flower had come up; and the little prince had watched very closely over this small sprout which was not like any other small sprouts on his planet.

JULY 9, 1977. As I crept into consciousness, my eyelids kept closing out the colorless forms that surrounded me. But I could hear myself mumbling in disbelief, "My baby's dead!"

The repeat of this morbid phrase was cut midway by the gruff voice of the anesthesiologist. "No, he's not. Your son's alive."

Instantly, my certainty that he was dead flipped to distrust that he was alive. I could feel my swelling excitement stimulating the monitors connected to me. I wanted desperately to believe what I was hearing, but could not understand how and when my tragedy had reversed itself.

"This blood pressure's going haywire," the anesthesiologist growled at one of the nurses in the room. "Get the doctor back in here!"

Before long I heard the soothing voice of the obstetrician. I forced my eyes open and caught brief flashes of his face as he spoke. "Your baby is alive. He has problems, but he's alive." His hands grasped the sides of my head to emphasize the firmness added to his voice. "Now, you have to relax." Finding the tone of his words more acceptable, I attempted to concentrate on slow, deep breathing while I pondered what he might mean by "problems."

Everything was still hazy, but my condition must have stabilized, for I heard arrangements being made to transport me to another room. As the gurney moved down the hall, I saw a succession of familiar faces. Any family happening generally attracted a multitude of relatives, and now they were all wearing happy expressions. The "problems" part

of "he's alive" did not seem to be of too much concern to them, or maybe they didn't know. I reluctantly zipped past them before I could ask, and my head was still thrashing in confusion when I caught a glimpse of a familiar profile close to my gurney.

"Robbie."

Within a blink, a green uniform swished between us. "Sorry, you can't talk to your wife yet, she needs to rest. The doctor will be speaking with you soon."

I did not want to be separated from answers my husband might hold, but I could not utter a second "Robbie" until he was far from sight. Feeling I had no other choice, I floated back to sleep with the contentment that "alive" was all that mattered to me just then.

While I slept, Robbie faced the barrage of questions from the rest of the family. He confessed later that he had not been sure how much, if any, of his private conversation with the doctor he should reveal to them. He had been hit with the same "problems" explanation about the baby, as well as a "no 100-percent guarantee" for me. Figuring that the less he told, the less panic he would have to deal with, he decided to keep silent until he was able to get his own handle on what had happened and was yet to come.

For the remainder of the day, during my short moments of consciousness, I pressed any nurse around me for reassurance that my son was still alive. I hated not being able to see him. I knew they couldn't bring him to me, and I had to concede that I wasn't physically able to get to him. But since I couldn't see him, he didn't seem real to me. Actually, nothing did.

Maybe if I retraced the jumbled events of that day, they would become more sensible. So, picturing myself rising from bed that morning in the familiar surroundings of my home, I forced a flashback to my earliest recollections of the day, hoping that my shredded memories would weave into a more sensible reality.

Through our bedroom window I had seen the morning sun illuminating what was about to become an amazingly clear Los Angeles summer day. To take advantage of the day while its beauty lasted, Robbie was loading our three sons into our new, accommodating, red van for a trip to Marineland. My mother climbed aboard, still stuffing her dripping washcloths into a plastic bag. After years of being entangled in sticky hands and smeared faces, she would never embark on any trip

without "wet rags." I was the last to get settled in my seat.

I never left the house without first seeing to everyone's needs, which is probably why I always enjoyed the inner peace of whizzing along the freeway with nothing to do but become lost in thought. Strangely though, on this road to an amusement park, I was engulfed in wondering why I had been so fortunate as to have had thirty-two years of life so unusually free from misfortune.

I had been a shy child, afflicted with the insecurity that comes from having an alcoholic father who sometimes gambled away his paychecks and an overburdened mother who was often quick-tempered. Even though I knew that everything could be lost with a single throw of the dice, I was able to retreat to an imaginary perfect family.

My countless hours of eagerly accepted babysitting jobs had helped me excel in mothering skills. Many nights during my parochial school years, I had fallen asleep with a pillow over my head, not wanting to hear the calling the nuns repeatedly encouraged me to listen for. Instead, I had looked forward to having a flock of well-kept kids.

For college, I had chosen to go to Berkeley during the middle of the Free Speech movement. I'm not sure why I was attracted to such a liberal school, for I seldom spoke up in support of only one side of an issue. I seem to have a few wild genes that occasionally try to tug me away from my conservative tendencies. I majored in criminology, and had faint hopes of becoming an FBI agent; but I procrastinated on checking prerequisites, and so I graduated before learning that I was too short to qualify! Afraid to protest, I had instead settled into a career as a probation officer for several years. Then I abandoned the job to marry a self-reliant man who was on his way to becoming a television producer.

We had parented three ideal boys and were expecting the birth of the little girl who would make our family perfect. I had always felt that there was a certain balance of nature whereby each of us is somehow dealt an equal number of good and bad cards. I kept coming up with aces. My deuces had to be somewhere in the deck.

My trance was broken by four-year-old Shawn's voice loudly insisting that his five-year-old brother, Robert, Jr., was "hogging all the room." As I got out of my seat to divide the territory, our one-year-old, Marty, jumped off Grandma Rose's lap to stake his claim in the dispute. When the boundaries were established to everyone's satisfaction, I ambled back to my seat as only a ninth-month pregnant woman can. I

spent several minutes trying to shift my enormous bulge into a relatively comfortable position before I resigned myself to the fact that the final stage of pregnancy does not lend itself to comfort.

The purpose of our Marineland outing was to help assuage my feeling that this baby was never going to come. Two days earlier I had gone to my obstetrician for a regular check-up. Unruffled, he announced, "You're going to have this baby today."

"You're kidding!" I screeched. "How is that possible? I haven't had any labor pains."

"Your membranes are really bulging," he justified his diagnosis while he put away his instruments and made notes in my chart. "And the head is in position. Since this is your fourth, the membranes will rupture soon. You'll probably just have time to go home, get your bag, and head for the hospital. I'll finish my last appointment and meet you there, unless you need me sooner."

After this abrupt alteration of my planned day, I had had no time to press for more clarification. "I'm going to have my baby today," I revealed to the receptionist without stopping at her desk as usual. I was thrilled to bypass the necessity of making another appointment; one less note for my bulging organizer.

"Congratulations!" she exclaimed, her words following after me. "Should be a lucky baby with all those sevens in the birth date."

Racing with excitement, I hurriedly headed for home. The receptionist's forecast for my baby's future was not clear until I made a short stop at a newsstand to purchase my traditional souvenir. The date on the newspaper was July 7, 1977.

At home, I passed out quick greeting kisses and asked the baby sitter to play with the boys a little longer while I made a few phone calls. I wanted an uninterrupted opportunity to relay my exciting news.

I called my mother first. She and my dad still lived in Las Vegas, despite repeated attempts by my sister, brother, and me to relocate them to Los Angeles. At the green age of fourteen my father had left his Texas home in the depth of the Depression and wandered to Deadwood, where years later he became adept at cards and married my mom, who had already forsaken sheep herding with her nine siblings in order to become a hairdresser. Since Dad had developed into a stiff-necked professional gambler, my very Irish parents moved to Las Vegas at a time when there were no paved streets to its solitary hotel. Now, after working and watching their three children grow up in this town that did not

stop growing, they were reluctant to leave the thriving city whose roots were so entwined with their own. Nevertheless, regardless of the distance involved, my mother could always duplicate my fluttering over a new child's debut and arrive in Los Angeles within a few hours.

After alerting my mom and Robbie, I stopped for a moment. If this baby was coming so soon, where were the usual precursory indications? Not wanting to entertain the depressing speculation that I was getting ready for a false alarm, I brushed away this thought and jumped into the tasks of packing and preparing the baby's brothers.

By the time Mother arrived, three hours after my phone call, I was ready to leave. But there was still no labor.

"Let's go, if you're ready. Maybe we can avoid the traffic," Robbie prompted, over-anxious to complete his part of the ordeal.

"Let me just check with the doctor again. I'll feel funny arriving at the hospital without any labor." Thus I made the fated phone call.

When I informed the doctor that I was still without pain, he did not restate the urgent need for immediate hospitalization. His voice and decision had mellowed. "I think you'll be more comfortable waiting at home until labor starts. I have another delivery, so I'll be here most of the night. Just come in when your contractions start." So we spent a quiet family evening as the excitement slowly collapsed into the disappointment that the baby was not going to cooperate with the doctor's prediction of "her" lucky birth date.

Early the next morning I was on the phone to the doctor again, hoping for an explanation of his miscalculation. To my dismay I found that he was not in, and much worse, would be out for four days. After requesting to talk to his associate who was on call, I recounted the previous day's prediction. I was expecting a concerned reaction, but instead I was told there was no need to do anything until labor started.

Now I was upset. "How could your colleague have been so certain that I was going to have this baby yesterday?" When I heard a placating "I don't know," I insisted on being checked. The same appeasing voice said, "Okay, I'll switch you back to the receptionist. You can set up an appointment."

After I submitted to an embarrassing exam, this obstetrician informed me that I was not dilated and probably would not have the baby for another couple of weeks. Peeling off his gloves, he spared me the "I told you so" that I could almost hear echoing after his words.

Confused, I asked, "But why did the other doctor tell me the mem-

branes were 'bulging' and that I was definitely ready to deliver? What does 'bulging' mean?"

"Look, they're not bulging now. The head isn't even in position," he sarcastically stated, one hand on the door to end our conversation.

I was infuriated by his unbelieving, uncaring tone of voice. He was totally unaware of the twenty-four-hour whirlwind into which this supposed "bulging" had sent my family and me. This was my fourth pregnancy, and I instinctively knew there was something strange about what had happened yesterday; but I was obviously not going to sway his obstinacy.

Still, my concern should have been given more attention than it was, especially since my third son, Marty, had laid transverse in the womb and was almost a Cesarean delivery. Yet I was unable to let go of my mistaken belief that one does not question a doctor's judgment. Deciding there was nothing further to do, I paid for the upsetting visit and left the doctor's office in perplexed anger.

The next morning arrived with still no indication of the baby's arrival, and I began to feel a nervousness come over me. My frustration with the doctors and my fear that something might be wrong were tangled with the feeling that everyone was waiting for me to produce, and I couldn't. The thought then occurred to me that the only solution was to plan a distraction...why not Marineland? All those exciting fish were bound to occupy our minds, and the exercise might stimulate some activity in my lazy baby.

But, no one shared my enthusiasm for the trip. My mother and Robbie felt that we should "try to enjoy a nice close-to-home Saturday," but in the end my need to get out of the house prevailed.

No thought ever occurred to me that anything harmful could happen to myself or the baby. I routinely took even needless precautions, and considered myself impervious to health problems.

My reminiscences came to an end as I was jarred back to reality by excited screams of "There it is!" We were approaching Marineland.

We had just started walking toward the front gate when I became aware of a powerful feeling of pressure within me. I harnessed my uneasiness with the thought that the baby's head might finally be moving into position. But soon I began sinking into a more drawn-out waddle, and the strange sensation became more and more uncomfortable. I was now sorry that this brilliant Marineland idea had ever flashed into my

head. We had just arrived, and everyone was having fun; how could I announce that I wanted to go home?

As the peculiar pressure grew more intense, my fear that something was wrong must have become visible on my face, for Robbie and my mom rapidly turned their attention from the fish to me. With very few spoken words, we all realized that it was time to head for the hospital.

An eerie silence fell over our bright-red van as we left Marineland. I was reaching a state of panic that I had never experienced before. What was happening to me was not normal labor. I felt like an over-inflated balloon that was ready to explode! Robbie's grip on the wheel and pressure on the accelerator seemed to increase in direct proportion to my pulse and pain. I never noticed the expressions on my three sons' faces, since they were behind me, but I'm sure the boys watched closely as events unfolded.

"We're in trouble," I eventually heard myself say, but it only took one glance at Robbie to know that this was not a secret.

The smell of flowers that saturated the first floor of the hospital had been completely washed away by antiseptic odor by the time I was pushed into the maternity ward on the third floor. I had been all set to run to the delivery room when we arrived, but I soon discovered that I could hardly move. After securing help, Robbie had been told to stop at the admitting office, so two nurses helped me slither from the wheel-chair onto an examining table. I was barely in position when I heard one of them shout, "Doctor, you need to check this one right away!"

An unfamiliar doctor was only a few steps into the room when he threw a wild glare at the alarmed nurse. They both latched their hands to the gurney and pushed it forward before the doctor had fully ejected his command, "Let's move!"

Still confused by shelves stuffed with supplies and ample professionals to use them, I did not suspect what they saw from their end of the table. Reaching medical help had banished my fears, yet I began to feel fear surrounding me as my portable bed zoomed down the hall to the delivery room.

"Am I going to have my baby right now?" The cheerfulness did not return...only more rushing, shouting, tension, and ringing phones. My confusion increased.

"But my water hasn't broken yet!" I said, trying to spark comments from someone.

"It will," the doctor said with a severity that finally silenced me.

Inside the delivery room, my feet were slapped into the stirrups, and I felt the real explosion. The membranes ruptured with an unbelievable force, causing the umbilical cord to fly into the air and amniotic fluid to hit the adjacent wall. Robbie, on his way to the delivery room, heard the thud before his entrance was barred.

I was in shock. All sensation of pain left my body, and for a while I became a silent observer of the gory scene that followed.

Feeling completely deflated, I saw the doctor's hands tremble as he fumbled through a tray full of instruments. Then I heard the quivering voice of the nurse who had her stethoscope on my stomach, "I can't hear a heartbeat." My teeth began to chatter in synch with the clinking instruments.

The next words I could decipher were from the doctor. "Damn, he's transverse! I can't get him out." This was followed by my plea of "Do a Cesarean!" I'm not sure how my disordered mind managed to verbalize that logical thought. However, judging from the activity in the room, this course was probably already considered.

"We can't do it here. Call O.R. and tell them we're on our way." The doctor forced the umbilical cord and the baby's arm back inside me, leaving his own arm inside also. This was necessary to keep the newborn from pressing against the cord and completely shutting off any oxygen that might still be reaching the baby.

Later I would come to understand that I had experienced a prolapsed cord. When the cord leaves the mother's body, the oxygen it supplies is pinched off, and all contractions cease. But when prolapse occurs, the body does not realize that the baby is trapped inside the womb.

This one-in-a-million trauma was further complicated by this newborn lying transverse, turned sideways, instead of in the normal head-down position. Even the extensive cutting of an episiotomy would not provide enough room to dislodge the baby from the womb.

Suddenly I felt like I was falling. The table had been adjusted to a feet-up slant to help keep the baby's weight off the cord. In this less than dignified position, I could see only waves of green starched cotton as we proceeded to the surgery room.

"Wait, she needs a blanket," the nurse interjected, a thought that hadn't even occurred to modest me.

"There's no time for that," the doctor snapped as the table continued to roll.

"There is time!" she just as swiftly snapped back, as a blanket flipped into the air and dropped down onto me. I will always remember a feeling of warmth with that memory that did not come from the blanket.

After I stopped rolling, I was scanning the maze of chrome around me when I became aware that the nurse who had had her stethoscope on my abdomen was still unsuccessful in locating a heartbeat. I heard myself ask the solemn doctor if there was any hope.

Within an instant he firmly declared, "There's always hope."

I never learned this delivery doctor's name; but in the years ahead, his answer echoed in my ears during many of my most hopeless moments.

A second after this shot of confidence, I heard the unrelenting stethoscope nurse say, "I think I heard something."

Then there was a faint return of my former optimism. "Please hurry, she may still be alive." The doctor picked up the scalpel as a mask of gas went over my face, and I began to drift away from the trauma.

I continued to rehash the day's events as I drifted in and out of a drugged sleep, then fantasized that maybe this was all a crazy nightmare.

My surgical complications had become more threatening during the night, but by morning I could hear the nurse, who was checking my vital signs, assure me that I was "doing fine" considering that there had been doubt that I would survive the night.

I could not see past the nurse's double chin, but as she adjusted my pillow I could sense that her face must be lined with compassion.

"Robbie?" I asked.

"Your husband went home for a couple hours' sleep. Said to tell you he'd be back this afternoon."

"The baby?" I hesitantly uttered.

She quickly turned to adjust my I.V. before answering, "The doctor should be in to talk to you soon."

Her voice was jovial, but just like the other nurses, she dodged my questions. I had so many questions, but I was too weak to press for any answers.

I was not sure when the nurse left the room and the doctor entered, but when I blinked and recognized Dr. Kirksey, I felt a rush of adrenaline that kept my eyes open for his entire visit. He was the pediatrician

who had examined my other boys after birth. I immediately noticed that he did not appear as cheerful as he had on those three previous occasions.

I barely listened as he went through the height, weight, and other measurements of my baby, for I was anxious to hear about the "problems."

He paused and steadied his voice before saying, "As I'm sure you already know, he was not breathing and was completely blue at birth. He started having seizures shortly after he was revived, and has had frequent bluing periods. We have him on oxygen, and phenobarbital for the seizures."

I really wasn't quite sure what he meant by "seizures," but then again, I wasn't quite sure about anything. I had heard the word "seizure" before, but I had very limited knowledge of what caused seizures and what one did about them. Since my mind was not together enough to progress to a higher level of questioning, I decided to restrict myself to the basics. "Will he live?"

"We'll have to wait and see." Suspecting how much I hated suspense, he touched my hand and softly added, "I'll keep you informed of any changes." Then he departed, and my adrenaline surge subsided.

With relief, I was soon able to filter the heavy-heeled click of Robbie's brisk strides from the other sounds of commotion in the corridor. Throughout our years together, I had always felt revived by signs that Robbie was soon to arrive. We shared an extended embrace until, looking like he needed lots of reassurance, he emphatically exclaimed, "You're looking good!"

"What did they tell you?" I was certain he must know more than I did.

"Same thing they told you." He moved a chair close to my bed and recited a report similar to Dr. Kirksey's.

"Did you see him?"

"I went in a couple of times. He's in isolation. He's a beautiful baby, it's just that...." He hopped out of the chair he had never quite settled into and stated, "I've got to make a few phone calls. Do you mind?"

"The boys?"

He fumbled through his dialing before answering. "They're fine...I guess. Actually, they've been very quiet." Trying to lift my spirits, he added, "Between my mother and your sister, they've been well fed and entertained. You're looking good!" he repeated, with a little more confi-

dence, before turning to his phone conversation.

Robbie had recently been finishing his work on the movie, *Five-Finger Discount,* the story of a teenager who seeks parental attention by stealing. He was vice-president of Cine Guarantors, a subsidiary of Taft Broadcasting, which guaranteed and supervised the production of movies for the three television networks. Since one long phone call ultimately strung into another, I relaxed into another nap.

I had met Robbie shortly after I moved to Los Angeles. We were close in age and interests, and always laughed a lot when together. He loved to joke around, and avoided depressing issues. I loved the sense of freedom and the excitement of adventure I felt whenever I danced away from reality with him. On the other hand, knowing that life does not always lead us merrily along one path, I began to worry that my comic mate would not be able to navigate wisely around serious obstacles. One evening my apprehension surfaced when I demanded, "Don't you ever take anything seriously?"

"What can I say? As each thing approaches me, I analyze it, deal with it, and move on. Life is nothing more than a blink of an eye. You have to spend most of your time on what makes you happy." He went on to reveal that under this clown's mask there was also a strong sense of responsibility. Then he maneuvered us back to another fun date.

I soon forgot exactly what else he had said that night, but I know it impressed me profoundly. The next evening when he arrived at my door in a tattered sweatshirt, shorts, and tennis shoes and strolled past me without an explanation for his unscheduled visit, then plopped down on the couch and mumbled, "Do you want to marry me...yes or no?" I didn't hesitate with my "Yes!"

When Robbie had completed his business calls, he became a permanent fixture at my bedside while Dr. Kirksey made his numerous afternoon visits. I was touched by Dr. Kirksey's gentleness as each of his reports sounded less encouraging. On his last visit that evening, he hesitated before saying, "I'm sorry, I've done everything I can."

"Do you mean he's dying?" I cautiously released each word.

"I mean it's out of my hands," he compassionately replied. "I'm...."
He turned and left with the sentence unfinished.

Most of my muscles contracted before I whispered, "He's dying again."

The words were followed by the tears I had been storing up all day. I was losing him once more, and I had never had the chance to know or

even see him. Adept at problem solving, Robbie consoled me with the promise that he would find a way to arrange a visit.

Within a short time, Robbie had recruited two nurses to help him hoist my bloated body with its attached tubes and bags into a wheel-chair. But as we finally entered the infant I.C.U., my apprehension also swelled. I was afraid seeing my baby would make losing him more difficult than it already was.

Even from across the room, I could tell he was the prettiest baby in the nursery. He had a full head of thick, black, wavy hair, and large, heavily lashed blue eyes. But as I got closer, I saw that his perfectly formed, slender body had a grayish blue tinge and appeared to be stuck in a continual quiver. Slowly I reached my hand into the incubator. When I touched his fingers, his eyes turned in my direction and I felt the formation of a strange but strong bond of love. The thought that he wasn't a girl never occurred to me. Thoughts of those "problems" we had never gotten into no longer bothered me. I did not want to lose him, and yet I felt helpless in preventing his death.

During our all-night vigil of shared grief, I felt closer to Robbie than I had at any other time during our seven years of marriage. While we waited for the final moment of death, Robbie paced the floor for hours before slumping into a bedside chair with a sigh. "I shouldn't have let you talk me into Marineland."

"No...no, it's not your fault. I never thought this would happen. I...."

Realizing that the burden of guilt had shifted, Robbie interrupted. "The doctor said it wouldn't have made a difference if we had gotten here sooner." He tried to jam a lot of belief into his words, but the exchange of looks that followed clearly acknowledged that we would both always be uncertain about this.

After a period of silent regrets, I voiced my realizations. "We can't change what is. I can see so many things that once might have changed things. I didn't see any of them before.

"Wait a minute," I interrupted myself. "We haven't even given him a name!"

"What did you decide...before this happened?" Robbie politely yielded.

"Let's call him Joseph Thomas, like you wanted."

"No," Robbie decisively declined. "You didn't like that."

"I didn't like that you were going to nickname him J.T." I stopped

crying to chuckle. J.T.'s was the name of a neighborhood coffee shop where we had had breakfast and argued over names almost every weekend during this last pregnancy. "I like the idea that he would be named after two favorite uncles, one from each side of our family."

"Okay, Joseph Thomas it is." Robbie lowered his head so I would not see the tears welling in his eyes. When one slipped out, I forgot my loss for a moment and cried over his pain. I never wanted him to be this serious.

Only a few minutes passed before Robbie pushed himself up and reached for the phone. "Why don't I call that priest you like at visitation?"

"Father O'Grady?"

"Yeah...see if he can come over and baptize him."

While Robbie was calling information for the number, I remembered, "But this one was supposed to be baptized in the Armenian church. Did you forget? We alternate, to keep the peace."

"I know, but this time we're going to break tradition. He's going to be baptized Catholic. My mother will understand." Then he dialed the number he was given, and I had a much more uplifting reason to cry.

When Father O'Grady arrived early the next morning, everyone was surprised that Joey was still alive for the baptism. Robbie witnessed the administration of the sacrament, then had breakfast with the priest.

Later I was awakened by the sounds of shaving in the adjoining bathroom. "How did it go?"

"Fine!" Robbie answered. As his six-foot frame moved into my room, I could see that his spirits matched his appearance. His thick eyebrows and black hair exemplified his virile Armenian heritage and somehow complemented his boyish charm.

"How come you look so good?"

"I conned one of the nurses into letting me sneak a shower. I need to go to the set for a few hours." He stuffed a script and assorted notes into his briefcase while he continued talking. "Joseph is looking good."

There was a pause before he delivered his determined forecast, "He's going to live! I knew it the second you touched his hand and he turned and looked right at you. Did you notice that?"

Dumbfounded that he had noticed, I only nodded before Robbie resumed, "I knew he'd turn the corner. Have you seen my keys?"

He was looking around the room, but I was certain he was recalling our night of mutual depression. Finally he confessed, "I didn't trust my

instincts. He's a fighter. He's going to make it!" He grabbed his keys off my nightstand and gave me a swift kiss. "I'll be back later."

Not equally confident that Joey had turned the corner, I reluctantly dropped into another nap, sorely missing my crying companion.

By noon I felt capable of doing more than sleep, and once again I found myself entertaining the thought that maybe our son might live. This time it also occurred to me that I should try to do something to help push him around the corner. Why was I just lying there accepting that he was going to die?

My first impulse was to call every doctor in Los Angeles. Then I composed myself and called Dr. Cobley, our children's regular pediatrician. He had a soft-spoken sense of humor and a common-sense approach to pediatrics, which made him well liked by both children and parents.

After relating my story, I pleaded with Dr. Cobley to get Joey to UCLA as soon as possible. He asked why I wanted UCLA, and what I thought they could do that was not already being done, but I didn't really know. All I knew was that people came from all over the world to be treated at UCLA. They must have the latest ideas and equipment, and I needed to feel that I was doing something, whether it was really necessary or not. Dr. Cobley concluded our conversation by discreetly informing me that UCLA did not accept transfers of hopeless cases, but he would see what he could do and call me back.

I was comforted by how quickly Dr. Cobley acquainted himself with the case via Dr. Kirksey, then pulled strings and arranged for Joey's speedy transfer to UCLA. Before the transport team left with our newborn, two of its members stopped by my room to relate that the baby's condition had improved greatly. Since they were overly complimentary about the quality of care our son had received from Dr. Kirksey, I assured them that my desire to transfer Joey to UCLA had nothing to do with any doubt about this kind doctor's ability. As I listened to what I was saying to them, I felt a little foolish. I had not altered the course of my son's life by switching hospitals. Nevertheless, I felt better just to be stirring up a few waves.

In the days that followed I was still unsure when one day ended and the next began, but I knew time was passing, because I felt less drugged each time I opened my eyes. My lingering emotional shock cushioned me from physical pain, but it also retarded my recovery from the surgi-

cal complications. This left Robbie uncertain as to who was in worse shape as he traveled between the two hospitals, converting each into a temporary office. Robert, Shawn, and Marty were shuffled between relatives, silently harboring their own fears of what was going on.

I made frequent calls to UCLA during those days, always bracing myself before I asked how Joey was doing. I was told that the seizures had stopped shortly after he arrived at the hospital, that he was slowly being phased off of phenobarbital, and that basically he was fine. However, the doctor I usually spoke with always felt it was necessary to tell me that the baby could not suck. I kept thinking she must be a below-average intern. Who ever heard of a baby who doesn't suck?

"Well, how are you feeding him?" I finally asked.

She went on to describe a process called "gavage," but I decided not to pursue the meaning any further. It sounded too complicated. "Gavage" was just another new word that had never been in my vocabulary before. I felt like I was drowning in a medical dictionary and preferred sinking rather than taking the time to understand all of the terms. Maybe I thought I wasn't going to be stuck in this quandary long enough to justify the effort, or maybe I had a tendency to avoid what I wanted to keep beyond me. I was only interested in hearing that the baby was alive and that this "gavage," whatever it was, was keeping him fed.

It was almost unbelievable, but once again we were pushing death off our shoulders. I did not completely trust the permanence of the push, but I could never have guessed how long we would continue riding this teeter-totter between life and death.

In the beginning I did not know what would develop with this child, who was not like any other on our planet. I could not see then that my tragedy had not been reversed by our son's living. It had only just begun to unfold.

Going Down the Tube

*Well, I must endure the presence of two or three caterpillars if I
wish to become acquainted with the butterflies.*

JOEY had managed to live for seven days when the doctors agreed to
discharge me from the hospital. I had promised to return to my own
bed at home, but instead I had Robbie take me directly to UCLA. I
had to see Joey.

Robbie's frequent shifts from the set of his new project, *Black Mar-
ket Babies*, to his personal hospital scene had made him a pro at the
neonatal admittance procedure. He must have picked up some pointers
from the current film, which portrayed a mother and her newborn
caught in an illegal adoption scheme. I was tickled by his rehearsed
demonstration of the scrubbing that preceded the cap-and-gown ritual,
which was required before we could enter the large wardroom that
housed Joey.

As I looked around the real neonatal clinic, I was stunned by all the
beeping breathing machines and ringing cardiac alarms attached to so
many tiny babies. A swarm of adults were scurrying among the incuba-
tors to sustain the fragile strings that connected the babies to life. Our
son's corner crib was too conspicuous to miss. He was the only baby of
normal size and coloring who was not attached to any life-support ma-
chine.

Robbie took my hand and started to lead, but a doctor stopped our
advance and requested a few moments of our time. Throughout our
conversation, my eyes seldom strayed from Joey's crib. From a distance,
he looked perfectly normal to me; but as I listened, the doctor ex-
pounded on all that was wrong with him.

They had successfully taken Joey off oxygen, phenobarbital, and I.V. fluid. However, he had no reflex to suck, or gag, no muscle tone, and lacked many other standard baby reflexes. Most of it was just meaningless negatives to me.

Sensing this, the doctor continued. "He has brain damage. Just how much damage and what areas are involved, we don't know. We'll have to wait and see." His words seemed to drift over me with no more credence than one would give a student's suspicions.

Realizing he had not sparked a reaction, he concluded, "The nurses will show you how to gavage him. We want to make sure that you, and as many members of your family as possible, know how to gavage before we release him. Now, you may pick your son up if you like."

"I can hold him?" I asked.

"Of course," he said, startled by my surprise.

I couldn't believe I could walk over and pick up a baby who had just spent a week so close to death. I felt as though I ought to be a doctor rather than a mother to handle him. From this permission to hold Joey, and from the doctor's implication that he planned to release our son, I concluded I could put my fear of his dying solidly behind me.

As we walked across the wardroom, a team surrounding one of the incubators sluggishly dispersed. I overheard their condolences to a couple who had remained to watch the closing seconds of their daughter's life. Robbie tightened his squeeze on my hand as we kept moving helplessly along.

Close up, my beautiful boy looked even more like a perfectly healthy baby peacefully sleeping. But when I picked him up, I instantly understood what the doctor had meant by "no tone." Joey's body felt like a large, droopy, wet noodle. But without delay I told myself this didn't matter. I was certain he would firm up in time. I cuddled him close, and sank into a rocking chair Robbie had pulled up for me.

Robbie and I never shared our reactions to the doctor's discourse or the depressing scenes that surrounded us. Even though Robbie was more aware than I of what lay ahead, he always forced himself to maintain a positive attitude. Knowing that I did not want to talk, Robbie stood silently behind me. Actually, I did not even want to think; I wasn't ready to subject myself to what might come to my mind. All that mattered to me was that my baby was alive...I would deal with the rest later. For the moment, I just wanted to enjoy rocking the infant who finally felt real to me and who undeniably had a firm grip on life.

My contentment was interrupted by a proficient-looking nurse who was going to show us how Joey was gavaged. She explained the procedure professionally as she swiftly slipped a clear plastic tube, an eighth of an inch in diameter, into Joey's mouth and down his throat until it reached his stomach. Then she paused to listen through her stethoscope for Joey's bowel sounds, and stressed the need to make sure the tube was in the stomach and not the lungs. Next, she attached the outside end of the tube to a funnel-shaped syringe, into which she put two ounces of formula. Robbie and I watched in amazement as she hoisted the syringe above Joey's head and the formula slowly gravitated through the tube into his stomach. When the syringe was empty, she promptly pulled out the plastic tube and proceeded with traditional burping.

Joey had opened his eyes during the feeding, but he gave no indication that he was bothered by what was taking place. A quick glance at Robbie showed me that we both felt a similar dismay. To keep my cover, I asked, "How often do you do this?"

"Every four hours. We'll gradually increase the amount of formula until he's able to tolerate the usual bottle amount for a baby his age."

Curious about her exaggerated concern for proper placement of the tube, I asked, "Why were you worried about getting into the lungs?"

"There is only a thin flap that separates the esophagus from the trachea. Since he is not voluntarily swallowing the tube, and since he lacks so many normal reflexes, we could easily slide the tube into the lungs by mistake."

"What would happen if formula accidentally got into the wrong place?"

"He'd drown! But don't worry about that. It only happens occasionally, and they always start coughing as soon as you enter the lungs. So you can pull the tube out in time."

I just nodded silently while I contemplated the news that Joey could indeed cough. This "no suck" was obviously going to be a bigger problem than I had anticipated! I had a private laugh when I remembered how I thought the doctor was crazy when I first heard her say Joey had "no suck." But, I still did not know how drastically this was going to affect my future sanity.

My release from the hospital freed Robbie to catch up on some neglected post-production problems at work. Conveniently, my mom was able to extend her visit and supervise the boys at home. Consequently, during the next week I made the trip to UCLA every morning, and

stayed most of the day. I managed to convince everyone, including myself, that I had made a speedy recovery. Actually, during Joey's first year of life, I never progressed very far from my original state of shock after his birth.

Joey, on the other hand, seemed to be making steady progress. When I arrived on my sixth morning at UCLA I was thrilled to hear that one of the night nurses had been able to get him to take a teaspoon of formula from a bottle. Maybe he just had to *learn* how to suck! My thrill was toned down a little when I learned of the necessary precautions and possible complications. The nurse explained that we should only practice with the bottle when the gavage tube was already down Joey's throat. A faint gag reflex was developing, and if we tried to pass the tube with something in his stomach, it might cause him to vomit; and because of his poor swallowing reflex, Joey might inhale the vomit. If we offered a bottle after gavaging, we wouldn't have the motivation of hunger; but manipulating both tube and nipple first would be a difficult feat for the tongue of even a normal sucker. In spite of this drawback, tiny successes with pre-gavage bottles were the sparks that would keep my hope kindled for many months to come.

I took my own poll of the nurses at UCLA, but I could not find one nurse who knew of a baby who had gone home on the tube. Failure to suck was not unusual for premature babies, and gavaging was the standard solution. Yet the preemies these nurses had worked with were always sucking by the time they left the hospital.

The last nurses I interviewed cheerfully harmonized their conclusion. "But you're so competent, no one has any fear of releasing Joey to you."

I produced a phony smile. I hated it when people said I was competent. It really meant they had incorrectly figured I did not need any help. They were unaware that my fits of crying were confined to the solitary car rides between my home and UCLA.

"When do you think he'll be released?" I cautiously asked.

"The doctor said tomorrow."

Knowing that my face did not reflect the happiness they expected to see, I turned around to change my serene son's diaper. At last, he was going to be my baby! I would not need anyone's permission to pick him up. I wouldn't have to scrub my skin with Phisohex before I touched him. I was anxious to take him home, but at the same time I was terrified. I felt secure gavaging and caring for Joey when I was surrounded

by doctors, nurses, and special equipment to tackle any complications that might arise. But how was I going to do this at home by myself? What if I put the tube into the lungs? What if he aspirated? I was skeptical about my ability to care for Joey, and unsure of what to expect from him.

By that afternoon I was ready to explode, and I admitted some of my fears to the hospital social worker.

"What about your husband? Can't he help you with the gavage?"

"No. He's under a lot of pressure at work. I don't want to burden him with learning to do it. He has great qualities as a father, but changing diapers was never one of them, and I'm sure gavaging would rank lower than diapers on his list of child-rearing preferences."

We both grinned, but she agreed that the situation was scary and helped me arrange for a private nurse, "just to stay with you for a couple of days to ease the transition."

The social worker then told me that doctors from the Child Development and Neurology departments wanted to follow Joey's progress. I sensed that these doctors suspected there would be more problems, since Joey was being released on a "wait-and-see" basis. I didn't have the slightest idea what I was waiting to see. Even if UCLA didn't know any more than I did about what this little jack-in-the-box was going to pop up with, I was certain they would be much more capable of dealing with whatever might arise. So I agreed to follow through with as many doctors' appointments as they wanted to schedule.

Before leaving the hospital that day, I stopped by I.C.U. just as one of the doctors from the Neurology Department was completing his examination of Joey. I had seen this lanky, reserved man observing Joey on several occasions. Whenever I had approached, he had always smiled and left without comment. This time I blocked his exit, and startled him and myself with a spontaneous question.

"How would you rate his degree of brain damage?"

"What do you mean?" he slightly stuttered.

"I mean, just how much brain damage does he have...on a scale...like, mild or severe?"

The neurologist focused on the chart he was shifting between his hands and affirmatively nodded his head. "Mild...maybe mild to moderate."

"Oh." I felt a tinge of relief. "Thank you."

"Sure." His oversized eyes looked directly into mine. "I hope it

helped." He left before I had time to formulate another question.

Grandma Rose and I arrived at UCLA early the next morning. After exchanging our gratitude to the staff for their good-luck wishes, we warmly wrapped our two-week-old bundle for his trip home. Throughout the drive I kept shifting my eyes to Joey. My mother had him cradled on her lap, and was delighted to have a chance to correct all the things she was certain the nurses had been doing wrong. Since I was always nervous with newborns, it was comforting to see Mom so confidently flipping her new grandson around while she sang her off-key Irish ballads.

My mother had also held our other three sons on the days they came home from the hospital. This son was different, but she was acting the same. I was probably just being more uptight than usual, yet I felt an eeriness like one might feel watching a sleeping volcano. But my apprehension faded when we pulled into the driveway and I saw Robert and Shawn charging from the house dressed in their favorite cowboy outfits to greet their new brother.

It was easy to imagine my two oldest sons preparing for this homecoming, since I had so often seen them adorned in the same fashion. There was not a wrinkle in Robert's shirt, and his jeans fit his slender body perfectly. Even though the mess in his bedroom reflected little respect for clothes he had already worn, he had probably lingered in front of the mirror until he was satisfied with his impeccable image.

Without a doubt, Shawn had watched respectfully as Robert stroked the brim of his cowboy hat to sharpen the creases. But then, after initial attempts to imitate his brother, the younger one would always opt for a sloppier look, and pull his hat firmly over his ears, rounding out the folds of its crown. Shawn kept every gift he had ever been given in mint condition; but his protruding tummy prevented him from having a perfectly tucked shirt.

Too young to be interested in clothes, Marty squirmed to be released from Grandma Betty's arms and scrambled to keep up with his brothers. I trailed behind my mother as she fought her way through the swarm of inquisitive tugs as everyone tried to see the latest family addition. Finally she made it into the house, where she gently placed the little creature on our living room sofa and unfolded his binding blanket, and his siblings advanced for a closer inspection. They speedily fondled each of his limbs, and then Robert, who was generally the leader, voiced their opinion with a questioning shrug.

"He looks okay to me, Mom."

Not needing to explore the controversy further, Marty snatched his bottle out of Grandma Betty's hand, and the other two whizzed past me on their way back to the car. They were anxious to see if any of my baggage held any surprises for them.

Robert always took advantage of his eleven-month seniority, and had already canvassed most of the car's contents before Shawn and I caught up with him.

"What's this?" Our oldest looked suspicious as he showed Shawn the gavage equipment he had discovered in one of the bags.

I was speechless for a moment. I had hoped to introduce the boys delicately to Joey's weird way of consuming food. Now, without a curtain and close to feeding time, I had to brace myself for the difficult demonstration.

Throughout the gavage, the boys were stiffly silent. They did not let a single detail escape their scrutiny. It was not reflected in my voice, but I was worried about the thoughts they might be juggling. I could not tell whether my carefully chosen words were able to pacify their hidden fears of the oddity they were witnessing.

Ending my discourse, I dislodged the empty tube and passed the baby to my mother-in-law for burping, in order to study the boys' faces for any telltale evidence of trouble. But, Robert was too quick with his question.

"What do you do with these things after he eats?" He pointed to the syringe with its inserted pump, which I was still fiddling with for support.

"I...I just throw them away. I have to use a clean one every time I feed him, so he won't pick up an infection."

"Oh." Robert raised his eyebrows as he looked to see if Shawn was operating on the same frequency. I was unsure of the decoded meaning when they asked in unison, "Can we have them?"

"Why?" I gasped, finding it unimaginable that anyone would want them.

"For squirt guns," they sheepishly chimed.

Realizing they had lost me, Robert grabbed the two pieces from my hand and darted off, with Shawn at his heels. "Let me show you, Mom."

I followed them to the kitchen sink and watched that instrument of fear transformed into an enchantingly effective squirt gun. Even I en-

joyed ducking and firing the recast weapon. This invention shot all of the tension out of our arrival, and would divert the boys and get them out of the house during the scorching summer ahead.

While I played with my more active sons, the two grandmothers gloated over their latest descendant. Before the morning had ended, my mother-in-law had given me an extra congratulatory hug along with warming instructions for her precooked chicken-and-pilaf dinner. She left just as the nurse whom we had expected arrived.

I fixed tea for the nurse and led her to the rocking chair beside Joey's crib in the center of our living room. I explained to her my son's complicated case history, and confessed my insecurity about severing his medical connection while some unknown problem might still arise. I told her that I would do all of the caring and gavaging. All I wanted her to do was watch and make sure I was doing everything correctly, and intercede if I did something wrong...like dump the formula into Joey's lungs. I had left my self-confidence at the hospital.

The nurse followed my instructions explicitly and rocked as I raced around the house. I thought all was going well until this woman set down her tea and left for the day. She was a cold person, and yet I felt like running after her, begging her not to leave me.

Luckily, the demands and interruptions of four children limited my time to mourn the sudden loss of my security blanket. That evening, when all four were finally asleep, I began to assemble the baby supplies I would need during the night. Misplaced things usually made me uncomfortable, but temporarily converting the living room into a nursery made Joey more accessible, so I put up with the disorder.

For most of the day, my mother had hovered close to the crib guarding our little stranger, who had not yet graced his new home with a sound. She probably saw the need for more help when she impatiently asked, "When will Robbie be home?"

"I never know...soon, I hope. Can I get you anything?"

"You can get back into bed where you belong. You've been on your feet all day!"

"I will, as soon as I set up this stuff."

Trusting my eventual compliance, but favoring my ability to fight fatigue, she turned her attention back to the crib and proudly assessed her placidly sleeping grandson. "He really is your prettiest baby. And he's so good! He never cries."

I did not respond. I had been raised with her belief that crying and

complaining were close to mortal sins, and I knew better than to attach a negative trailer onto any of Mom's positive feelings. This baby was pretty, all right, but he was mysteriously too good.

"He's so good, and he never cries," had been my exact words to the UCLA nurse a few days before we came home from the hospital.

"You want him to cry," the nurse had solemnly stated.

I had never wanted any of my babies to cry. Then again, it had never occurred to me that one of them couldn't. Did she mean that Joey couldn't cry, either? Who ever heard of a baby who couldn't cry? Then again, I thought no one had ever heard of a baby who couldn't suck. I continued trying to sort it out in my mind, but ended up sticking it off in an unused corner.

This brain-twister was untangled on that first night home. Joey started to cry shortly after we went to bed, and continued throughout the night. I was pleased that he could cry, but the all-night proof I could have done without.

Curiously, with each passing day this good baby's irritability increased. Unsure of what this meant, Robbie and I decided to extend the nurse's supervision for a couple of weeks, or until everyone was stable.

A week after Joey's homecoming, I noticed his eyes twitching during the gavage. When his head also took up this motion, I interrupted the nurse's reading and asked her to watch. She was alarmed by what she saw, so we left for UCLA.

When we arrived at the hospital, we were immediately escorted to a room. Looking back at the waiting area full of people with problems that appeared more severe than ours, I hated the questioning fear of why we had been sent to the head of the line, and then later, why we had to resume Joey's phenobarbital. His ability to learn to suck would undoubtedly be weakened by drugs.

Then it began: the not-quite-seizure, but not-quite-normal movement we called "the jerk." Joey's little twitches of the head or other parts of the body were never consistent in location or duration, but were jumbled senselessly. They gave me panicked surges of adrenaline, and made me feel like a goon as I tried to describe them to the UCLA neurologists.

During each of my weekly clinic appointments, the neurologists who were following Joey listened intently to my ambiguous accounts. Then came the questions. Almost the same questions every time, like, "Which side did the jerk start on?" or "How long did it last?"

I had never been able to tell left from right quickly, and fear always interfered with my ability to estimate time. Furthermore, I never really understood why it was important for them to know these details; and yet I thought my only hope for their help depended on how adequately I described the jerks. My private nurse claimed she was unable to translate my description of Joey's jerks, so each week I left her in the waiting room and sweated out my senseless responses alone.

On my third clinic visit I was embarrassed by the strange look on the doctors' faces as they watched me nervously trying to calm Joey. They wanted to know if he was always this irritable.

"Well...yes," I replied defensively. What mother wants to admit that the sweet infant originally entrusted to her has turned into a grouch?

"Let me check his reflexes," one of the doctors said as he took Joey and laid him on the table for a knee tap.

"He's spastic," he announced soberly to the other neurologist, who returned a supporting nod.

"What do you mean by spastic?" I asked from far below their level of understanding.

"You've probably seen some older people who walk with a jerky movement; well, that's spastic. See, when we tap his knee, his tone is too high."

"You mean you can tell from that little tap that he will have a spastic walk?" I dubiously questioned.

"Well...if he walks." My expression after this comment seemed to unnerve them.

"Here, let me see if he responds to Mommy." I cringed when Joey's crankiness was unaltered by the change of hands. I was too preoccupied with wrestling Joey to pursue the issue of walking, spastically or otherwise, and the doctors made an abrupt exit after telling me they would see me in a week.

I was never able to get much out of these time-consuming clinic appointments with their continual flurry of doctors, students, and questions. No one ever seemed to volunteer any information. Did they not have any? Did they not want to upset me with their suspicions? Did they think he was dying? I never understood. They would watch and listen and then ask if I had any questions. By the time the ball reached me, I was already drained! My only concern was getting off the court and home before the next gavage was due.

The full impact of this visit did not hit me until later that day after I entered my green bathroom. I thought we had a "no tone" problem and that Joey had been improving since birth. How and when did we go from "no tone," past normal to "too high?" How could they make such horrible predictions just from a little overreaction to tapping? Maybe they just hit a more sensitive spot. I could not come up with anything sensible as I stood there in the bathroom. Nevertheless, I preferred hating them to asking them…it seemed to take less time and bring more relief.

Before long, the telltale signs of minimal sleep coupled with daytime stress told Robbie that I might need a little more glue to keep me together.

"Why don't we get a night nurse? You need sleep. You can have one nurse come from eleven in the morning until after dinner, and another from eleven at night till morning. Then you'll only have to worry about the two four-hour shifts inbetween."

Realizing that I was listening attentively, Robbie continued. "You can get one of those big spiral notebooks like the kids use at school, and have the nurses help you keep a daily record. Then when those doctors start hounding you with a lot of questions, you can just hand them the notebook, and let them read for themselves."

With a nagging suspicion that the situation was going to get worse, I eagerly agreed to the additional help. Being an ardent note-keeper, I knew a notebook would enable me to use the nurses more effectually. They would record medicines given and vital signs. I would record amounts that Joey was able to take by nipple versus gavage. Everyone would record jerk descriptions. Written down, things were always more understandable to me. The appearance of even a tiny common denominator in Joey's wildly inconsistent behavior would make this diary invaluable.

Robbie and I then agreed that more nurses would necessitate a larger work area with easy access to a water supply. Also, Joey's gavage equipment had to be safely stored away from one-year-old Marty and the squirt-gun team. Our master bedroom with its attached bath looked like the most sensible location, and it would require only a little rearranging. We moved our king-size bed into Marty's room, which was to have been shared by Joey. A crib for Marty was awkwardly positioned in the small room we used as an office. Then a twin bed, rocking chair, and Joey's crib could easily settle into our spacious bedroom.

"Now everyone should be comfortable," Robbie concluded as he surveyed the situation and left for work.

Being surrounded by neatly matched furnishings was high on my list of priorities. I had spent years decorating this house, using meticulous coordination of colors, fabrics, and wallpaper to achieve the look I wanted. Still, I did not even feel the rug being pulled out from beneath me as my two-year effort was drastically rearranged in two hours so that the nurses would be more comfortable. At the time, it appeared to be the only logical solution.

Remodeling turned out to be easier than tracking down private pediatric nurses who knew how to gavage an infant. This was an uncommon nursing chore. I contacted most of the registries listed in the yellow pages before finding a qualified nurse willing to work from eleven P.M. to seven A.M. But when Rosa Wingfield first walked into our home, both Robbie and I knew we were finally going to have a good night's sleep.

Rosa was a religious woman, close to fifty, and never arrived late or missed a scheduled night. Any of her shift not spent consoling Joey, she spent praying for him. It was unfortunate that Rosa could only work a maximum of three nights a week, because we would *not* have her prayers or competence with all of our night nurses.

Each night that a newcomer arrived, I would escort her to our makeshift nursery, where I commenced a lengthy description of Joey's birth trauma and its resultant problems. Then I outlined the procedures for nippling and gavaging—just in case she had forgotten a few things, but also to study her reaction. I would judge by her facial expressions how capable she was of getting my son through the night. The result of that judgment would determine the quality of my sleep.

One night I did not like the reaction I got during my instructions. The nurse was very sweet, but she seemed too unnerved by my lecture. I stressed for the fourth time that she must wake me if there were any difficulties, and then took my uneasiness to bed. By 2:00 A.M., I was still awake enough to hear Joey's cries. Not wanting to let my night remain totally useless, I decided to spy on the nurse. The idea seemed more rational when I realized that Joey's cries were growing louder.

When I entered the room, Joey was thrashing about while the nurse was shakily trying to insert formula into the syringe. Concentrating on the wrong end, she had failed to notice that the tube was not far enough down Joey's throat. If I had not interrupted when I did, the

formula would have squirted out around his throat area, possibly drowning him.

While I was consoling Joey, the nurse, perspiring and near tears, confessed she had never gavaged an infant before. I did a lot of checking on the nurses after that...which wasn't too much trouble since I seldom slept very soundly anyway.

Searching for available and reliable nurses and performing my changing-of-the-guard routine ate up too much of my time, which was dwindling rapidly. I always felt it necessary to thoroughly update the arriving nurse and profusely thank the departing one; I never considered that these nurses were well paid for their contribution to my security. Our bedroom worked perfectly for them. All of Joey's clothing and gavage supplies were arranged in an orderly fashion, separated from the rest of the household turmoil. The nurses could read quietly while Joey napped—he always napped on their shifts. But because I treated the nurses as guests and supplied them with whatever food or drink they desired, I was never able to work them fully to my advantage.

Solutions are easy to see when you're looking back on a problem, or when you're on the outside looking in at how someone else deals with a dilemma. But when you're stuck right in the middle of a quandary, your vision is not quite as clear. Most observers of our nursery arrangement thought the situation was well organized, and so did I. The nurses felt right at home...but where was *my* home? This problem which I had created for myself would have to be dealt with later, and it would not be easy to solve.

In the meantime, I found my salvation in the green bathroom. To this day I remember the comfort of being surrounded by its soothing fabric wallpaper, which had shaded strings of lime green and was complemented by matching carpet, tile, and enamel. With the congestion of nurses, kids, relatives, and friends, the bathroom was the only private off-ramp in a house that was beginning to resemble a Los Angeles freeway during rush hour. Everyone had rushed in to help, but no one knew *how* to help, and I was becoming more and more incompetent as a traffic director. I could never see where I was heading during that first year with Joey, but from frequent green bathroom stops I was able to pick up the courage to keep moving.

Bathroom visits are a time of privacy that everyone can understand. No one questioned my need to go. I'm sure the frequency of my pit stops seemed strange to some, but everyone knew I had a lingering

bladder infection. This justifiable excuse soon became overused, but I was careful not to exceed the commonly accepted length of stay. No one ever knew at the time why I really went to the green bathroom.

Even I became somewhat confused. Originally, I had been looking for a place to hide, but what I actually needed was a place to pray, a place for my type of praying, something like talking things over with an imaginary friend. The green bathroom became my church, in which I had a few uninterrupted moments to take in my nicotine and talk it out. I experienced more moments of closeness to God during my visits there than I ever had before. My religious beliefs had relaxed considerably from my rigid Catholic upbringing, but there had never been a lapse in my belief in God, nor in the value of these casual conversations.

Sometimes, while sitting in the corner beside the tub with my face resting on its cold rim, I chanted over and over, "Please, help me! I can't think!" Other times a sounding board was more useful. "Now what? He likes jello, but I can't keep changing red diarrhea. He hates me when I gavage. He just has to suck! He has to suck, but how?" Almost miraculously, after many rapidly inhaled cigarettes a new idea would came to me, like "Put honey on the nipple!"

Although my green hideout served me well for quite a while, in time it developed a snag—the intrusion of one son after another. I was often startled into laughter when they suddenly asked, "Who are you talking to, Mom?" But eventually these interruptions got out of hand before I was able to cut them off.

At first I thought I must have forgotten to lock the door, but one night I accidentally ran into the real culprit during one of our weekly shampooing, ear-cleaning, and nail-cutting sessions. I always put one boy at a time up on the sink for an assembly line run-through. This time, however, I slowed my regular non-stop pace to ask why Robert had been giving me so much static for several weeks about cutting his thumbnail, which was grossly discolored because of his various artistic endeavors. Our creative son casually confessed that the nail was used to unlock my bathroom door. He had discovered the trick one week when I had overlooked his thumb. Further questioning of the other two intruders confirmed that he had shared his discovery with them. Then Shawn added accommodatingly, "Don't worry, Mom, you can cut mine. Now I can unlock it just by pushing real hard on the center while I turn my finger."

In spite of these frequent interruptions, the green bathroom continued to work for me during those first months with Joey. Ordinarily, people leave things behind them in a bathroom, but I always seemed to leave *with* something—some consoling thought, some new idea or approach, or a little more strength to keep going until the next visit. Sadly, it would not be secure enough to shelter me from what was to come before the metamorphosis.

Chapter 3

Let Me Have My Problem

I set myself to attempt the difficult repairs all alone.
It was a question of life or death for me.

AS Joey approached one month of age, his irritability passed beyond bizarre. The word "crying" could not cover his howls. He locked into a rhythmic shrill of such volume that he seemed to be in excruciating pain. While sustaining this screeching sound, he repeatedly arched his back with a thrust that required all my strength to keep him in my arms. Drenched in perspiration, he would continue like this for hours, or until he commenced the second phase, an exhausted pant with tightly clenched eyes. Just as suddenly as he stopped one stage, he started the other. In the notebooks we began referring to this strange phenomenon as "the cycle."

The jerks worried me, but the cycle wore me down. I could easily understand why the noise devastated Oliver, our dog, who had already been neurotic before Joey arrived. Still, their howling competitions made me feel closer to insanity than any dog could ever get.

Rocking, singing, bathing, diapering, or filling Joey's stomach only stimulated a tiny occasional difference in his behavior. Of course, the real root of the problem was his brain damage. But whatever the cause, I could not bear for him to go through this terrible torment alone. I felt a small consolation from knowing that at least someone was trying to help him. So, the nurses, relatives, and I all took turns walking him. Since he was calmer in the early morning, I decided to start moving him before his "cycle" reached full steam, in the hope of delaying its onset. I thought the results were consistent enough to justify continuing this movement. Nevertheless, by the time he was into his fifth week of

life, Joey was rarely in his crib, and peaceful moments were few or none.

Each of us developed his or her own favorite type of walk that seemed most effective at calming Joey. I preferred pacing briskly with my son firmly in my arms. Robbie modified my method with his "march"; on many hot summer evenings he would unwind from work with a vigorous march accompanied by his loud but tone-deaf singing of "The Red, White, and Blue." Taking Joey in his arms, he paraded around the house, out the front door, and up and down the driveway. After several reviving squirt-gun shots, he would return to the kitchen, where I would mop off the sweat with a cold towel and help him gulp down enough orange juice to energize him for the next loop. I was never quite sure whether Joey was soothed or shocked into silence, but since it was the end of the day, my only concern was the end result. So I mopped as Robbie marched.

Just prior to the end of Joey's third month, Rosa arrived for her overnight duty. It was this night that she confessed her unrecorded activity, and asked permission to turn in Joey's name to Channel 52, so that he could benefit from an all-night pray-in. Naturally, I agreed. This television channel to God differed from our own preference, but I believe that all religions are just different paths to the same God. When I found Robbie in our makeshift bedroom and related Rosa's request, he was equally impressed by the sweetness of the thought—though obviously not by the likelihood of overnight success.

It just so happened that the next morning we were able to put off Joey's screams longer than usual. But instead of enjoying this prolonged peace and attributing it to miraculous intervention, I chose to worry about it. Maybe Joey was sick! Or worse, maybe he was getting ready to hit us with a different strangeness. I decided to call Joey's doctor at the UCLA Child Development Department for her opinion, and she too felt that the change in behavior merited a check-up.

By the time we reached UCLA, Joey had returned to normal. Relieved of the necessity to respond to the phone, doorbell, or another problem, I calmly paced the floor of our assigned room with Joey locked in my arms. It was not until he collapsed into his panting stage that I noticed all the stunned doctors in the doorway. After they had also witnessed the swift change back to the arching shriek, they all agreed this might be some uncommon kind of seizure state. Whatever it was, they thought it abnormal enough to require immediate hospital-

ization for further analysis.

I was stumped by their reaction. My phone call to the hospital had been motivated by the peculiar silence that morning, not by the "cycle," which I had finally accepted as just normal for Joey. Familiarity can certainly cloud the craziness in a situation! Until then, my descriptions of the "cycle" had not perked up any ears. Apparently the doctors had all thought I was exaggerating, whereas I had really been understating the problem. I was now worried about their concern and by what their "further analysis" might unleash.

Hospital admittance procedures can be very draining. Sometimes just going through them can be enough to merit hospitalization. It was a full day of successive questions, X-rays, and blood tests, including three unsuccessful attempts at a spinal tap to rule out meningitis. I was never quite sure how meningitis had been ruled in! UCLA is notorious for its thorough care. Yet, sometimes in their attempt to cover all the bases, the doctors create a few extra ones. Mercifully, they conceded that further attempted taps might be more disastrous than the disease.

It had been Robbie's first day of filming the television movie *Grass Roots*, a comedy about two youngsters who go on a shopping spree after finding a million dollars. He was not able to join me until later that evening, just as Joey was being wheeled into intensive care. We were told to wait while the I.C.U. doctors made their rounds and acquainted the oncoming shift with Joey's medical history and current test results.

The interim of anticipating the verdict left all of my internal organs in a flurry. After hours of waiting for the doctors' diagnosis, sadly slouched together on an uncomfortable couch, Robbie injected the silence with a sigh. "Well...I guess Rosa's pray-in didn't work."

I looked at him in disbelief, but only seconds passed before I began laughing and could not stop. At first, Robbie flushed. But then, after shifting his eyes from me to the stunned and sober audience, he helplessly joined this embarrassing fling.

Maybe I had been too dubious of his sincerity. But for whatever reason, his statement struck me as amazingly funny. Then, shortly, the hysteria itself became considerably more humorous than the bland comment that had provoked it. The more we realized that this was not the time for laughter, the more difficult it became to stop! Although our behavior was inappropriate, or at least unusual, for the setting, it provided us with a greatly needed release from tension, a lasting fondness for Rosa, and a lovely memory of togetherness.

We were beckoned back to reality by the nurse who escorted us into the intensive care ward. Our snugly sleeping son had no visible scars from the day, and several nurses were supervising him. We were at ease even before his attending doctor announced, "All of his blood work has not come back yet, but we can't find any signs of an infection, and his chest X-rays are clear. If you don't object, we'd like to keep him in I.C.U. for a few days of observation."

Robbie and I exchanged a glassy-eyed look and nodded our agreement.

"Why don't you go home for the night? He'll be given excellent care by the nurses here. You both look like you could use some sleep."

It was after midnight when we left Joey and compared our thoughts on the way to the parking lot. Since we had all survived the siege, maybe we could milk something out of this hospitalization.

In my mind, the cycles and jerks took a back seat to the gavage. When we had originally become acquainted with this alternative to sucking, Joey had been a calm, no-tone, no-cry, no-gag baby. The tube had slid easily down his throat, with no resistance and no discomfort visible on his face.

However, I had never had complete confidence that this would continue; I had already been exposed to too many children. Picturing one-year-old Marty's reaction to tube-feeding, I always found it hard to imagine how any baby progressing in strength and passing into a toddler's defiance would tolerate this procedure. Joey was now approaching that age, and a gag reflex was blossoming along with his vocal ability. I did not have to wait and see—I knew it would soon become impossible to pass the tube.

But I also knew that when all these medical minds who were observing our son put their knowledge together, they could certainly give us a workable way to get food into Joey. With this dividend in mind, I invested a lot of time during the next three days describing Joey's idiosyncrasies to anyone willing to listen.

I was awed by the continuous flow of doctors from almost every branch of medicine who thronged at Joey's bedside. They all seemed so interested in him. I, of course, thought they were all interested in finding a way to feed Joey. I would find out later that most of them were just interested. At UCLA it was difficult to tell who was going to teach you and who was going to learn from you. They all wore the same white uniform!

On the third day of hospitalization I returned from a lunch break during Joey's nap, and came upon an alert young doctor who had a reassuring air, which instantly attracted me to him. Since he was engrossed in Joey's chart, I hesitated before interrupting him with my hello. He pleasantly introduced himself, but as always I concentrated on his face and overlooked the accompanying name.

"I see here that he has developed a slight suck." His enthusiasm was stirring.

"Yes, but we're not getting very far with it."

"Why is that?"

"Well, he can only tolerate very slight stimulation of his mouth. Too much nippling always triggers his cycle."

"Cycle?"

"That's what we call his screaming pattern. When he really gets going, it's difficult to even hold him. Getting him to swallow formula or the tube is impossible, because the opening closes. I guess you physically can't scream and swallow at the same time."

"That's right. But you've kept him well nourished."

"But not for long," I continued, trying to get him to share my panic. "Every day he seems to be more capable of gagging or fighting to keep the tube out. I don't have any tricks up my sleeve. I need you to help me find another way to feed him."

He was noticeably flustered by my unexpected plea. "I wish I could…but this isn't my field. I'm specializing in radiology. But I'm sure whoever has the case will be able to come up with something before you leave."

Since I was never certain who would supply the help, when I was not talking to the doctors I was telling the nurses our most successful nippling and gavage gimmicks, hoping to provide a foundation for the improvements I was confident they would come up with.

I had no experience with pediatric hospitalization, so after Joey fell asleep for the night, I felt safe leaving him in the intensive care unit and returning to my abnormally quiet home. Fortified by the full enjoyment of three blissfully uninterrupted nights of sleep, I was physically in shape for the shock of entering the I.C.U. on the fourth morning and discovering that Joey wasn't there! I might have been able to deal with this a little better if I could have found someone who knew why, when, or where he had gone. I quickly realized that it is unproductive to bring up a moot point in any hospital during a shift change.

I decided to table the why and when, and concentrate on the where.

I finally found a nurse who guessed, "He probably improved and was transferred to the pediatric ward." This sounded a lot better than my own speculation, which included scenes at the morgue.

In the maze of pediatric rooms, I eventually heard my son's distinctive screams, much higher pitched than those of the unbelievably large number of hospitalized children. But the reunion I expected was pre-empted by the sight of my previously pampered baby. This time he had an obvious reason for crying. He had been put into a crib which had a mattress four inches smaller than its frame. His body was wedged into this groove, with his arms and legs dangling out between the rails. He had been left without blankets or anyone to respond to his cries, since the many nurses on the ward were involved with other patients.

After examining Joey for injuries, I bundled him up to console him and went to track down a nurse. I refrained from making the first one I found the recipient of my wrath. My priority was to find out how much food Joey had taken during the past ten hours. If his feeding had not been supervised, it would have been easy to slip below his required twenty-four hour minimum. That, in turn, would increase the possibility of his dehydrating.

"Excuse me, I need Joey's intake record for last night and this morning."

"Oh, he's NPO," the nurse casually replied, unaware of the importance I attached to the question.

"What does NPO mean?"

"Nothing by mouth. They have him scheduled for a CAT scan this morning, and he can't have anything in his stomach."

I could not get the words together for my next question before the nurse left to check a monitor alarm that was beeping for attention. As she was leaving, she added, "The intern will talk to you after rounds."

I was not sure which of the emotions I was feeling would surface first. Returning to our nook in the ward, I assumed a pensive quiet while I clutched my son and paced around his crib. My thoughts were only mildly affected by Joey's shrill crying. There was such a big difference between I.C.U. and the pediatric unit; it was like stepping out of Tiffany's and onto the streets of New York.

A few hours later my stewing was interrupted by the intern who was now in charge of Joey's case. We clashed instantly. I found myself returning his abrupt coldness as I reluctantly went through Joey's case his-

tory again. In a teaching hospital, everyone needs his own set of notes.

When we reached the point where the intern asked, "Do you have any questions?" I was able to control myself enough to ask, "Why are we here? Why were we moved from I.C.U.?"

"Well, I haven't had a chance to go over the details of the case. Apparently, he has improved..." they all seemed to like that word that I was beginning to find so distasteful "...from the meningitis or whatever it was he had. Since he was in the hospital, the Neurology Department thought it would be a good idea to hold him over an extra day for a CAT scan. Didn't they talk to you?"

"No."

"Well," he continued with an irreverent shrug, "they will. Also, the anesthesiologist will be in to explain the procedure and have you sign the consent papers."

"Anesthesiologist?" I wasn't sure of my ability to control a response of more than one word.

"He'll have to go under a general anesthetic for the scan."

"Oh?"

"By the way, I need another blood sample while I'm here," he said, readying his equipment.

"Why?"

"The lab keeps coming up with a bacterium. It looks like a lab contaminant," he continued flippantly, "but we have to make sure."

The intern's skill at drawing blood matched his talent for tactful communication. After three bloody attempts, he made a speedy exit, wringing his quivering hands and grumbling, "I'll be back when he's calmer."

My next visitor was considerably easier to receive, but he also thought that someone from the Neurology Department had talked to me. He explained that the CAT scan was a sophisticated multi-angled series of brain X-rays that might give us some insight into Joey's problems. The impossibility of getting any baby to agree to hold still made a general anesthetic necessary. Because of Joey's unstable condition, and because his head would have to be inside a revolving X-ray machine during the scan, the doctor also felt it a wise precaution to insert a tube into his lungs and attach him to a breathing machine during the test. Since we ensured his eating with a tube, why not ensure his breathing in the same way? Frightened but trusting, I signed the consent papers for the test, which was scheduled for ten A.M.

After he left, I continued my pacing until two P.M. Since Joey was still on NPO, maybe walking my screeching son past the nurses' station might prompt a decision to test-or-feed. We stood within hearing range to ensure the actuality of "we'll check into it."

It turned out that Joey's test had been canceled hours earlier due to several priority emergencies.

"You can go ahead and gavage him now. His test has been rescheduled for tomorrow morning."

At that moment, feeding Joey was more important to me than yelling at the staff. Once again, we returned to our room. Joey was rapidly reaching exhaustion from hunger, as well as his usual unknown reasons for crying. Before he drifted into sleep, I filled his stomach, then tucked him into his crib. I missed the relief from walking that I had been getting from my private nurses. So, after compensating for the short mattress by stuffing towels in the gaps, I left to splash some cold water on my face and do some stretching exercises.

As I approached Joey's bed five minutes later, I was alarmed to hear his familiar squeal. My favorite intern had decided to sneak in another unsuccessful attempt at drawing blood. He did not notice that I was standing there when he said to his assisting nurse, "Damn, this vein is no good, either. Let me see how they look on the other arm. I think I'll try this one."

I had never been one to make waves, but there are times when even the calmest person can swell with rage.

"Oh, no, you won't!"

As they stood in startled silence, I flipped the tourniquet off Joey's arm, wrapped him in a blanket, and balanced him on my shoulder while gathering the rest of our things.

"What are you doing?" the intern defensively demanded.

"We're leaving!" I said, not interrupting my packing.

"You can't do that, you haven't been discharged," he said, expecting me to stop.

"Oh, yes, I can," I said with a voice and a look that told him he'd better leave for help.

I was almost to the elevator when I was stopped by the resident doctor.

"Please, can't we go into a room and talk about this?"

I would have refused, but I had been rehearsing my complaint story all day and couldn't resist the opportunity to let someone have it.

"For the past three days this baby has been handled like a hot potato by an enormous number of medical professionals. How did he suddenly get tossed into the back room and slapped with an "improved" label? *What has improved?* And where are all those answers we were expecting from this three-day pow-wow of doctors and nurses?"

As I went on to describe the crib and blood scenes, the doctor just nodded sympathetically; but then he stopped me by saying calmly, "You're right in being upset; none of these things should have happened. The intern assigned to your case is extremely qualified in his medical ability, but he has difficulty with the social aspects of being a doctor. I'm sorry all these things happened."

I had prepared myself all day for a long, rugged battle; now I felt somewhat defeated to have my opponent surrender just as I got mounted for the attack.

The doctor sensed my melting anger and suggested I try to bear with it for one more day. "The CAT scan is an important diagnostic test. After it's over, you will be able to have a conference with the various doctors involved in the case, and hopefully they will be able to answer all your questions. Leave now, and you won't have accomplished anything to justify what you've been through."

Who can beat the power of politely delivered logic? I thanked the doctor for his intervention and passively returned to my designated corner. This seemed like a day of punches. I was dazed, and unsure of whom I was fighting or why I had stepped into the ring. I decided that a good night's sleep would give me a better foot forward in the morning.

Robbie joined me after work. When he heard my description of the day, he understood my apprehension about leaving Joey alone in the hospital, and tracked down an unused mat in the children's playroom which would serve as a suitable bed for me. When Joey collapsed into his unbreakable evening sleep, which usually lasted five hours, Robbie tucked me into my slot and instructed the nurses to wake me whenever Joey woke. Then he left for home to tuck in our other boys.

When Robbie returned the next morning at six A.M., he found me where he had left me. "No one woke me?" I opened my eyes to the frightening realization that I did not have one reassuring idea of what might have happened to Joey during the night.

We hurried down the hall to Joey's room. He was gone again! His test was not scheduled until eight A.M. Where was he? I felt myself

leaning on the same foot that had started the previous day.

Salvation came sooner than expected; our first encounter was with a nurse who knew for sure where Joey was. Someone from transportation had picked him up early for the test, which was to be done in the basement of the hospital. She tried to give us directions, but concluded with, "All those corridors look alike down there. You'll just have to keep wandering around and asking people until you find him."

That's just what we did. Our tension built as we followed different sets of directions down what seemed like the same hall over and over again. Finally, we turned a corner and saw what appeared to be a mirage: In the middle of this colorless corridor was a child's bed. People in white uniforms that blended in with the walls were moving from room to room, oblivious of the crib and its occupant. As we approached, we saw that in the crib was our heavily sedated Joey, wearing only a diaper.

"Why is he always transferred without a blanket?" I muttered, clenching my teeth and clutching his icy feet. "Maybe he has to have all these problems. Maybe he has to have all these tests. But he doesn't have to have cold feet!"

Robbie was even more heated. I instantly released my jaw and Joey's feet when he bellowed, "Is there a *fucking* shortage of blankets in this hospital?" He roused a few looks which indicated he was more in need of a straight-jacket than a blanket.

I was mortified by his outburst, but it did bring results. From behind a closed door came the anesthesiologist, who had been given no prior notification that Joey had arrived. He apologized for the previous day's mix-up and the cold feet, then he wheeled Joey away to the CAT scan machine. I hated always running into the nice guys when I needed to scream at someone nasty!

After they returned our son, Robbie and I staunchly watched him sleeping off the anesthetic while we waited for "the word." We felt a little intimidated by the doctors who arrived en masse for the conference on Joey. Since we were never able to distinguish the UCLA students from the credentialed doctors, we had stopped trying. We barely listened to all the introductions; our only interest was the conclusion. Surely, with the accumulated results of all the tests and observations, these professionals could present us with a clear picture of what was wrong and what would fix it.

"Joey's CAT scan was normal."

The group was a little puzzled by our unenthusiastic response to these positive results, but we were contemplating the ambiguity of "normal." Somehow Robbie and I had mistakenly thought that this test, which was significantly more sophisticated than a knee tap, would reliably pinpoint the exact locations of Joey's damaged brain cells. Then, knowing what bodily functions were controlled by those areas of the brain, the doctors would be able to tell us conclusively what problems, if any, lurked in Joey's future. Either he won't see, or he won't walk, or he won't talk, or he won't be too smart, or he won't...what?

The summation of the conference was, "We don't know." Evidently a CAT scan can expose problems like a tumor or blood clot, but not always the specific location or degree of neuromuscular brain damage like Joey's.

Our response was a bewildered "Oh."

"Well, what about the feeding?" I urged expectantly after a pause.

"He shows no sign of malnutrition or dehydration. We think you're doing a wonderful job with the feeding problem."

I managed another "Oh."

Everyone seemed to feel a little uneasy with the silence that followed. Consequently, the primary physician concluded, "We would like to continue following Joey, and help you in any way we can. Are you sure you don't have any more questions?"

This time we could only shake our heads. Then the doctors left without having fulfilled our expectations. I did not feel anger as I watched them go. I knew they cared and wanted to help, but neither they nor we knew how they might do so. I felt sorry for all of us.

Robbie and I packed our things and went home. We managed to keep our composure until that evening when the kids were all fed, gavaged, and put to bed. After an extended visit to the green bathroom, I sat down beside Robbie, who was pretending to watch a television show.

"I thought they were making such enormous strides in the medical field."

"So did I," he said, still staring at the screen.

"I don't think they have any idea what we can do about Joey's screaming and eating problems."

"I don't think so either." His response came without a change of tone or focus, so I resumed.

"I always seemed to be talking to the wrong doctor. We never did

get to talk to anyone from the Neurology Department," I snickered and aroused a superficial grin from Robbie. It was enough to keep the conversation alive.

"I think I'm just frustrating myself more with all these doctor appointments. I think it's entirely up to us to find a way to feed Joey."

"You got it!" Robbie exclaimed decisively as our eyes met. "You and I are going to arrange a meeting with Dr. Cobley and ask him to oversee Joey's case. In the future, we will only deal with the specialists through our own pediatrician. I think we need a break from UCLA."

"So do I," was my consenting conclusion. It was not a detailed discussion, but I felt that we were completely in synch. We had shared the anger, fear, frustration, and disappointment of the past five days. I always felt more comfortable with Robbie calling the big plays, and I wholeheartedly agreed with his decision to withdraw.

I had been thrown abruptly into the labyrinthine field of medicine. I did not know the jargon, the rules, or whom to throw the ball to. I faked the catch and ran with it. Thus, no one had yet realized I didn't know how to play the game. There was too much to learn in too short a time. Maybe if I had had a brain-damaged child who ate quietly, I would have been able to fit in a crash course in medicine. Or maybe if I had hit the right person with the right questions, I would have gotten more answers. I felt I was leaving a lot of needed help behind, but I knew I had to get off the field. Perhaps I could return when I knew what direction I was heading.

The Friday after this retreat from UCLA, we were forced to face another bone of contention when Robbie came home from work at nine o'clock and noticed a difference. "Where's Oliver?"

"Our neighbor and my mom took him to a pet farm which is supposed to find him a new home."

"Why? Did you know they were taking him?"

"They asked, and I agreed." Knowing Robbie would be baffled, I continued. "You should be here during the day when Oliver and Joey harmonize. They each make the other more hyper. If I let Oliver in the house, he would just race from room to room panting.

"If I put him out, he'd get worse. When Rose dropped by for a visit, Oliver was howling so loud that I'm surprised you didn't hear him on the set. Then, you know how he leaps into the air and throws himself against the sliding glass door? Well, Rose took one look at this, and then at me trying to keep Joey calmer than Oliver. It was obvious that

one of them had to go."

"I could see it getting out of hand a few weekends ago," Robbie concurred. "He was a goon, but I hate to lose him." He braced himself on the table for a few seconds before he lowered himself onto the kitchen chair beside me. "Remember how cute he was that first day I brought him home to surprise you, after months of your nagging for a dog?"

We were both sinking when Robbie forced a laugh. "I'm sure you also remember the years of neighbors' complaints and failed obedience classes."

"I know it's sad," I summarized. "I never thought I'd be able to give any animal away, but I appreciate Rose's insight. Every little bit of quiet around here helps. I wish someone would drop by and remove the phone!"

Robbie gave me a questioning look but not even I was expecting the outpouring that followed.

"Your mother and brother call every day, along with everyone else we know!"

"They're concerned," he defended.

"I know. Sherry comes over every night after work and walks Joey until he falls asleep. Yesterday she pointed out that I always raved to all the nurses, even those I didn't like, raved about how wonderful they all were; yet I'd never bothered to thank her even once. Actually, I don't know what I'd do without her.

"She's the only helper I feel comfortable enough with to ignore! They all mean well, but...." I felt unappreciative as I admitted, "I don't have time to go to the bathroom! I can't think! Someone is constantly coming, going, or calling."

"She's your sister; she wants to help," Robbie reiterated. "They're all trying to help."

"I know! It's just that...they're all clamoring for a chance to take the boys off my hands so I can, and I quote, 'take care of Joey in peace.' In peace, would you believe? Of course, they're just trying to help." I mellowed my sarcasm. "But no one knows how to deal with Joey—I definitely don't! We all know how to feed and entertain Robert, Shawn, and Marty."

Sensing Robbie's understanding of my allusive remarks, I went on, "The boys are my only link to sanity. Any time I can spend with them gives me a break from round-the-clock Joey."

Fishing for possible solutions, Robbie probed, "What about the answering machine I bought? I thought that was helping."

"Listen, I don't have time to return all those phone calls at night. Whoever called has already resolved whatever it was they called me about, or they want to know how Joey is. All I do is talk or think about Joey all day long. Besides, I'm exhausted by evening. I don't want to talk to anyone about anything."

"So don't call them back."

"But they all know that I know they called and didn't call them back."

"Then take the phone off the hook for most of the day. I'll ask everyone to call me at work for their updates. By the way, why don't you let your mom go home? I know she's been a big help, but it also might help to have a few less people around here."

I panicked at the initial suggestion of eliminating any assistance. But as we continued our conversation I realized that by totally concentrating on Joey's problem, I had overlooked the effect it was having on relatives and friends, special people who were devoting all of their energy toward helping our family move forward. After three months, our "problem" was certainly not leaping to a quick solution, and they could not leave their own lives in neutral forever. That evening, Robbie and I decided to insist that my mother return to Las Vegas and to ask the other overly concerned supporters to stay away until summoned.

The Monday after our weekend housecleaning, I was shaking when Robbie left for the airport with my mom. It helped me to remember a cute story Robbie's Aunt Betty tells of her oldest son's delayed walking ability. Her pediatrician had also been baffled by the delay until he discovered that five adults resided under the same roof with this child.

"My God, no wonder the kid doesn't walk, with all those adults around to carry him! Just don't pick him up. He'll walk." As the doctor predicted, the boy soon took his first step.

Sometimes we need people to leave us alone in order to help us stand on our own. Our relatives and close friends wanted to convince us and themselves that Joey was going to be okay. The doctors knew he wasn't, but they were unable to predict his future clearly. I felt like I was on the fence between the two groups, being badgered by both sides. The doctors needed a thorough description of Joey's behavior. The relatives and friends needed an understanding of what the doctors were saying about this behavior. I didn't know how to question the doctors or

answer the others.

For now, everyone had to let us have our problem. There were too many people and too many phone calls, which equaled too much commotion and too much crumbling going on within me. Maybe I was just too close to the problem, but Joey depended on me, and instinct said this child could be lost in a second. No one around me seemed to understand this urgent need for a solution. I could never afford to wait. For me, there was too much at stake!

After eliminating all the excess pressure, I was able to pick up something from the ashes. The extent to which a person can help someone is limited; you can't take the problem away from them. You can only try to help them find ways to reduce it or help them learn to live with it. But jeopardizing your own life solves nothing for either one of you.

It would take me even more time to see that, someday, I would have to let Joey have his problem.

Chapter 4

Sneaking Into the Night

"What makes the desert beautiful...
is that somewhere it hides a well...."

AS I sat in my green bathroom contemplating what had transpired with my four-month-old Joey, I felt an overflowing of confusion and fear. I had thought we had started on the road to rapid progress, yet Joey had not only failed to move forward with sucking, he had moved backwards in the "acts so sweet and normal" department. We now housed a baby who had transformed from a quiet toneless state to extreme hyperactivity with super-strength back arches and high-pitched screams. Even during his sound evening sleep, these shrill sounds echoed through my head and permeated my dreams. I did not know why he was crying; but what bothered me more was that I didn't know if *he* knew why.

Joey had no consistent responses to anything or anyone. He had shown no self-interest, like babbling or watching his hands. There was no indication that he received any comfort from being held by me or anyone else. I did not know his preferences, because he did not give any clues. He didn't smile, and there was no positive evidence that he could see, hear, smell, or feel...not even a flicker of an emerging personality.

The only thing that was developing according to my expectations was his ability to make gavaging more difficult, and this protest was premature. He still could not control or swallow enough of anything that entered his system via his mouth.

Joey could take a teaspoon of phenobarbital from a dropper. This made it seem possible to just squirt liquid down his throat throughout the day, but whenever I tried, he would shriek or choke within seconds. When I estimated the total number of teaspoons I would be able to insert during his relatively short recesses, it was far from enough to keep

him from dehydrating. Since irritability is a known side effect of phenobarbital, Dr. Cobley suggested eliminating the medicine, but even this did not help.

I had always thought that sooner or later one would run into everyone in a restaurant. What happens to people who can't eat? When I had bravely slipped my question to a UCLA nurse, I had received what sounded like a freakish mouthful of words about surgery and a gastrostomy tube. Apparently this tube would enable food to be pushed directly into the stomach, bypassing the mouth and throat. At this point in my life, it sounded so grossly inhuman that I refused to consider it as an alternative to restaurants.

During one of my numerous retreats to the green bathroom, I weighed my options. If I chose to believe that brain damage was the cause of Joey's inability to suck and swallow, then what could I do about it? Gastrostomy? Or sit and wait for what not eating eventually brings. If I put him in the hospital for intravenous feedings, how long could I hold him still enough to keep the needles in? Not long. I saw the nipple as the only sensible way out of this mess. I had to resolve that he would learn to suck.

Consequently, I purchased every type of bottle, medicine dropper, or infant feeding device that was on the market, hoping I could find the right gimmick to increase Joey's swallowing skill as I was forced to decrease the number of gavage sessions.

Always convinced that there was nothing wrong with her grandson, my mother continued her calls and attempts to convert doubters. She cheered any plan for attacking the problem, which gave me the courage to keep trying. I never shared all of the setbacks with her.

Once, when Mom had flown in for the weekend, she was controlling a nippling session when I heard, "Quick! Come in here! You won't believe this!"

After sprinting into the room, I stared in silence at Joey. He was sucking! His facial muscles looked like they were working perfectly. What happened? What nipple? What contents? It didn't matter. It was a miracle…he was sucking! No symphony orchestra could stimulate what I felt as I listened to that wonderful slurping sound.

"I knew he could do it!" Mother said, confident that the problem had come to a successful end.

"Shh" I was afraid to let any noise interrupt this long-awaited event.

"How much do you think he's getting down?" Mom soon had to ask, since her excitement was never easy to control.

There was still plenty of formula in the upturned bottle. I noticed, but not wanting to entertain any doubts at this moment, I didn't reply. Instead, I focused my eyes on Joey's mouth muscles. They were moving in the correct way and making the correct sound, so the bottle must be emptying. After ten full minutes of Joey's longest and strongest suck, his muscles slowed. Anxious to measure the results, Mom immediately removed the bottle.

With the bottle upright it was easier to see that the only missing formula was a few drops which had been swirling around in Joey's mouth, deceiving us. The swift swing from elation to dejection was depleting. Neither of us seemed able to speak until I discovered my own mistake. "Damn, I put the nipple with the tiny hole on here!" Mom and I were never able to exchange our thoughts about episodes like this, but we always concurred on an appropriate scapegoat.

Subsequently, I considered the importance of what was behind the nipple. Maybe he just didn't like the taste of the formula. The average baby never seems to object to it, but every mother knows it tastes horrible. Maybe Joey was just earlier than average at recognizing and protesting this. Thus I frantically tried every conceivable fluid, in innumerable combinations and consistencies, that would flow through or flavor the outside of a nipple. To my advantage, there was never enough time to contemplate reasons for the failures.

Fortunately, before hope faded and just in time for Christmas, my oldest son helped me unravel an alternate escape from Joey's tube. This way out of the Catch 22 of Joey's feeding cycle was not instantly visible, but once recognized, this exit would lead us onto a seldom traveled path.

The initial insight came during an afternoon gavage session. By now, gavaging Joey required two sets of hands, since the only opportunity to sneak the tube down his throat was the second he paused for a breath between squeals. This particular day, my five-month-old Joey seemed stronger and more determined than ever *not* to be tricked. As we were to discover, Joey's greatest area of development would be his determination. This was only a preview of the difficulty we would have in controlling this strong-willed son.

Finally, the physical and emotional fatigue of many futile attempts to insert the gavage tube forced me to suggest to the nurse that we all

take a half-hour break. As I grabbed Joey and marched into another room, his cries subsided and he shut his eyes. He seemed to know that he had won this tube battle, which apparently was more important to him than the food. Feeling close to a dead end, I failed to notice six-year-old Robert sadly watching this scene. Then I heard him say, "Why are you crying, Mom?"

"I can't get the tube down Joey," I said, quite sure that the situation was beyond his comprehension. But Robert, like his dad, could never pass a problem without suggesting a solution.

"Why don't you have the nurses do it? I thought that's why they're here. Don't go in the room so often, Mom; then you won't have to think about it and get so upset. You won't know what's going on." Then he resumed his trip outside, leaving me to wonder who had the superior insight into the situation.

While I absorbed Robert's wisdom, a fresh idea whirled into mind when I looked down at my soundly sleeping son. You don't have to "get so upset" about what you don't know. I could concede a few battles, but I could not let Joey win this food war. So, I silently tiptoed back to the battlefield with the hope of sneaking the tube down before he woke up. It worked! Now, on days when Joey was able to sustain an all-day screech, I could at least count on getting his nourishment gavaged into him while he slept at night.

Contrary to my expectation, it was not long before this, too, started to show some signs of being a short-lived solution. During the day it might have been impossible to silence Joey, but at night it was becoming even more difficult to rouse him.

The possibility of sliding the tube down Joey's trachea into his lungs rather than down his esophagus into his stomach always hung over me as I passed his throat with the piece of plastic. When Joey was awake, it seemed a relatively sure wager that he would cue us about the misplacement with excessive coughing. But his abnormally deep sleep pattern took all the certainty out of the bet. As the tube slipped down on still nights, I was often tormented by Joey's strange gasps, skipped breaths, or sudden coughing and sneezing attacks. Always enough to wonder, am I in the right place?

With the gavage tube positioned, the formula in the syringe, and my finger on the clamp, I perspired profusely every time I released the fluid and watched it flow through the clear plastic tube. It never did get into the lungs, but instead of making me feel confident, this merely in-

creased my conviction that I was running out of lucky breaks.

The final straw fell upon me one traumatic night late in December. After chain-smoking too many cigarettes while getting ready to feed Joey, I could still inhale the fumes that surrounded me as I picked the toneless boy out of his crib and sat down in the rocking chair. Shaking like I was afflicted with a palsy, I took several deep breaths before starting. Then, down went the tube and out popped the sweat as I watched the formula disappear.

Just at the moment when I was usually able to liberate a sigh, the inevitable catastrophe hit. Formula shot back out of Joey's mouth in a steady stream, making him look like a creamy fountain. He never even flinched under this white flood, and he didn't appear to be breathing! I promptly pulled the tube out and studied my wet bundle, but I was unable to take another breath until I was positive that his lungs were not involved.

As it turned out, there had been a kink in the tube, causing it to circle back up the esophagus. With no stomach to catch it, the formula had simply headed for its only exit—back out the throat. One of those "probably never happen" possibilities the UCLA nurses had warned me about.

Strange how you can sometimes take and take, and then, when you finally take that too-filling last sip, you vomit with the conviction that you are not going to take this again. After I changed Joey and cleaned up the mess, I charged past Robbie, tossing a sharp "I'll never gavage that kid again!" Robbie looked mystified, but my tone made the message believable.

I headed for my green fortress, which was occupied—now, of all times! Instead I took refuge in the kitchen, where I thumbed through the five months of Joey's recorded activity and tried to devise a plan of attack. I'm sure God knew that I had reached my limit and that someone had to come up with a better-than-usual gimmick. Suddenly, the scene of passing the tube down sleeping Joey flashed into my mind. When we did this, he frequently swallowed several times. If he could swallow the tube in his sleep, why couldn't he also swallow food when he was asleep? That was it! I'd forget the tube. I'd even forget the nipple. We were going to isolate the food.

I rushed to include Robbie in the discussion. He was in the living room reading *Three Hungry Wives*, a script about three female murder suspects who had each had an extramarital affair with the victim. My

previous pass through the room had already clued Robbie of my need to talk. My new idea had to be well planned and would require his support. I knew I could never go back to the gavage.

We sat up for hours going over all possible angles until we arrived at a feasible scheme. Since previous attempts to get off the gavage had failed due to insufficient consumption, we would have to use a thicker formula in order to cram more necessary nutrients into the smallest possible quantity. Robbie's consuming career and clumsiness with infants limited his time and willingness to become actively involved with this cumbersome mush, but he was enthusiastic about the strategy and said he would hire whatever help I needed to implement his part. Our plan looked promising, but it was a frightening step in an untrampled direction.

It bothered me to think of a future adult who screamed by day and ate at night. But then, you always hear it's better for your digestion to eat when you're relaxed, so why couldn't we just extend that idea a little? Sleep is just an unconscious form of relaxation. Since Joey didn't seem too conscious day or night, maybe we didn't need to be bound by normal etiquette.

I started on the nurse's nights off, in order to monitor the results myself. I checked the notebook, and about a half hour before Joey generally had his gavage feeding, I carefully picked him up and set him into an infant feeder. With a prayer and a spoon, I scurried to shovel in bites of a pasty cereal. Joey was able to gulp down two ounces before he was awake enough to protest the intrusion. It was not a full meal, but it was the most food that had ever gone down without a tube.

The plan could work. With Joey asleep, the speedy spoonfuls of thick cereal were easier for both of us to control. Quantity would be our major problem, as it always had been. Susan, one of our most special day-shift nurses, who was working on a degree in nutrition, was able to add a valuable thrust to the campaign. She made comprehensive charts of the most nutritionally loaded foods in each basic food group. After balancing our proteins, vitamins, and minerals, we pureed and thickened different combinations with powdered milk. Since Joey would be sleeping through our forced food attack, we did not have to worry about flavor, so we were uninhibited in concocting the most power-packed mush. Maybe we could substitute quality for quantity.

In the months that followed, our notebooks were filled with details about Joey's intake measured to the quarter ounce. I always liked the

written proof that he was getting enough to eat. I could never ascertain from any doctor or book how many ounces Joey needed each day. There are infant formula guides, but no guides for the child who can not adequately swallow anything.

Most toddlers consume untold amounts of fluid on top of their solid food—even illicit consumption of their bath water. Joey had been maintaining an acceptable weight and hydration on only twenty-five ounces of fluid per day with the gavaging. It looked possible to maintain his weight if we could get him to swallow at least twenty ounces each day of concentrated, high-caloric nutrition. Since dehydration remained the biggest threat, we made frequent visits to Dr. Cobley for medical monitoring.

Feeding Joey while he was lying almost flat on his back invited the possibility of aspiration, but it also left gravity on our side. Gratefully, we did not have to contend with a single aspiration during this time. In all of these unorthodox feeding sessions, the food always headed in the right direction.

I was boosted by the thought that we were approaching the age when most mothers are struggling to get their toddlers to stop sucking and start eating. So we would just hop over suck and get a head start on eating skills. "Why does he need to suck, anyway?" was a question I had posed to different doctors. They would invariably insist, "You want him to suck!" But every lay person I asked thought it was a great idea to just skip it.

When the paste campaign was in full swing, it became apparent that learning to suck was not as simple as I had assumed. There are a lot of different muscles involved in sucking, controlling, and swallowing, but it takes the coordination of more muscles to manipulate a liquid than a thicker substance. By eliminating Joey's need to suck, I had unwittingly simplified the eating process for him.

Later, however, I would understand that you can't play hopscotch with child development. Down the line, it would be necessary for those same underdeveloped sucking muscles to work together for speech. But at the time I fantasized that when Joey was a teenager, he would suck down an eight-ounce bottle in two minutes before leaving for school, then toss the bottle back to me with a flippant, "See, I told you I could do it, Mom!" I would respond with a proud grin, "I knew you'd get it. Our timing was just off!"

Gradually over the months our fussy baby responded more favor-

ably to our pacing and marching. Each day of this decreased irritability brought an improved eating situation. What Joey saw, heard, or felt was still a mystery, but with his taming came more and more uniquely captivating smiles, which were our first flickers from a vital and undamaged area of his brain.

Toward the end of his first year, Joey could tolerate some swallowing while awake, provided we could supply him with enough distraction to take his attention away from his mouth. As soon as he lost interest in the diversion, his cranky frustration intruded and the eating ceased. Now, all imaginative thinking had switched from nippling ideas to new sounds or sights to preoccupy him. Even though some meals required hours of conning, I was aided by three other children and an overabundance of toys. Someone always managed to pull a new rabbit out of the hat!

Luckily, I was adequately insulated by our recent successes when we received the news that our insurance company would no longer help fund the nurses. I had originally thought I would only need a couple of days of nursing assistance. After a year of their support, I would certainly be wobbly without them. But in a short time, I came to appreciate that insurance incentive.

We now employed a reliable crew of friends, but they blocked my way back to establishing a normal household and repairing my shattered self-confidence. All the nurses had provided tremendous security, but they had been expensive. I had let them strip me of privacy within my home, yet they had never been able to lessen the pressure on me of twenty-four-hour responsibility. I was Joey's mother, and motherhood doesn't work in shifts.

I was initially most apprehensive about the nights without relief. After setting up several meals before going to bed, I was surprised how much easier things went than I had anticipated. It was like starting over with a new baby. Instead of warming a bottle, I warmed my paste, pumped it down, changed Joey, and we both went back to sleep. With the passing of a few more months, the need for these middle-of-the-night feedings also passed.

To buffer the loss of the nurses, Robbie and I decided to hire Suzie Lang, the seventeen-year-old daughter of Joey's godmother, Pat. Normal households recruit high school students to help with child care, and Suzie's patience compensated for her lack of medical training. She fell right into the food-pushing position I desperately wanted to vacate for

at least part of the day. With her placid persistence at entertainment trickery until the last ounce of paste had reached its destination, I was able to concentrate on the ingredients and enjoy washing the empty dishes. She was my indispensable extra pair of hands, and as my sole supporter for short hours, she did not distract from my need for normalcy.

As the days of Suzie's unobtrusiveness and Joey's compliant eating stacked up behind me, I began to see the possibility of an end to our problems. Our sixteen-month-old son had slowly moved up from flat-backed, somnolent swallowing to wakeful high-chair eating. Although the notebooks had been too integral a part of my life to ever throw away, I soon felt secure without recording Joey's daily intake. I could stand alone, even on days Suzie wasn't there.

The war was over...but I was not positive who had won. Even though my home was finally without invaders, I did not feel victorious. Whether we had conquered Joey or he had given in was irrelevant to me. What mattered was that he was eating and smiling. He was surviving. Now I would have to commence the search for my own well-being. Like so many Vietnam vets, I would find the flashbacks of what I had been through more difficult than the actual fight had been.

Chapter 5

A Push Around the Corner

A baobab is something you will never, never be able to get rid of if you attend to it too late. It spreads over the entire planet. It bores clear through it with its roots. And if the planet is too small, and the baobabs are too many, they split it in pieces.

IN retrospect I can see the different aspects of my life as a close arrangement of dominoes. Eventually the wobbling one put pressure on one too near, and all the dominoes began to fall. Back then, trying to intercept the falling dominoes seemed futile. Therefore, they all fell before I was able to commence the long, tedious task of resetting them.

Joey's birth had only been the first domino in a chain of family medical traumas. One significant tumble occurred during the summer after Joey's first birthday. Deciding to sneak in a brief phone call before dinner, I snatched the cigarette I considered integrally attached to any communication, and started to dial. Suddenly my ears picked up a distant scream that could have been heading in my direction. There was something different about this sound…it carried a tone of more trouble than I had previously heard. My finger soon stopped dialing, and hearing seemed to become the only functioning ability of my body. I found myself selfishly hoping that this cry belonged to someone else's child, but as I heard my front door open, I felt all hope leave.

There was Shawn, his face masked by blood the consistency of tomato paste. For a second my mind actually became preoccupied with thoughts of what I should do with the cigarette in my hand. Apparently, Shawn was horrified by the expression on my face, because he instantly stopped screaming. I finally dropped the cigarette, seized Shawn's arm, and pulled him over to the kitchen sink. Water on and cloth in hand, I froze again…I didn't want to see what was beneath the

blood. It looked like his eyes were not going to be there.

"Please, God, help me!"

Just as I finished the plea, someone's hands grabbed my arms, and the voice connected with them said, "Just relax. I'm a doctor. I'll take care of him."

Before my heart could beat again, I felt myself melting with unbelievable joy. "Oh, God, you really outdid yourself!" It seemed like I had instantly been transferred to the emergency room. I no longer had to think; I could blankly relax and await the results. For a moment, this deliverance was so effective it overshadowed my fear of what might be found under the blood.

As he carefully cleared Shawn's eyes, the miraculously appearing doctor tried to replace my need for Valium with calm conversation.

"I followed him home, since I knew how upsetting this would be for a mother to see."

"His eyes?" I bravely asked.

"His eyes are all right. The blood in them came from the forehead. It will wash out."

"What's that white?" I asked as my eyes moved up and met the hole in Shawn's forehead.

"That's the skull. He's going to need a lot of stitches, but I think he's all right."

"How did this happen?" I inquired, unconvinced of Shawn's healthiness.

"He was riding on the handlebars of his friend's bike. To avoid running into my bike, the friend hit his brakes. Your son flew off and hit the curb. He jumped up immediately after it happened, which is a good sign. I'm a neurologist. I'll give him a more complete neurological exam after we get him cleaned up a little."

We went from the exam for possible brain damage to the emergency room for X-rays and stitches, then home for a "possible complications" vigil. The fear that came from knowing what complications were possible made the night long in passing.

Shawn's wound became infected and required a lot of care during the next couple of weeks. Nevertheless, he rebounded rapidly, and he felt the ugly scar made him look macho. But I was never able to recover from the spinal chill I experienced whenever I heard "Mom!" uttered with even a tinge of pain by any of the boys.

Two weeks after Shawn got his stitches, I heard him dart through

the back door into the bathroom and commence a strange rumbling through the medicine cabinet. I was spared the chilling "Mom!" indicator. Instead, motherly suspicion led me into the bathroom, where I discovered Shawn trying to put a Band-Aid on a finger that was about to fall off.

On the way to the emergency room I learned that Shawn had rammed his finger into a razor blade mysteriously buried in the garden. I spent the rest of the day arranging and then comforting Shawn through the surgery necessary to reunite the ends of his severed tendon.

During our stressful months with our fourth son, his three brothers continued their encounters with normal stumbling blocks that required parental involvement. One domino that fell unnoticed was Robert's grades.

Robert had started exhibiting signs of learning disability when he was three, but this type of problem cannot be confirmed until reading age. Unfortunately, Robert reached his should-be-reading age the same year that Joey was born. Anticipating Robert's impending difficulties, I had mistakenly told his teacher at the beginning of the school year that we might decide to have him repeat first grade. The teacher, figuring she would have more time to devote to him during his second journey through first, let his work pass without correction.

Engulfed in Joey's problems throughout Robert's first-grade year, I failed to notice the feelings of inferiority festering within my oldest son. He was guessing at answers in order to complete his work in step with his friends. Trying to protect himself from peer pressure, he was living in constant apprehension of being exposed. Toward the end of the school year, his classmates started to see through the bluff, and he became battered by the other children's teasing. The teacher failed to correct him or inform us, and I failed to follow through with help for the difficulties I had anticipated. Robert failed to pass first grade.

By the time the problem became apparent, we had to contend with enhancing Robert's reading ability as well as his self-esteem. His need for my time had not been as vital as Joey's, but it was just as crucial.

In the midst of Joey's fundamental eating problem, the question of his vision had surfaced as another area of concern. An ophthalmologist agreed that very distorted vision might be triggering Joey's "cycles," but he added that "no vision" was also possible. I had always considered "no suck" an absurdity more than a problem. Now we were getting into areas I could understand. I knew the ramifications of no sight, and it

seemed a lot sadder than no suck. This doctor prescribed corrective glasses, but we never saw a difference.

Besides questionable sight, Joey had a continuous jiggling eye movement called nystagmus. At first there was nothing we could do about his sight, except carry the sorrow. Then, as Joey approached his twelfth month, his left eye began to shift into a "lazy eye" position. The ophthalmologist informed us that Joey seemed to have improved vision in his right eye. However, if the left eye were allowed to continue its lazy drifting, it would regress to eventual blindness. The doctor felt that surgery would bring only temporary results, so to avoid the one-eyed blindness, Joey had to be forced to use the lazy eye. Patching Joey's right eye was the simple solution.

The solution was simple to discuss, but extremely difficult to implement. When the patch covered the eye, Joey's irritability increased, causing more problems with feeding. In spite of his inability in most areas, Joey was amazingly adept at removing his eye patch. Of course, the frequent tearing away of the tape that held the patch led to skin irritations, and these, in turn, led to more irritability. Thus, although we were taking steps toward vision, we were losing headway we had made in eating, and all the while we were feeding my growing neurosis.

When Joey was fourteen months old and gradually resuming his eating progress, I had to undergo knee surgery to remove cartilage which had been torn while I was roughhousing with the boys. I had heard of lots of football players who had experienced the same operation and had been back in the game the following week, so I expected the surgery to be only a minor setback. But either I had heard wrong, or I had miscalculated the difference in our pre-surgical conditions. The surgery turned out to be a major setback, and the pace of my life was too fast for crutches.

We can subject our bodies to a great deal of stress. Still, if that stress continues for too long and is not properly controlled, the body starts to send out little signs of protest. My body first signaled me with headaches, which led to poor eating and sleeping and right back to bigger headaches.

I sneezed throughout the day, as my allergies blossomed. At night I was seized with chest pains and labored breathing. Nervousness over these conditions increased my already excessive smoking habit. I had X-rays taken to diagnose my chest pains and they showed pulmonary

embolism. So I took an anticoagulant drug to dissolve the clots, and stacked the additional medical stress onto the developing pile.

Eventually these pressures started to reach a boiling point, and the steam headed in the direction of the marital domino. I seemed to need to find someone to blame for the things going wrong in my life, someone to vent my pent-up anger upon. Naturally, someone whose life was intimately attached to my own stood the greatest chance of attack.

Fifteen months after Joey entered into the world, the proper pieces fell together in Robbie's career, making possible the long-awaited formation of his own television production company. Robbie had started at the bottom of the movie-making business, and with long dedicated hours and a keen eye on where he was heading, he had risen quickly into his career as a producer. Because he had dabbled in every aspect of production on the way up the ladder, including directing and editing, he carried a unique expertise into his focal area of television movie production.

Being the type of person who thrives on stress and the swift solution of problems, Robbie was baffled by the longevity of Joey's puzzling behavior. Although very openly affectionate with those he loves, Robbie tends to back away from tearful exhibitions. Overconfident in my ability to maintain the homefront, he directed the major portion of his energy into his career.

Having lost his father at age twenty-two, Robbie had always helped with the financial support of his mother and grandmother and had been accustomed to coming home to the tranquil environment they were able to provide. At the beginning of our marriage, I had been able to pick up where his two pampering mothers had left off, and attempted to sustain this ideal atmosphere for him. I was feeling more burdened through the years when his expectations remained unaltered by the addition of his sons, but my own idea of a wife's responsibilities kept me silent about my growing frustration.

I shared Robbie's longing to be pampered, but I was never able to express my desire or allow someone the opportunity. Now, bombarded with more than I could juggle, my need had become too great too fast. I felt that the biggest battles were taking place in our home. I was too battered to comfort someone else. I wanted to come home to the tranquillity of someone's arms. I was sinking, and I could not feel anyone pulling me back up. The frustration was turning to anger, and the anger was heading in Robbie's direction.

Robbie was also becoming more edgy. After putting in a long, stressful day, he longed to retreat to his formerly peaceful home and smiling mate. Instead he was generally greeted by sons who were far from typical, a wife who was near tears, and no handy solution for anyone's problems. Thus, the inevitable began.

Robbie pulled into the driveway after an unusually taxing day. Opening the front door, he encountered a foreign sitter bouncing an irritable Joey in time to a Spanish chant. Marty and Shawn were involved in a heated tug-of-war over a toy, and Robert was resting on the couch with his chin stitched from the day's unsuccessful skateboard stunt.

Robbie moved unnoticed past the motley crew and into the kitchen, where he first noticed a note on the sink from the school regarding Shawn's suspension that day for slugging a classmate who had jokingly criticized Joey. Then, when he found my not-too-glad-to-see-anyone face focused on making a fruit salad, my trigger-happy husband snapped out a disappointed, "What's wrong with you now?"

I did not choose to discuss our problems politely, either. Instead, I flung the fruit while furiously ranting, "I'm tired of pitting your damn cherries!"

I did not feel capable of solving any of my other problems, but I could get rid of the cherries he liked to see in his salad. With this misfire of nasty words and flying fruit, I created an additional obstacle. Robbie was defensively stunned. I had never cued him that I was annoyed about the precious time his cherries consumed, I had just pitted and remembered.

In the months that followed, the darts continued to fly as the wall between us grew. Divorce began to rise as the only solution to the falling marital domino, but emergencies always seemed to preempt the separation proceedings.

Caught in a never-ending whirlwind of problems, I ultimately lost sight of ways to get on top of any of them, and bounced from one to the other while I sank into depression.

With Joey's birth, our family came to a screeching halt and made a sharp, permanent turn in another direction. Robert, Shawn, and Marty landed on their feet and perhaps may have benefited from the self-bandaging job they had to do. Robbie was shaky, but his strong psyche buffered the extent of his injuries. What Joey lacked, he compensated for with determination.

And then there was me. Completely unprepared and carrying a few unresolved conflicts into the crash, I landed face down and would have a difficult time catching up with the rest of the family.

My excessive investment of myself into Joey's feeding crisis sent me deeper into debt, despite any gains he made. Eating was only the tip of the iceberg, and floating around him were three brothers with their problems rising to be seen. I was way over my head in mothering responsibilities. Drowning as a mother left me with only fury to combat the pressures of maintaining my role as wife. I was becoming too sick emotionally to recognize my real physical illnesses.

When it was all totaled up, I had became allergic to life. The expectations of the people around me added to my expectations of myself, and the result was an inability to do anything effectively. "Nothing" kept flashing through my mind as all I was capable of producing. Nothing became what I wanted to be. So each day I just prayed for a fatal accident to eliminate *me* from the problems.

As I wandered among those flattened dominoes of my life, it seemed impossible to reset them, and that hopeless feeling clouded the need to reset them and the way to start. But by chance, during a return visit to the UCLA clinic when Joey was twelve months, I stumbled upon someone who would lay the foundation for my recovery.

Leaving my visiting mother on guard with Joey, I had slipped out to the clinic's main corridor for several briskly inhaled cigarettes. There was really no need to hurry, since every clinic appointment included hours of waiting. Being on the fast road to nowhere, I felt I had minimal break time. Frantically trying to puff in some relaxation, I did not notice Dr. Jack Wetter pass me on his way to the elevator. He was the head of the Child Psychology Department at UCLA. Gifted with a warm sensitivity and sharp insight, this doctor was a nourishing man whom anyone would want for a best friend. Robbie and I had consulted him about Robert's learning disability during my fourth pregnancy, but after Joey's birth I had failed to schedule a follow-up appointment.

It took the doctor several over-the-shoulder glances to confirm his recognition of me. However, he was not deceived by my mobile breakdown, and followed his quick assessment with a gently inquisitive, "Hello, how are you? Is everything all right?"

I briefly explained the birth of our "problem," and he expressed his condolences before reluctantly leaving me alone.

Four months later, during a divorce discussion, Robbie remembered

my mentioning this chance reunion with Dr. Wetter. Since my head-strong husband refused to give up on anything, he was quick to propose that our marital strain might benefit from a talk with this comforting counselor. When I agreed, Robbie called Dr. Wetter and described the more intimate details of our current family picture.

During the conversation, Dr. Wetter bypassed Joey's problems to zero in on our sleeping accommodations. He emphatically advised Robbie to restore our master bedroom, regardless of any inconvenience to the children or nurses. I was amazed at how blind one can become to the easily adjustable things that are awry in one's life.

Revived by our first night back in our own room after a sixteen-month separation, we mutually agreed that this man might be able to push us around the corner.

Now that we had our bed back in place, our analyst wanted to set the marriage aside for a while and see me alone. He was initially more concerned about my deflated condition.

During the first month of weekly sessions with Dr. Wetter, he kept trying to get me into "what now," but I was reluctant to let go of "what had been." So he patiently listened to my poignant memories.

"His screams were so powerful...sometimes I needed two other people to hold him down while I waited for an opportunity to force the tube down his throat." I swallowed several times to inhibit a gag.

"Not quite your typical mother/child feeding relationship," Dr. Wetter sympathetically summarized as he positioned his chair closer to mine.

"It was horrible!" I confessed. "I was torturing him!"

"But he had to eat."

"Yes, but maybe I could have found a better way to feed him. If I knew...if I had more time." A swarm of possibilities came upon me at once. I buried my face to hide the feelings. "I...I couldn't find a way for him to suck."

"Sandy, all I hear from you is 'I, I, I.' For weeks you keep saying 'I' couldn't find a way for Joey to suck." Then, with X-ray vision Dr. Wetter lowered his voice and reached for my hand. "*He* couldn't suck! He has brain damage. You can't change that. Once those brain cells are dead, you can't bring them back to life."

Since I was only able to respond with more sobbing, he continued. "You did what you did to help him, and you did just that. You did find a better way to feed him. Not as soon as you would have liked, but you

did find it. Didn't you tell me his pediatrician said he was well nourished?"

The gush of tears tapered as I nodded affirmatively.

"*He* couldn't suck; but he is doing fine now." He squeezed my hand to underscore his words. "What are you afraid of?"

"I keep having this nightmare. It seems so real. I see myself so clearly, rushing up and down aisles of a grocery store. I'm clutching Joey under my arm and grabbing different types of food from the shelves. Right at my heels there is this lunging vacuum tube trying to suck us up. I can't go back to those piercing screams…I can't go back to those torture sessions. I…." Now aware that I had been shouting, I drooped with an embarrassed weep.

My discerning doctor seemed pleased with the outburst. "From what you've told me, it doesn't sound like you will have to go back. But if you do, you do, and we'll deal with it then. Sandy, listen to me, you can never move forward until you let go of the past!"

Regaining my composure, I felt myself being hypnotized by his philosophy: "What happened, happened. I believe in the here and now."

When I straightened up and freed a smile, Dr. Wetter rolled his chair back slightly. "Now that we have Joey settled, let's move on to you. Tell me some of the things you do for yourself. When was your last…."

I was relieved when the phone rang. I thought the interruption would give me a moment to adjust to the altered course of the session. Instead, I became engrossed with eavesdropping. Shortly it became obvious that Dr. Wetter's hospitalized mother was dying of cancer and that he was carrying the heavy burdens of final medical decisions, funeral arrangements, and his family's grief.

His hand remained on the receiver for a while after he hung up, but he returned to his chair beside me without any signs of pain.

"Now…you need a vacation. I'm going to send your husband a prescription for Hawaii. When was the last time you took a trip together?"

I had lost the urge to talk about myself.

"How can you do that? I couldn't help overhearing. How can you get so involved with my problems when you have so many of your own?"

"Thank you for your concern. I'm very close to my mother. But why sit here and cry all day? I have a family to support and people I can

help. For now, I've done everything I can do about the problem, so I shut the door on it. That's what I want you to learn how to do."

I was dazed and drained when I left Dr. Wetter's office that day, but slowly I would begin to recognize the slight but solid steps toward rehabilitation that he was helping me to take.

While I was in therapy, Robbie was entrenched in the production of *Murder By Natural Causes*, which was the first project under the auspices of his own production company. Before I had time to contemplate any other opinions, my optimistic mate had booked Dr. Wetter's prescribed Hawaii trip for the week before Christmas. By then he would have finished producing his intriguing mystery, and our five- and six-year-old sons could accompany us without interrupting their schooling. We rehired our most reliable nurses, and asked our closest relatives to supply meals and supervise Marty and Joey. Just the packing and planning for what was ahead proved to be a rejuvenating experience!

Ironically, on our first restaurant outing in Hawaii, a couple with an infant were seated at the table next to ours. Without our realizing it, our four pairs of eyes were drawn to this baby's mouth as the mother inserted an eagerly awaited bottle. We were all unaware that the waiter had served our order until Robert's startling sentiment pulled our attention back to our table of food.

"Wow, look at that baby suck!"

There was no need for additional words. Our instantaneous convulsive laughter communicated enough to release us from our collective obsession.

Each day during our Hawaiian holiday I made my one phone call home and then, carefully, closed the door on Joey. Robbie and I became reacquainted with our functioning sons and forgotten fun, and rekindled some familiar feelings of love. In this euphoric atmosphere, I was able to gaze through the rippling ocean waves and see things I had never seen before.

I was the only member of the family who had turned our mutual family obsession about Joey's learning to suck into my own problem. I had refused to consider the gastrostomy tube, and I had dismissed my green bathroom idea that Joey's brain damage prevented him from sucking. Then, feeling divorced from my dream family, I had twisted his problem into the belief that *I* couldn't find a way for him to suck. With this guilt on top of my fear of losing, the past had became too heavy to let me move forward. It is strange how prolonged misconcep-

tions can be so swiftly clarified by simple recognition.

Combining Dr. Wetter's subtle inferences and looking deeper, I saw that through the years I had let myself become a no-preference doer. I did not know how to take the opportunity to engage in a non-productive activity I preferred, and give it a productive label. I never considered what might make *me* feel a little bit better, so I never saw the cumulative effect of what a lot of little bits of pleasure could amount to.

Robbie preferred quiet nights and weekends of puttering around the house and watching football games, which gave him the relief he needed from the multiplicity of events, people, and stresses he encountered in his work. I had never protested this dull, settled existence, since most of the time I was too tired to think of anything exciting to do. I had become content in having no relieving contrast to my career —no nights or weekends off, no vacations, no sick days. My life ran the same circular course seven days a week, and I had just gotten stuck in the groove.

My favorite fantasy was of the day when every drawer and closet in our home would be organized simultaneously. I recalled an exemplary day when I had been admiring my kitchen catch-all drawer. It had just undergone my best organizational effort. Everything was so logically and conveniently placed, there was no way anyone could avoid returning used articles to their appropriate slot.

I slid my perfect accomplishment back into place just as Shawn walked into the kitchen. He hastily whipped open my prized drawer. I paused in order to catch the "Gee, this drawer looks great" stroke I was sure I was going to get, since his own neatly arranged possessions indicated a keen appreciation of organization.

Sometimes expectations can fall considerably short of reality. In the silent seconds that followed, Shawn's two hands whipped through the paper clips, rubber bands, pencils, stamps, and other things until they all became mixed-up again. He pushed in the drawer, which now closed only with difficulty, and pulled open the hardware drawer, which was next in line to be organized. Without looking in my direction, he said, "Mom, can you help me find an eraser?"

Before I could muster an appropriate answer, Shawn resumed, in his typical thoughtful tone, "Thanks anyway, Mom, but I found one." His innocent hands swiped the eraser from its misplaced position in the hardware drawer, and he scurried out of the kitchen.

We all need varying degrees of recognition from others and from

ourselves for what we achieve in our daily life. The likelihood of acknowledgment is enhanced by tangible proof of our accomplishments. The clue to the forever-vanishing evidence is known only to the housewife.

Being a housewife does not have to be an underrated career, if you know the tricks to stay aboveground. Before Joey, I hadn't. Instead, I had dug myself into the housewife hole, where the more dirt I disclosed, the more I discovered!

As the years went by and the number of our children increased, the hole got deeper and deeper. I completely lost sight of my identity, and became secure within my hole. My increasingly busy schedule gave me less time to realize that I had less time to spend on myself. Thus, I never really felt deprived.

I could have sailed along in this housewife mode for the rest of my life, just as most of the population can sail along with poor eating habits and minimal exercise and survive a non-problematic life. But if one happens to be stricken with a severe illness, these poor habits can mean one's demise. So too, when one is stricken with an emotional battle: If the psyche is in good condition, one stands a good chance of picking himself up; but if it is not, one may not survive. A little Joey might unintentionally pull a mound of sod right over the only opening to your neatly dug hole!

In the months that followed, I would continue to see that by letting Dr. Wetter help me find the thin threads of things that I liked to do and by holding on to them like fragile safety lines, I would be able to pull myself out of my depressed state. During our first session after Hawaii, Dr. Wetter's enthusiasm was contagious.

"Look how good you look! This is how I want you to look most of the time. Now, we can't send you off to Hawaii every weekend, so what carrots can you give yourself every day?"

After my astute doctor convinced me that I deserved an hour of pampering every evening, I eliminated my speedy showers and began a ritual of stepping into a scalding, bubbling, perfumed tub surrounded by reading material, nail and facial gear, candles, and succulent drinks. Through the headphones attached to the cassette recorder my sister had given me, I could indulge in my love of blasting music without disturbing the chaos outside my bathroom.

During these ritual baths, I forced myself to forget about everyone else and focused on myself. I was not very successful in controlling the

people and events around me, but I might learn to control myself more. I could experiment with a new make-up technique. I could work on losing a few pounds. I could have my hairstyle updated. I could establish a workable wardrobe. I could have my teeth cleaned regularly. I could replace my lopsided, scratched glasses with contact lenses. I could sign up for cooking classes. There was a lot I could successfully do for myself. As I soaked, I decided that I first had to change my verb from *could* to *would*, and then the results would fall into place more quickly.

Even though interruptions sometimes prevented me from profiting fully from my tub therapy, the average bath was sufficiently cleansing to my spirit. Seeing a better image in the mirror seemed to make whatever I had to face the next day look better.

Under Dr. Wetter's direction I learned how to manipulate the doors in my life. I learned when to open them and when to close them, and the danger of letting too many doors fly open at once. When the effects of my soaking and his words became noticeable, the doctor included Robbie in our sessions.

It is surprising how much more productive an argument can be when it is witnessed! Both participants seem more understanding and less nasty, which leads to a lot of points being made for both sides. In time, Robbie and I were able to recognize the pieces we had each contributed to our marital problem.

Robbie believed in "one step at a time," but since Joey's birth I had been able to see only the cliffs ahead of me. Facing the fear of separation and finally believing that I could survive alone made me strong enough to take steps back toward Robbie and to try to face the future together with him again. We were not instantly transformed into the perfect couple; but we could see our mistakes, and we could see the compromises that could bind our marriage back together. Fortunately, we had shared enough moments of fun to offset our dismal differences.

So, even though it could never be the same, little by little, the garden was weeded, the splits were mended, and the life ahead of me began to look better than the life I had left behind.

Chapter 6

UCLA Intervention

It is only with the heart that one can see rightly;
what is essential is invisible to the eye.

AS my time with Dr. Wetter helped me understand how to take care of myself, my time at UCLA gradually led me to a better understanding of how to take care of Joey.

When Joey approached his first birthday eating more and screaming less, I was less worried that he would starve and more able to deal with the medical world again. I knew this was no ordinary child and that he would require more than the standard parental skills. I also suspected that one of those UCLA corridors would someday lead to some solutions. So I proceeded to phone for another appointment with the Child Development Department.

After my first fortunate encounter in the corridor with Dr. Wetter, I was received pleasantly by the child development physicians, who remembered Joey and were pleased with his progress. They found him to be in perfect physical health, but developmentally delayed.

"Then he couldn't have cerebral palsy?" I asked with more conviction than question.

"Has someone applied that term to him?" one of them cautiously inquired.

"Dr. Wetter asked me if he had cerebral palsy." I remembered my response to Dr. Wetter had been a fast "Oh, no!"

Their response was slower. "Well...yes, he does have brain damage, but we're not certain at this point how it will affect his later life. We prefer not to saddle him with a C.P. label just yet." I wholeheartedly agreed with their preference.

I detected a puzzled caution in their next question, and guessed

that they were unsure how I was juggling this labeling discussion or why I had previously distanced myself from UCLA.

"What can we do to help you?"

"What can *I* do to help *him*?"

This turned out to be my jackpot question. Information was instantly gushing about the UCLA Intervention Program, directed by a Dr. Judy Howard and designed to help children like Joey and their parents. I was having trouble concentrating on their description of the curriculum because of my excitement that this program might have a prototype of my son. Only from other children like Joey could I learn how to handle him and what to expect from him.

Surely all these months would have been easier with footsteps to follow. I wished someone had told me about this program before now. Then again, I could have emphasized the importance of knowing about it to the right people. When the ship finally comes in, the arrival time should be irrelevant! I decided not to waste any time in getting on board this Intervention Program.

I had intended to dash home and promptly place a call to Dr. Howard. Instead, I opened the front door and detoured toward the bookshelf.

Little things I stuff away in my mind too quickly always seem to sneak back to the foreground. I had a nagging suspicion I was not falling into a bed of thornless roses. Not enough suspicion to merit an all-out investigation, but enough to look up cerebral palsy in my copy of *Better Homes and Gardens Medical Book* and see whether the label fit Joey. Before I could let second thoughts interfere, I skimmed to the definition of cerebral palsy and read:

CEREBRAL PALSY: A form of paralysis manifested by jerky, writhing, spastic movements, resulting from damage to brain center controls of muscles. Cerebral palsy is not a single disease, but a group of syndromes with a common denominator, some form of injury to motor control centers in the brain. It is not always possible to determine the cause of brain damage. It may result from birth injury, from infections of the mother or embryo, from errors of development, and other causes.

I felt a chill scurry down my spine as I swiftly closed the book. I knew Joey had brain damage. I had not realized that the words could

mingle so smoothly into the definition of cerebral palsy. I thought C.P.
was a crippling, deforming, and incurable disease that the afflicted were
born with. My beautiful Joey could not be further from deformed. He
would never have been born with these "problems" if his perfect body
had been able to make a faster exit from the womb. Could a perfectly
beautiful baby develop into an adult with cerebral palsy? Impossible!

It was easy to shake this thought. How could *Better Homes and
Gardens* know more than UCLA about what was wrong with Joey? Be-
sides, it shouldn't make any difference how anyone chose to label the
problem. I just turned to smell the roses before heading for the phone.

Dr. Howard's vibrant personality was evident during our lengthy
telephone conversation. To my surprise, when Joey had been in the
UCLA neonatal clinic, the Child Development Department had famil-
iarized Dr. Howard with his case and possible candidacy for her pro-
gram. Apparently my abrupt exit had kept them from telling me of this
potential aid.

Dr. Howard explained, "The Intervention Program's goal is to im-
prove the quality of life for developmentally handicapped children and
their families with a therapeutic and educational agenda based on indi-
vidual assessment of problems and needs. Eventually we would like you
and Joey in our afternoon group. In this part of the program, a physical
therapist, occupational therapist, and a speech therapist work together
with the teachers in a classroom setting, sharing their skills and allow-
ing us an almost one-on-one ratio of children to staff. But first we'd
like to see Joey on an individual basis."

The energetic doctor seemed to answer most of my questions be-
fore I could ask. Then she concluded her enlivening discourse by
scheduling an orientation appointment for Joey with Ann Landecker,
the program's physical therapist.

I arrived at UCLA full of apprehension on the designated day, and
entered the physical therapy room just as the previous patient was get-
ting ready to depart. I'll never forget what my eyes took in as they
zoomed around a room cluttered with assorted toys and padded floors,
then locked on a boy in a wheelchair. With warm coaxing from Ann
Landecker, the therapist, the boy was trying to activate this chair by
touching a joystick on the armrest.

He looked incapable of grasping anything! As he struggled with the
attempt, his extremities seemed to twitch randomly and his mouth
dripped with saliva and strange sounds. Looking less than five years

old, his emaciated body was twisted awkwardly in the chair. He was very close to the image that had flashed into my mind from the dictionary definition of cerebral palsy, and his youth made the sadness of the picture all the greater.

The boy's tender-hearted mother and the therapist watched patiently. They obviously did not see what I saw. In my numb trance, I could hear the therapist's cheerful conclusion, "Good try! We'll work on it some more next week."

These words forced my eyes from this child to the son I had been clutching too tightly. There was no doubt that I was holding a perfectly formed, beautiful boy! There seemed to be no doubt that the child I had just seen was not an older Joey. My Joey may have had more than a few developmental delays, but those delays could not possibly develop into this scene.

My thoughts of not belonging here were interrupted by Ann's welcoming voice. "This must be Joey!"

The comfort I derived from my first encounter with this lady was also unforgettable. I felt she already knew what our year with Joey had been like. She understood my fears and protectiveness, and in a short time I realized she understood my Joey.

It wasn't at all mysterious to her that Joey would scream in a moving car whereas a normal child would be soothed. She said something about his lack of proper balance causing an increased fear of external movement. I marveled at her perception of Joey and her ability to interpret his behavior to me, so much so that I could only partially listen to her words. I was too electrified to learn anything then, but calm enough to know that I needed this lady's continued involvement in my life.

That night, while soaking in the tub, I pondered the day's events. Without a doubt, I was hooked. This program positively had the potential to help me push Joey's development up to normal.

In the weekly sessions with Ann that followed, I learned, slowly but surely, how to start moving in the right direction with my son. Ann was wisely careful not to push too much or too fast.

Initially she looked at how we could turn our ways of dealing with Joey into future advantages. For example, I always carried Joey over my shoulder, cuddling him as I paced the floor. Of course, Ann did not advise halting my movement. She aimed first at turning Joey around, showing me how it would be equally cozy but more therapeutic if I

cradled him facing forward with one leg bent. She explained the need to balance the strength of Joey's back muscles with increased development of his abdominal muscles, which would help eliminate his strong back arching. Joey would not be able to flex his body for creeping and crawling until this "extensor pattern" was broken. I was amazed to see how simply bending his leg prevented him from going into the back arch that was becoming beyond my control.

Ann's next alteration was to our feeding technique. She made it very clear that she did not want to diminish the quantity of Joey's intake. However, she wanted us to start elevating him gradually toward a sitting position for meals. At the time, this seemed hopeless, but I could placate her by putting a wedge under Joey's head. Driven by Ann's continual, "when you're ready," reminders of where I should be heading, I found myself six months later feeding an awake Joey sitting in a padded but real high chair.

I did not immediately recognize how much Ann had altered my attitude. During one of our earlier meetings, she suggested that I offer Joey a sip of liquid "just once or twice every day. Whatever you can handle." I could see no way of handling this suggestion at any time. Even if I could get him calm enough to try, Joey could not hold his head up, close his lips, and swallow before the liquid ran out of his mouth.

But the success of Ann's other suggestions made me optimistic, so I tried. Folding Joey into a sitting position on the sink, I braced the back of his head with my shoulder and brought a cup to his lips. The touch triggered a shriek and a back arch, sending his head and arms flying backward and the contents of the cup all over me.

In the next session I told Ann why I did not think Joey was ever going to be able to take liquids. She sympathized with my stressful trial but urged me to *try*, "just once a day!"

Agreeing that it was probably possible to endure almost anything if it was just for a minute a day, I continued my small attempts. But I could not concede the possibility of progress until almost a year later, when I sat Joey on that same sink. Since he had left most of his arching in the year behind us, I was able to wrap one arm around him and hold his lips together with my fingers while he sipped from the cup in my other hand. Then, within a minute, he consumed four ounces of apple juice, leaving only about an ounce in the rag underneath his chin. I was astounded!

Progress can sometimes be painfully slow in coming, but persistent application of Ann's "just once a day" had pushed me to what seemed like a moment of instant success. I looked back on those days behind us, unsure of how we had finally arrived, but so glad we had started!

When Ann felt that Joey and I were ready to move into the group, she completed our private sessions by opening the side door of her therapy room, which led to a classroom. A group of mothers were sitting on a rug, holding their children and singing nursery rhymes. It was not quite the group one would run into at the local park. The mothers looked typical, but their children were different.

My focus fell first on Michael. This toddler had a handsome face that beamed with intelligence, but it was attached to a body with muscles incapable of supporting him. Next to him was a girl of comparable age, whose beauty was masked by skin covered with incurable blisters. Then there was Daisy. Her beauty was unmistakable, but her body had less flexibility than Michael's. It was a relief to see little Ryan adeptly manipulating some blocks, until I noticed the hole in his neck that held a tracheotomy tube, which inhibited speech. Matthew, sitting next to Ryan, could use his voice and both of his hands, but his facial muscles were paralyzed and incapable of any form of expression. The delightful expression on Mitchell's face made him naturally appealing in spite of his Down's syndrome.

I was revived by the sight of twinkly-eyed Christie playing in the corner with dolls. Like Joey, she didn't seem to belong in the group. There were no visible signs of deformity, only delicate femininity. But the picture blurred when her mother told me of the imperfect heart that sustained all this perfection.

I did not see another Joey in the group, but I felt instantly that I belonged with these mothers. They were other Sandys. They had children with problems and were trying to rebuild their lives, either around, beside, or away from their tragedies.

The Intervention Program offered mothers a weekly group therapy session with social worker Nancy Miller. Not usually one to join a group, I was delighted by the quick camaraderie I developed with these other moms, who were riding in my same wobbly boat to uncertainty. I soon learned that when an assortment of people with similar problems are drawn together, they are able to give and take on a unique level of communication as they struggle to stay on top of their shared burden!

The mothers' meeting became the highlight of each week. It was

my needed alternative to the green bathroom. Talking to them became easier and more rewarding than talking to myself or relatives. Firsthand experiences enabled us to identify with each other, and endowed us with tools for mutually constructive contributions. Relating sadness to someone as close as a sister was guaranteed to ruin her day, but the emotional state of our group of moms was more uplifted than disrupted by sharing sorrows. Our own problems did not feel as heavy when someone else's sounded worse, maybe because we were not already lopsided with the weight of love.

By forcing myself to overcome shyness and converse openly with other mothers, I released stress and was able to keep going into the next week. In time I grew to identify with Nancy Miller's favorite quotation, "Yard by yard, life is hard; inch by inch, it's a cinch."

Both Joey and I tramped through the months of therapy until his second birthday came around. Considering where we had started, the progress we had made seemed tremendous. I had marinated lots of tenderness back into my attitude toward life. Joey's screeching problem had slowly fallen away and exposed the ripening of his delightful personality. Normality couldn't be too far beyond the age of two.

Joey had already graduated into the morning toddler group of the Intervention Program. Generally, mothers and children were separated in this group, yet I tended to still linger in the classroom. I did not feel comfortable burdening the staff with my hyperactive son. Also, I did not think Joey was ready to be separated from me, since he was just beginning to recognize his mom. Actually, I could not release so quickly what I had held onto so tightly for almost two years!

The classroom had an adjoining room with a two-way mirror, through which parents could watch without distracting their children. I had seldom used this observation area, preferring to be on the more active side of the mirror. But one day I sauntered into the observation room, and ended up staying longer and seeing more than I had expected.

Joey was in a kneeling position, strapped to a classroom prone board. This position enhanced his hand and head control. Ann was beside him, helping him activate a battery-operated car by touching the joystick attached to it. As Joey struggled with the attempt, his extremities seemed to twitch randomly and his mouth dripped with saliva and strange sounds. He looked incapable of grasping. Dazed by deja vu, I did not realize that my body had drifted away from the window and

into the corridor outside the classroom. Ann had apparently caught a glimpse of my face, and I became aware of her bracing arms around me.

"He doesn't have mild brain damage. He has severely involved cerebral palsy." These whispered words floated sluggishly from my mouth with a prayer for rebuttal.

"That's right," was the indisputable truth! Ann continued on with positive reinforcement, but her "that's right" just kept repeating in my head until I really heard it.

I felt incapable of facing the thoughts that began bombarding my mind, yet I tried to salvage some hope. Surely he had to be able to lick an ice cream cone or pick a flower or pedal a bike. I could get over my child's inability to suck; I could even pass on walking and talking. But not these other things. Surely God would not expect any child to live without ice cream, flowers, and bikes? But I never verbalized the question. It was now too obvious that Joey could not project his tongue, pull with his fingers, or push with his feet.

I had always thought the burden of normal parental responsibility was heavy, but when you have nothing working for you, you can't even get on the scales. A handicapped child is born without a normal parental completion guarantee. He is yours to carry until death do you part, and if you depart first, who picks him up? My preciously perfect Joey was never going to be able to stand alone!

I now accepted that some of those adult C.P. bodies had once been someone's beautiful babies. I thought I had heard the word "repairable" whenever brain damage was mentioned, and had assumed that catching up was always possible for the developmentally delayed. The label did make a difference! I had accepted Joey's problem, but I thought I could fix it! I had skillfully avoided looking at the permanence that was spelled out so clearly in the definition of cerebral palsy.

Holding these thoughts, I looked around at the other mothers and the staff who had witnessed my acknowledgment of the truth. Their faces said they already knew what I was finally able to see. Joey had always belonged in the group. Why had I been so blind? Had the doctors deceived me, or had I deceived myself, or did it matter?

In the years ahead, as I encountered more parents of handicapped children, I would realize that we each reach our moments of awareness at different times and in different ways. Since there are some who never catch on, I could also understand the dilemma for medical professionals in choosing the appropriate time and way of presenting the whole truth

to the parents. Sadly, too many parents are displeased with the delivery of the facts, but the blow hurts, regardless of the amount of padding on the glove! As for me, it suited me comfortably that the woman who had given me such hope for Joey's future held me through the acceptance of the permanence of his problems.

Since the problems had been such a hardship to carry, at first, it seemed too heavy to even consider that they might be permanent. Yet, as I passed through the automatic door to take Joey home, I sensed a strange exhilarating breeze of freedom. I paused for a long piercing gaze into the smoggy sky and felt like a child watching her helium balloon fade into the clouds. I had let go of "normal!"

"Normal" had become so frustratingly difficult to hang on to. Now it was clearly not necessary to keep jumping to catch the impossible; I could relax and enjoy what was on the ground! Even though I looked like I had just swum the English Channel, I had to lighten up as my eyes shifted from the sky to Joey's face. He was still wearing the same smile he had brought to school, and was ready to get on with his day.

The humor of the contrast gave me some comforting thoughts. I had always been heading in the right direction with Joey; it just wasn't toward "normal." I wanted him to attain as much success and happiness as his limitations would permit, which was the same set of goals I had in mind for his three brothers.

Joey did not have to be normal to be treated normally. I remember Ann once wisely telling me that the worst thing we can ever give children is our expectations. I did not expect his brothers to be Bruce Jenners. Why should I expect Joey to walk? I wanted all of my sons to be propelled by their own expectations and to accomplish what was within their own abilities.

Realizing this, I knew I had developed a lot more than swollen eyes. Accepting reality can be very difficult, but it is the first step toward turning it around and making it work for you.

When we got home, I put Joey down for a nap and watched him fall asleep. Unaware of the different diagnosis I had accepted for him that day, he could rest normally. But I needed two hours of studying the individual parts of his body before I could see that despite the switched labels, the contents had remained the same. He was still the same Joey I had taken to school that morning.

Then I happened to notice the tee-shirt he had worn the day before, stuffed on the side of the mattress. The timely uncovering of this

shirt, which was emblazoned with a sloppily printed "PERFEƆT" forced me to laugh out loud. Joey was still my perfect little boy. He hadn't changed! Only the letters had turned around for me.

Just as the first UCLA mother I met did not see what I saw when I looked at her son, I knew I would never see what the world saw when it looked at my Joey. I would always be close enough to him to perceive more than perfection.

This thought carried me through the completion of that day, and I didn't have to let go the next day, either. In fact, it was truly impossible to let go of. Somewhere in those two years of problems, my love for Joey had found its place beside my love for his brothers, by developing into a permanent part of me.

Thought I Saw a Person

But I, alas, do not know how to see sheep through the walls of boxes.
Perhaps I am a little like the grown-ups. I have had to grow old.

THROUGHOUT the first two years of Joey's life, Robbie and I could both feel our fourth son's strong determination to live and control his life, but we did not always feel as positive about the intellect behind his drive. It was hard to guess what potential lay beneath a lot of toneless muscles. I had encountered many parents who were hoping for more than any unattached spectator could expect. I had even seen a few situations where, instead of increasing their child's motivation, overly optimistic parents had unintentionally crippled the child or themselves with pressure. Now, knowing the pain of a false hope that was inexorably drifting out of my reach, I wanted to be positive about Joey's potential, within the bounds of reality.

After one morning class a few months before Joey's second birthday, I impulsively initiated a conversation with Kit Kehr, the Intervention Program's head teacher.

"Kit, I need your honest opinion about Joey's intellectual potential."

"Sure," she replied. Her responses always expressed a willingness to help. "Let's go into my office, where we can be more comfortable."

Before I could turn, Ann disclosed her presence behind me with, "I'd like to work with Joey for a few extra minutes. You two go ahead." Consistently, the Intervention staff skillfully supported each other.

"Sorry about the mess," the stylishly dressed teacher said after leading me into a small office which reflected her many involvements. "I've been trying to get a grant proposal together for my dad's group."

Kit had originated a unique Saturday session so that dads could accompany their children to school. These morning meetings gave the

mothers a break, and provided the often-forgotten fathers with an outlet for releasing their feelings, forming friendships grounded in empathy, and becoming more therapeutically enlightened about their handicapped children. Kit enhanced the Saturday sessions with her attractive congeniality and reassuring attitude. It was easy to settle into a chair beside this teacher and try bravely to clear the field of any other bombshells.

"This morning…I couldn't believe it…I found Joey sitting quietly in a corner of his crib. He's never been able to get into a sitting position, and as you know, he's hardly ever voluntarily quiet." Our smiles concurred as I continued. "He didn't seem to notice me. Actually, he never does."

"What does the ophthalmologist say about that?" Kit was equally curious.

"He's not sure. I told him that I can come into the classroom and sit down right beside Joey without his giving any indication that he recognizes me. But then, lately I've noticed that when he hears my voice, he throws his head back and squints his eyes in my direction. This seems to stabilize his jiggling eye movement, and he either smiles or whines. He mostly whines, but I assume that means he's glad I'm there."

We shared a short snicker before I proceeded. "Well, back to this morning. If he doesn't hear me come in, Joey's easy to spy on. He was sitting quietly in the corner, then he reached up, put both hands on the railing, and pulled himself to a standing position. Now, I know his hands are not strong enough to pull him up. He arched, and it looked like he used his back muscles. Somehow he got up."

I shrugged and moved forward with gestures. "Then he dropped his arm down the side of the crib and clutched the railing with his armpit while he turned his body around, angled his back into the corner, then lifted his pivoting arm up, just as he slid to a sit. He sat there a second before dropping to his side and worming himself into a position to repeat this…four more times. This went on for ten minutes! He's never been silent that long without someone providing some sort of stimulation!"

Kit's raised eyes and grin confirmed her many challenging classroom conflicts with Joey, and I concluded, "It really seemed that he knew his arm and hand muscles were useless. So he devised his own way of sitting up by using his back and armpit. I thought it was brilliant!"

Kit was quick to agree and added, "He's very creative when it comes to manipulating his muscles."

This made it safe for me to reverse my stand. "But we only get these rare flickers of genius! Most of the time his behavior is just plain bizarre. He's almost two years old, and yet no toy contents him for more than two minutes. He doesn't seem able to look directly at anything or anyone. He's only interested in moving or being moved. He's not able to communicate anything, except a smile. He has a wonderful smile, which he uses more and more every day. I'm not always sure what he's smiling about, but...."

"Well," she attempted to uplift me, "when he defiantly jerks that little head of his off to the side, with that perturbed grunt, you know he means no."

"You're right...but that's his only response to anything. I think I know a little about what he does and doesn't like, but I'm mostly guessing. I don't feel like we're communicating without at least one yes to something!"

"We'll have to work on that," Kit picked up after my pause. "Maybe we can get him to sign with his fingers."

I'm sure she guessed that I was a long way from home. "You know, I always sing nursery rhymes while I'm feeding him. He eats more, and it seems to pacify me too. About a month ago I started repeating that catchy tune you play all the time. I almost hypnotized myself, 'Shake your head, yes, yes, yes. Shake your head, no, no.'"

"Oh, yes, I know that well," she cheerfully cut in on my singing to help me resume the story.

"Between bites it looked like he was trying to mimic the yes part. Ever since then that's the only meal song I sing, over and over. I'm getting dizzy from all the nodding, but I haven't gotten any substantial feedback. I'm not sure if he's just physically unable to move his head vertically, or if he's just not positive about anything, or if he just doesn't...."

Gripped by a melancholy sensation, I straightened my slouch and came to the point. "Look at all that Danielle can do compared to Joey. Yet Jan told me you felt Danielle was retarded. You've never said Joey was retarded." I hesitated. "Have you just been sparing me the news?"

"No," Kit swiftly denied. "I don't feel Joey is retarded." I trusted the sincerity in her eyes, and continued to listen. "To be honest, Sandy, I really can't tell you exactly why. It's just that after so many years of

working with these kids, you sort of develop an instinct. Sometimes we're wrong, but we always try to give the kids the benefit of not doubting them, without giving the parents false hope. Not enough belief can be damaging to the child, but too much can be damaging to the parent. It's a difficult balance to keep."

As I drove home that day, my attention was intermittently drawn to Joey's unrevealing face while I continued thinking about my conversation with Kit. I wondered if we would ever know what thoughts lurked behind that delicate face.

A few weeks later, however, an incredible afternoon paved our way to communication. UPS delivered a new handicapped toilet that I had ordered for Joey. This portable toddler toilet had a high backrest and a large tray in front, which seemed to provide safe confinement and support while enabling a toddler to keep his feet on the floor. After strapping Joey into this apparatus, I left for a few productive moments in the kitchen, forgetting that Joey had Houdini's ability for worming his way out of any confining equipment.

I was rushing to get dinner into the oven when our round-faced Marty, who was almost three and looked like Spanky on "The Little Rascals," approached me with an odd expression on his face. "Mom, you'd better check Joey." He paused to lick his fudgecicle. "Quick!"

"Why?" I foolishly asked.

"You won't believe it!" He finished his cryptic statement by rolling his eyes.

I understood his repulsed look when I arrived at the bathroom door. Joey had managed to squirm out of the toilet seat, grab the contents of the toilet bowl, and had left little of his body uncovered!

"Oh, my God!" I screamed as I tried to remain untouched by the situation. But by the time I transferred my thrashing, floppy child to the bathtub, I was equally smeared!

Close to tears, I caught a glimpse of Marty, still engaged in his wide-eyed licking.

"Why are you just standing there?" I screeched.

"I can't believe it!" His frozen face just licked. "This should be on *That's Incredible!*"

The expression on Marty's face combined with the reality of his observation somehow transformed the scene from devastating to humorous. Weakened with laughter, I slid into the tub with Joey. The release seemed to make the incredible cleanup a lot easier for both of us.

After dinner, Joey was able to sit patiently in his high chair while I shampooed his brothers' hair. Then he resumed his usual whining. Tired and frustrated by this inexplicable noise, I snapped out, "Stop that whining!"

To my astonishment, he did! Since he had never before responded to a command, I pretended to remain angry and pushed for more results.

"You don't have to whine. You can shake your head, you can point to tell me what you want."

After a string of questions, all of which got a sharp negative grunt, I was afraid I would not be able to solve this charade. Then, groping, I asked, "Can you *point* me in the right direction?"

Surprisingly, Joey's index finger seemed to move toward the kitchen sink.

"The sink...." I remembered that after finishing his brothers I usually washed his hair and gave him a bath. "You want your turn in the sink?"

After a moment of intense concentration, he produced his first nod for "yes," followed by a soft sobbing.

I lifted him from the chair but I was reluctant to stop hugging him. For once, I knew why he was crying! He was disappointed. And he had appropriately communicated his displeasure.

"But you already had several baths today, remember?"

Delighted by the smile my playful taunting awakened, I continued to probe for more responses. "You can have another bath tomorrow. Would you like some ice cream?"

Promptly, his head struggled through another yes nod.

"Can you show me where the ice cream is?" With this, his finger moved to indicate the freezer.

I spooned bites of ice cream into his mouth, then held his lips together so he could swallow. His face was expressionless and his jerking eyes made the object of his gaze uncertain, but I knew—we both knew—that we had engaged in our first real conversation!

Joey did not have a good hold on walking, talking, eating, or playing, but from that day on, I was sure my "perfect" son had a firm grip on what was essential!

Having found the beginning of a way to communicate with Joey freed me emotionally to hurdle some obstacles in my own life. So,

shortly after this pivotal afternoon with my youngest son, Robbie was able to get me to go along with his desire to stop smoking. He was reading the newspaper when he came upon an advertisement for Smokenders.

"Look at this. They claim they can make you stop smoking in six weeks. I have to quit. Let's go to this introductory meeting."

"All right," I reluctantly agreed. I wanted to be supportive. "But I have absolutely no desire to give up my cigarettes. I'll go along with you. I'd like to see you quit, but I don't want any pressure to join you."

Even though he agreed, I felt a little uneasy about how his quitting might infringe on my own freedom to smoke. Still, during this first gathering of smokers, the instructor titillated me with the guarantee that she would convince all of us before the end of the program that we *wanted* to stop smoking, and then show us the way to succeed. I was already convinced she would fail with me, but I was curious enough to let her try. Both Robbie and I ended that evening by agreeing to comply with the program's weekly homework assignment.

Smokenders allowed us to smoke freely during the six weeks prior to our cut-off date. Always feeling the need to be stocked for any future deprivation, the next afternoon I was sitting in my kitchen corner, surrounded by smoke, when my sympathetic six-year-old, Shawn, strolled in.

"What's wrong, Mom? You look sick."

"Oh, no," I said with the realization that I was getting there. "I just think these cigarettes are a little stale."

"If you don't like them, why do you smoke them?"

Not wanting to get into a muddle above his head, I tried a pacifier. "It will make more sense to you when you get older. Why don't you get an apple to hold you till dinner?"

He got the apple, but it did not silence him. "Just don't think about cigarettes all the time, Mom. If you don't think about them, then you don't have to suck in all that smoke and burn out your *heart*." He strolled away eating the apple, leaving me in the murky smoke remembering Robert's similar solution to the gavage problem.

When I reached my smoking cut-off date, I linked the boys' shrewdness with the instructor's words, "You can only hold one thought at a time in your mind." Forcing my sons' faces to pop up whenever I contemplated a cigarette helped me change mental channels.

Through this trickery, I was able to persevere to the accomplish-

ment of something I had thought too impossible to consider! I reached out beyond my abilities and snapped back with the brass ring. The fact that this ring was often so difficult to hold on to made it even more valuable to me; it became my private halo of self respect. In the months ahead, I would discover that exercise could replace cigarettes as a crutch, leaving only a residue of contentment.

Smokenders reinforced my belief in the power of bonding with a group when tackling a problem. Both Robbie and I graduated into non-smokers, and we grew closer after leaning on each other throughout the stifling struggle to succeed. Robert's and Shawn's advice and giving up smoking also fortified my faith in the potency of positive thinking. I could so easily be taken in by the conning salesman at the door. If I could use that same con on myself more often, maybe I could open the door to a lot of potential I didn't know was there.

Since Joey's birth, I had learned that one sometimes has to give up in order to gain. Just as I saw the benefits of letting go of the nurses, normalcy, and smoking, I began to see an alternate angle to housekeeping. My focus was sharpened by my three-year-old Marty, on a day when he was suspiciously observing one of my standard house patrols: I bustled from room to room transporting things to their appropriate place as I picked up more along the way.

"What do you do around here, Mom?" Marty asked, undoubtedly planning to follow the question with one of his profound observations.

"What do you mean?" As usual, I was unsure where this was coming from or going to.

"I mean, you always just seem to be walking around the house, I was just wondering what you did."

Marty got a peppy fifteen-minute lecture on all the things I did, but he never lost his smug expression, and only returned a composed shrug, "Hmmm I just see you walking."

As he sauntered away I wondered why I had felt such a need to justify my time to a toddler, and why he remained unconvinced by the attempt. Maybe all the picking up didn't amount to enough for either of us. Maybe I could limit my frivolous cleaning and transfer most of my energy to something else. These thoughts led me to accept Robbie's suggestion that we employ a live-in housekeeper, since Suzie, my valuable helper, needed to devote her full time to college.

Having a housekeeper is not always as perfect as it's thought to be, but it can provide some vital freedom when needed. I had to give up

clean baseboards, organized cupboards, and many of my new blouses were shrunk to doll clothes. On the other hand, the losses were outweighed by my newfound ability to shut the door on family pressures. I was able to give up the unnecessary and get out of the house.

One fun venture was to go out for breakfast. Prior to Joey's birth, my sister and I had established a tradition among our nearby relatives of congregating at a local restaurant for Saturday brunch. But Joey's arrival and his unpredictable fits kept us eating at home. Now that he could express his enjoyment of riding in a baby seat on the back of my bicycle, we again had a rewarding destination for our Saturday morning rides.

I entered the restaurant knowing that when Joey reached the limit of his tolerance, I could walk him outside until the others finished. Although I did a lot of street walking in the beginning, after a while Joey could sit through a full family meal. More than the eggs, I was nourished by the renewed family unity, which included this little odd one.

Between Joey's first and second birthdays I had darted through life resetting dominoes, with the cushioning support of Dr. Wetter, UCLA, family, and friends.

A year of wearing a patch had corrected Joey's lazy eye. His nystagmus, or twitching eye movement, would still hinder his ability to learn, but I knew that with a slight backward tilt of his head he could recognize me. After his first successful nod, we all continually demanded responses from Joey, and he continued to oblige. After weeks of yeses, noes, and points, our family gradually came to know and understand the person behind the problems.

We had transferred our two oldest boys to a new school, and because of Shawn's age and Robert's dyslexia, we held them both back a year. With tutors, caring teachers, lots of rewards and praise, and a little whip cracking, Robert was going to pass into the second grade with enhanced self-esteem.

My own mental and physical health had been improved by eliminating the nurses and quitting smoking, and by the addition of a housekeeper and exercise. In turn, the relief these gave me from the pressure I had felt made my marriage more stable.

Robbie's new production company was supported by a continual flow of movie offers. In the fall he would start producing *The Yeager Series* for ABC. This contemporary *Bonanza* focused on a family in a log-

ging community, and would have to be filmed on location in Coeur d'Alene, Idaho. Bringing in the difficult Yeager pilot on time and on budget boosted his reputation as an entrepreneur, and left me with the excitement of organizing our family's future traveling adventures.

One day as I sat at the kitchen table working on my list of things to do, the pages of the previous two years flipped past me. So much had happened…and too much of it had been sad. I had fallen into tragedy so quickly, had been so unprepared, and had sustained so much damage. And yet there I sat, out of intensive care and happily making plans for my return to the normal world. The breakdown seemed so long, and the recovery so brief. Just as we never see a baby grow, changes sometimes happen too slowly to be seen until they have become significant.

I recalled that when Joey was born, a former neighbor, Rose Senor, had sent us a card laced with memorable words. Having looked up the meaning of Joey's surname, which is "he will add," she had poetically prophesied that in the beginning it might be difficult for us to visualize the addition, but that clarity would certainly come with time.

I thought it was always clear that Joey had added the mound of problems which had initially blinded me. Perhaps I no longer had the insight I possessed as a child. Nevertheless as predicted, almost two years later, time brought something else into focus—while I had been digging up answers for Joey, I had discovered myself.

Our two-year nightmare was finally over, and we were looking good, individually, and as a family. From patching to vision, sipping to drinking, entertaining to eating, tutoring to passing, and exercising to health, I had really learned the cumulative value of "just once a day." We had inched our way to yards of progress. But, alas, who could have guessed that we were only being lulled by the deceptive calm of a dormant volcano.

The Sleeping Volcano Erupts

And I felt him to be more fragile still. I felt the need of protecting him, as if he himself were a flame that might be extinguished by a little puff of wind.

ON a seemingly placid morning in June, I was drifting awake with plans for Joey's second birthday party. Suddenly my thoughts were rudely interrupted by the terrified voice of our housekeeper. She was rushing toward our bed with Joey in her arms. Perplexed, I tuned out her Spanish rambling and studied the child she had handed me. Within seconds, my trembling voice began to utter, "Robbie," as my mind searched to understand what was happening to my Joey.

His body lay there in my arms, but instinctively I knew *he* wasn't there. His limbs dangled lifelessly. His eyes darted back and forth, and his entire face and neck were quivering weirdly. Choking sounds heightened his frightening appearance.

Not coming up with any answers, I shifted from thinking to robotic action. I laid Joey on top of Robbie, who was trying to recover from sleep and shock at the same time.

"Do something!" I urged. Leaving him with this blunt plea and Joey, I dashed to phone our pediatrician, Dr. Cobley. While my shaking fingers dialed the number, I repeatedly reminded myself, "don't think, just do!"

When the doctor answered, I tried to give him an accurate description of what I had seen, but the words didn't make sense to me. How could I expect someone else to understand? Without giving him a chance to speak, I announced, "We'll meet you at the emergency room!" and hung up.

In record time, Robbie and I threw on our clothes, grabbed Joey, and reached the car. Without speaking we started our tense race to the hospital. It never even occurred to us to call the paramedics. Panic-stricken, I clutched Joey tightly and stared at the road ahead while my voice still echoed in my ears, "Please, God, let him live!" I made myself repeat this prayer so that no thought of the horrible monster that had taken possession of my precious little boy could creep into my conscious mind.

Unexpectedly, my mental chanting was interrupted by Robbie's anxious words, "Is he breathing?"

My first thought was, "How ridiculous, of course he's breathing." But as I slowly released my firm grip on Joey, I was too stunned to speak. Robbie had guessed correctly—he wasn't breathing! His body lay limp in my arms, and in terror I watched the blue color of death darken his handsome face.

In the moments that followed, Robbie and I were thrown into the horror and panic that only the presence of death can bring. Together we screamed at the rush-hour cars jammed around us on the freeway, our pleas for help alternating with shouts for them to get out of our way.

Images of Joey's first two years of life flashed through my mind. But now all those problems and pain seemed microscopic compared to the thought of losing him. I realized that what I wanted wasn't the walking, talking, what-could-have-been son; I didn't want to lose the amazingly determined Joey who had problems making any muscles work except those required for a smile. In those seconds I realized that I loved what he was and what he could do, without any expectations. Had my realization come too late?

Robbie's hand slammed down on the wheel with a loud determined blast of *no!* It was the slap I needed to make me realize that death hadn't taken me too.

Robbie pressed down on the horn, accelerated, and in one breath shouted at the cars to "Move!" and at me to "Hold his nose! Breathe into his mouth!" His voice carried so much authority that the cars and I all followed his instructions. People stared at us as if we were crazy as they moved in every direction to let us plow through.

The thought that I knew nothing about CPR leaped into my mind, but just as swiftly I tossed it back out. Somehow I struggled through my breathing part, and Robbie pumped on Joey's chest with one hand while holding the wheel and blowing the horn with his other hand.

The rhythmic inhaling and exhaling were the first substantial breaths of air I had taken since awakening to this nightmare.

Just before we arrived at the hospital, a slight gurgle arose in Joey's throat, followed by a cough, and his complexion faded back to an "alive" color. We sprang through the emergency room doors with our hearts pounding, but now to a different rhythm...we had made it!

Joey was pale and lethargic but breathing adequately when I laid him on the table and told the doctor on duty what had happened.

"Has he ever had seizures before?" the doctor interjected.

"Well...yes." My answer came slowly, for I had not been aware that this horrifying episode had been a seizure. "He started seizing right after birth, but he stopped having seizures over a year ago. He's certainly never had anything like this!"

After a nod I could not interpret, the doctor continued to drill me with questions. When I had completed Joey's case history, I took a deep breath and waited for an explanation of my frightening morning. Instead I got another nod, followed by a request to wait outside. I had just witnessed my son's bounce from life to death and back; now, with his future still up in the air, I was asked to leave the scene and wait outside for the outcome. This did not make sense to me.

The doctor noticed that I wasn't leaving and added, "He won't recognize you for a while after a seizure. We need to get him ready for admittance."

I was not capable of presenting my own case, so Robbie came to my defense and assured the doctor that I would be a help and not a hindrance. Then Joey started a restless whining, but supported me by immediately calming when he heard my voice. He had never before demonstrated an awareness of me as his mother, but now, even though he was slightly delirious, he knew I was there. This simple recognition brought comfort to both Joey and me. God and the doctor must have known how much I needed this comfort, and no one asked me to leave again—this time.

After Dr. Cobley arrived and examined Joey, he told us that he had consulted with a respected pediatric neurologist, Dr. Harriet Cokely, and that she would schedule Joey for some tests.

Upstairs in our assigned room, Robbie and I entertained Joey, who was back to his old self. We had shared our most intense moment of togetherness during that terrifying morning, yet we said nothing to each other about it. Although Robbie and I exchanged a few glances

that said volumes about our mutual fears, confusion, and respect for each other's performance during the emergency, we synchronized our plans for the rest of that day as if the morning had not been a part of it. We were running on the same track, but we had experienced something beyond words.

When both Joey and I looked comfortable in our new surroundings, Robbie left for work. It was an uncanny coincidence that he was currently producing *Topper*, the television remake of the original comedy about a couple who return as ghosts from a fatal car accident to help their abandoned friend.

Throughout the rest of that morning and at lunch, Joey and I laughed and played together, pretending everything was the same as ever. Then I simply held his hand as he fearlessly went back to sleep.

I went into the bathroom to wash some life back into myself, but paused in the middle of brushing my teeth. It took me an extra moment to realize that I was actually hearing that eerie choking sound again, and not its echo; but with only one peek, I knew that an instant replay had begun.

Numbly watching from the foot of Joey's bed as a doctor and several nurses flurried through their emergency routine, I worried that Joey might stop breathing again.

Forty-five minutes later, he did!

The medical team promptly positioned a balloon bag with an attached mask tightly over Joey's nose and mouth, and the doctor squeezed controlled amounts of air into his lungs. After several long, drawn-out minutes, the doctor announced, "He's breathing on his own." I waited for my smiling Joey to return, but this time he remained in a deep sleep.

Before leaving, the doctor explained that the stiff dose of phenobarbital he had given Joey to stop the seizure would probably knock him out for the rest of the afternoon. I felt like I needed a similar shot, but I was too shy to ask for it. Instead I slowly eased myself into a chair beside Joey's crib and stared at his body for several hours, pacing my breathing to his.

Death! There it was. That ugly final word that had always been difficult for me to face, despite my religious beliefs. My mind kept transferring the dead face I had seen twice that day to that of the sleeping Joey. We had covered so much ground since his birth; had we just traveled though hell for two years only to arrive at death?

At least I now understood why I had always been afraid to press anyone with too many questions. I could finally see that the fear of all those strange jerks and of not getting enough food into him was really masking my fear that Joey could never keep far enough away from death.

Robbie and I waited patiently through several days of tests, but as usual there were no real answers. Joey's new neurologist, Harriet Cokely, came in to talk to us before discharging Joey. Looking slender and sophisticated in her tailored suit and with a stethoscope hanging loosely around her neck, she stated simply that all of Joey's tests, including an EEG and CAT scan, were normal. We knew this did not mean much, but we appreciated that she admitted it. We also welcomed her comprehensive and straightforward approach to the questions we took turns asking.

"Why would he suddenly start having severe seizures after making such steady strides in his development?"

She did not know why, but she knew that seizures could happen at any time, especially to a child who was already neurologically off-balance.

"Will the medication stop the seizures?"

"I hope so. If it doesn't, we'll have to keep trying different combinations of medications until we find something that works." Her confidence of eventual success was reassuring.

"How long will he need the medication?"

"After his type of seizure activity, I would guess a long time. There is a possibility he will outgrow the seizures, but I wouldn't count on it."

"Have you ever heard of anyone having his type of seizure?"

"No."

"Why does he stop breathing?"

"I don't know. Usually a grand mal seizure only lasts a few minutes. It can be followed by brief respiratory arrest, but the person is usually able to resume breathing on his own. Joey's seizures lasted close to an hour! This length of time and his prolonged arrests are extremely unusual."

"Would he have started breathing again on his own?"

"Since he turned blue on you this morning, and since the doctor who handled the noon seizure reported that Joey needed breathing assistance, I doubt that we can count on him to resume breathing on his own."

"What should we do if he starts another seizure?"

"Call the paramedics, then call me. I'd also recommend that you purchase an apneic monitor and take a Red Cross course in CPR. Here is my number. If you think of any questions later—and I'm sure you will—call me. I'll give you whatever answers I can. I know this is all very frightening."

The touch of compassion I heard in her voice gave me courage to ask, "What would happen if we didn't give him the medicine?"

"I think he could go into a seizure every time he went to sleep. Without medication, he could start into a seizure that we would not be able to pull him out of."

"He could seize right into death?" My hounding thought was unintentionally verbalized.

"That's right," came the answer I already knew.

The questions continued for another hour, but the situation did not become any clearer to me. How were *we* going to survive?

Robbie, Joey, and I all looked a little drugged as we drove home from the hospital that day. The future was hazy, and I felt too weak to contemplate it. I did not know how far we were going to get with this child. Then again, I never had known.

I knew that if I allowed myself to think too often about his possible death, I'd just slide back down the tube, right past all those things I had worked so hard to achieve.

Fortunately I did not know it then, but we had only experienced the first of many violent seizures followed by respiratory arrest that our son would survive. During the next five months, these life-threatening seizures occurred at least twice a month. Their frequency, coupled with the intense emotional strain, gave us barely enough time to recover from one episode before another began. Each seizure brought panicked phone calls to the paramedics, rapid ambulance rushes to the emergency room, and traumatic scenes at the hospital. There was tremendous pressure to get Joey transported safely to the emergency room and through the occasional intubations and other medical procedures necessary to keep him supplied with oxygen until he was able to resume breathing on his own.

When an opportunity arose to do an EEG on Joey while he was sleeping, we finally got official confirmation of the scattered, abnormal spiking of his brain waves. The EEG and CAT scans taken when he was awake were still normal.

The most perplexing aspect of Joey's seizures was the mucous complication. Increased mucous production during a seizure is not unusual. But the thick consistency and tremendous volume of Joey's seizure mucous was phenomenal. It was also deceptive. Its presence was not always audible, but still it blocked his bronchial passages, initiating and prolonging his respiratory arrest.

We purchased our own hospital-type suction machine and suctioned Joey intermittently throughout his seizures, without waiting for the audible cue that suctioning was necessary. When Joey stopped breathing, we alternated suctioning with puffs of mouth-to-mouth air. Unfortunately, Robbie and I had lots of opportunities to practice our developing medical skills.

The most frightening aspect of Joey's seizures was the camouflaged respiratory arrest. We became fully aware of this deception during a family Labor Day vacation in Las Vegas.

Robbie and I had left the boys with my parents. We never expected the phone call that interrupted our dinner and sent us on a desperate five-minute ride to Sunrise Hospital, where the paramedics had reportedly taken Joey.

We found our seizing son surrounded by a tense medical team performing emergency procedures. One person was holding Joey's head back to keep the airway open; one was suctioning; one was sticking wires onto his chest and connecting him to a cardiac machine; one was holding his arm reasonably still so that another could probe for a vein that would hold an IV. It was a relief to see that Joey was still breathing.

Recognizing us as Joey's parents, the doctor overseeing all this activity quickly guided us away from the gurney while asking questions about Joey's medical history. I responded with the requested information, but I never took my eyes off Joey until I instinctively knew he had stopped breathing. "He just arrested!" I shouted.

The doctor turned and darted toward Joey, confirming my alarm with "My God, you're right." Robbie and I stood quietly in the corner and watched the familiar race to sustain our son's life.

When Joey's condition was stable, Robbie went back to my parents' home to assure the other boys that they still had their brother. I stayed at the hospital and pensively watched Joey sleep peacefully through the night, while I contemplated the evening's harrowing event. All those people had been doing their jobs very proficiently, with total concentra-

tion on Joey, yet his arrest had slipped by unnoticed. Of course, they would have recognized the arrest in a few moments, but a few moments' delay could have meant more brain damage for Joey.

Even when Joey went into respiratory arrest, his heart continued to beat without interruption for several minutes. Joey would already be pale from the onslaught of the seizure, and the additional loss of color following the respiratory arrest might not become apparent until he was close to cardiac arrest. Moreover, the body jerking continued even after the respiratory arrest, which made it difficult to tell that the rising and falling of his chest has ceased. Heartbeat, color, or visual examination could not be relied upon to announce Joey's respiratory arrest until precious seconds of oxygen had already been lost. If these cues became apparent while Joey's doctors were involved with another critical case, those seconds could stretch into minutes.

After observing so many of Joey's unique seizures, I developed a non-medical sense for when he would stop breathing. I would start mouth-to-mouth resuscitation just prior to his actual arrest, and thus guarantee an uninterrupted flow of oxygen to his brain. What I sensed, however, would not have been obvious to an emergency room technician encountering him for the first time.

I felt a tightening of my already binding tie to my son, and a very pressing need to curtail our social life for a while. It would have been too risky for Joey to arrive at an emergency room unaccompanied and unknown!

In the morning, Joey awoke with no indication that his future had been altered by the previous night's events. He smiled at me and then proceeded to unplug his IV.

After cleaning up all the blood, I talked the Las Vegas doctor into an early discharge from the hospital so that we could return to Los Angeles and consult Dr. Cokely. She would have to decide on the next alteration in Joey's seizure medication before another bedtime approached. Joey went to sleep that night with an additional half a pill, which proved to be enough to keep him in his own bed for the night, and the same dosage kept him quiet for another couple of weeks.

As we had done with Joey's jerking and his inability to eat, we analyzed his mysterious seizures from every angle, hoping that a solution would appear before the next attack. After innumerable consultations with what were considered the top pediatricians and neurologists, we learned that our only solution was to experiment with various medica-

tions. It was like playing roulette, hoping to come up with the right number of pills in the lucky color. We felt most confident and comfortable with Dr. Cokely's expertise in manipulating the prescriptions and dosages, so we followed her advice.

Before the medicines provided any benefit, they brought their share of problems. All of the various seizure medications come with a wide range of side effects. After hearing about a few, like loss of hair and liver damage, I agreed with Dr. Cokely's original opinion: "You don't want to know."

Some medicines even produced side effects that have not made the list yet. Naturally, Joey was also unique in this area, and we survived several scary episodes that were eventually diagnosed as Dilantin overdoses.

One of these occurred after a swimming lesson at UCLA. The mothers had gone to the coffee room while the teacher read the children a book in the classroom. My cup seemed cold, and I felt a familiar chill when I caught a glimpse of Kit coming my way carrying Joey.

"He suddenly fell sound asleep," Kit said with surprise.

Whenever Joey suddenly did anything, I knew we were in trouble. We did not have to wait too long before he jumped from asleep to awake and began a vomiting session that kept us all busy. Then he seemed to be all right. He looked a little pale, but he smiled at our dazed faces.

I was just about to relax when Joey dozed off again. Knowing how his cycles tended to repeat, I carried him to the bathroom and readied a place for the vomit. After several rounds of this same scene, Dr. Howard suggested that we wait out this repetitive drama in the UCLA emergency room.

Once again I found some comfort in physical movement. Then I spent a draining afternoon watching Joey suffer until his muscles were too weak to produce another dry-heave.

When exhaustion was beginning to overcome both of us, Joey finally fell into a normal sleep. I sat down on a stool and leaned my head on the side of his bed.

During the previous week Joey had actually started producing an "M" sound and had been trying to extend the consonant to "Mom." Being so close to this accomplishment would trigger his smile and break the concentration that was necessary for the difficult muscular maneuver. Seeing his undisguised development of pride was almost as

important to me as hearing his speech progress. Yet it seemed that whenever he started to succeed at anything, he would suffer another setback.

My crying must have deviated from the intended silent sobs, for Joey stirred slightly and turned his face in my direction. He slowly opened his eyes as I lifted my head. Then he not only managed to produce my favorite smile, but followed it with his first perfectly enunciated "Mom" before returning to an exhausted sleep. Joey did not seem capable of giving up, but he was always capable of throwing a kink into my attempts to do so!

The next day Dr. Cokely explained that Joey's body had a strange way of storing Dilantin and then releasing an excessive amount into his bloodstream, causing a sudden overdose reaction. She speculated that the warm water of the swimming pool might have stimulated this effect.

As usual, Joey regained his strength rapidly and was back at school in two days. I picked up a new medication at the pharmacy, canceled his swimming lessons for a month, and started rebuilding my strength for the next hospital ordeal.

So much emotion brings a lot of energy which has to be channeled in a positive direction or it will stumble into the negative. My need for an uplifting outlet grew after each of Joey's escapes from death. I had to do more to prevent the next seizure than give him an extra half a pill. Thankfully, a caring neighbor led us to a nutritionist, Dr. Krakovitz, who helped me uncover a uniquely valuable pot of beans. I discovered that although I could do nothing to stop the seizures, I could do a lot to increase Joey's chance of surviving them.

Under Dr. Krakovitz's guidance, Joey received the most nutritionally balanced meals I could put on a plate. Different shapes, colors, and combinations of beans and vegetables were the major components of his daily menu, augmented with whole-wheat breads and frequent snacks of fresh fruit.

Prior to my talks with Dr. Krakovitz, the only beans I had ever eaten had been canned pork and beans. But when we had completed our first month on this vegetarian diet without a visit from the paramedics, it was enough of a hint of success to keep a pot of fresh beans brewing in our home every day. Since I had a slight tendency to overdo, I had shelves of every available type of bean, and all the information and recipes that went with them. Each tablespoon I conned Joey into

swallowing let me swallow a bit more confidence that I was at least doing something to block the doom I feared.

Along with the beans, Joey was given a daily dose of supplementary vitamins and minerals. He also swallowed a few teaspoons of things like chlorophyll and acidophilus, which I admit were a little strange; but I believe in starting with a complete program and giving it a fair chance before modifying it.

I always felt more comfortable taking a poll of medical opinions on any particular question about Joey before settling on a course of action. A good many doctors laughed about the beans, but Dr. Krakovitz was certain that Joey's only hope for health lay in discontinuing his seizure medication and focusing on his diet. Dr. Cokely felt that without this medication Joey might go into a seizure whenever he fell asleep. But without laughing she told me, "Beans do contain a lot of B vitamins, and studies are currently being done on the effects of these vitamins on seizures." So I settled on keeping the drugs in the bean program and increasing Joey's dosage of vitamin B.

I agreed with Dr. Krakovitz one hundred percent about the harmful effects of the drugs and the healthful benefits of his nutrition program; but beneath it all I knew that Joey needed the medicine and *I* needed the beans!

I could now see that close encounters with death were to become a way of life for Joey that his father, his brothers, and I would have to learn to live with.

Chapter 9

Forget This One

*...If I forget him, I may become like the grown-ups who are
no longer interested in anything but figures...*

CHRISTMAS was wonderful that year. Our last ugly hospital scene
was a fading, month-old memory. With Joey's beans, vitamins, and a
new seizure medication, we were all starting to feel comfortably insu-
lated from tragedy.

By New Year's Day I was also insulated with a few extra pounds.
Apparently I liked my bean recipes more than the rest of the family did.
So, while only half-watching the football game, I was setting up my
new 1980 calendar with schedules and goals, when Joey's leg twitching
distracted my thoughts of the future. For luck, we stuffed him with
anoush aboor, an Armenian mince-meat traditionally eaten at the new
year, and he was fine for the rest of that day.

This had been a "petite mal" warning; Joey had not lost conscious-
ness. But it cued us to tighten our slack in checking on him. Still, by
the last Wednesday in January, the month had proven to be pleasantly
uneventful, and I woke up at six-thirty in the morning without an
overwhelming compulsion to leap out of bed. I decided to sneak a few
tranquil moments of merely monitoring the typical morning commo-
tion.

Through the intercom beside me I could hear the activity in the
room shared by Marty and Joey. First Robbie checked Joey before
heading for his shower. Then Shawn entered to give Marty his first
wake-up call. These two brothers shared a similar physique, but Marty
tended to be more sluggish in the morning. This had been wearing on
everyone's patience, especially Shawn's. Since Robert had to leave the
house before seven-thirty for his tutoring, Shawn was responsible for

walking Marty to nursery school, and his morning was perfectly planned toward a seven-fifty-five departure. If he discovered that Marty was just arriving at the breakfast table at that time, the resulting uproar could set the whole family off on the wrong foot. Shawn fixed the situation by allotting Marty time for a five-minute wake-up stretch before pushing him to "hurry up." Marty's cooperation was probably improved more by the extra pampering than by the stretch.

I was enjoying my eavesdropping when Robbie entered the bedroom and reminded me, "It's seven o'clock. Are you still in bed?"

Before he completed the sentence, I got up to give Robert brief breakfast instructions before I moved on to the third bedroom. From the doorway I observed Shawn sweetly helping Marty choose his wardrobe, while Joey slept serenely on his side a few feet away.

I decided to let Joey sleep until I got dressed, but when I reached my bathroom I had a second thought. He was usually awake by seven. Having learned to be suspicious when Joey made even the slightest deviation from usual habits, I headed back to his room for a closer look.

"Joey's having a seizure!" I screamed after rolling him onto his back and exposing his quivering face. He had started into this seizure without any sound of warning. We had all been so close, and yet so unaware!

Sweeping Joey off the bed, I dangled his stiff body upside down to drain mucous and moved automatically toward the suction machine.

By now the word "seizure" was like an alarm that sent each of us scurrying to our respective battle stations. No one had ever assigned anyone a specific function, but as I connected a fresh suction catheter to the machine, eight-year-old Robert dialed 911 and succinctly reported our address and the reason for calling. "He's not breathing!" Shawn, then seven, rushed in with towels for the mucous and water for the suction machine. Half-shaven Robbie arrived to take over the suctioning while I slipped Joey out of his pajamas and tilted his head back slightly to help keep his airway open. Three months short of four and always taking his self-assigned role very seriously, Marty soon stumbled out the door shouting, "I hear the paramedics coming! Don't worry, Mom! I'll wait on the corner so they don't miss us."

The siren seemed to be in hearing range for hours before Marty came running back into the house trailed by two men.

By now most of the paramedic teams knew us. This one didn't, so I spouted a short medical history while Robbie and I continued our care.

"He'll have a respiratory arrest soon, so we need to transport him to the emergency room as quickly as possible. Could you set up your suction machine with a size 10 French catheter so we can make a quick transfer?"

One man left to ready the suction machine while the other knelt beside us. "You seem to have things under control. We won't interfere."

His words were intended as a compliment, but they did not settle well with me. I guess we had learned to handle these emergencies like a real medical team—block out all emotion and move toward the goal. We did this, and we did it well, but it was just an act! Inside, the real me was yearning to scream, "This is my son! I don't want to be his doctor, I want to be his mother! I don't want to be in control of what could turn into *my* tragedy any moment!"

To be a hysterical mom sitting in the waiting room seemed easier than being in control, but I had bypassed my ability to indulge in that luxury. I knew Joey needed me. He needed my suctioning and my puffs of air. He needed me to give the doctors his medical history. He needed me to show the nurse his best IV vein and save him extra pokes of the needle. If he awoke, he would need the comfort of my voice. And if he never awoke again, I would need the comfort of knowing that I had been there when he needed me.

I was called away from this emotional turmoil by the returning paramedic's shout of "All set!"

Robbie extended Joey's last suction before carrying him to the ambulance. Grabbing my purse and the bag of clothes the boys had put together for me, I dashed to catch up. I did not want to look back at the plea for attention written on the three faces I was leaving behind. They were breathing on their own, and I had to go with the greater need and make atonement to the neglected later.

After hopping into the back of the ambulance, I squatted in the small space beside Joey's stretcher. Following our routine, Robbie would stay behind to comfort the boys before sending them off to school and joining me at the hospital. We exchanged glances as the ambulance doors closed. Then, seconds later, the wailing siren was turned on and we took off for another wild, wobbly ride to the hospital.

"He's stopped breathing!" I announced as I swayed with the ambulance's first skid around a corner. I steadied Joey's head and began mouth-to-mouth resuscitation. The paramedic readied his ambu-bag while hollering to his partner who was driving, "Code blue! Step on it!"

"You suction, I'll take over the air," he said as we made a rhythmic transfer from mouth to bag.

I could hear the driver notifying the closest hospital of our status. His increased speed and preoccupation with the radio made me feel like we were riding in a high-speed Cuisinart. Despite the conditions, we managed to maintain adequate color in Joey's face.

The second the ambulance abruptly stopped at Marina Hospital, its doors opened. What followed was identical to television's dramatized emergency room entries: lots of people with sober faces swiftly manipulated equipment while exchanging questions and answers.

I knew the procedure so well that I blended right into the staff, even in my maroon robe. The doctor in charge of this particular scene did not voice any objection to my presence. Instead, he incorporated me into the crew with a share of questions and orders. I was always mystified by the various degrees of acceptance and rejection I would receive from doctors, and I was always apprehensive about it.

I froze when this doctor announced, "It doesn't look like he's going to resume breathing on his own. I'm going to intubate. Call for a portable X-ray machine and respirator."

My lips began to quiver as the doctor pried open Joey's mouth and inserted a quarter-inch tube past his esophagus into his lungs. They had to take several X-rays to place and then adjust the tube in the correct location. The standing end of the tube was attached to a large stainless-steel respirator, which made the sloshing sounds of a dishwasher as it transported air to and from Joey's tiny lungs.

Another set of tubes attached by suction cups to Joey's chest led to a cardiac machine, which monitored his heart activity. Bottles containing saline solution and phenobarbital hung upside down from what looked like a metal coat hanger. The bottles fed fluid and seizure medication through the tubes and a needle, directly into a vein in Joey's arm.

When this maze of tubes was properly connected and functioning, the tension seemed to relax and the number of hands on Joey decreased. The crew had done all they could. But Joey's little body continued to convulse.

"Well, I'd better go talk to his mother," the doctor said, obviously not too anxious to relay the news.

"I'm his mother," I mumbled.

"You're the mother? I thought you were his nurse."

I could tell he was sorry he had let me stay and unsure about why I

had wanted to.

"Does your son have a neurologist?"

"Yes. We called her from home. She was on the way to her office. She'll return the call when she gets there." I had barely finished the sentence when a nurse came in to tell us that Dr. Cokely was on the phone.

When the doctor left, I too started to wonder why I wanted to witness all of this. Petting Joey's head, I realized there was more beyond our need for each other that I had not examined before. I needed the stimulation of physical movement! I could shoulder a lot when I was moving from one instant to another. But if I was standing still with no way to escape full realization of the long-term implications of the crisis, it became too heavy! When circumstances stabilized and the outcome was relatively clear, then I could afford to stop and let unnecessary thoughts infiltrate my mind.

That infiltration began an hour later as I noticed that Joey's seizure was finally subsiding. Robbie entered the room, and I was about to tell him that the worst was over; but then Joey's body went into an even more violent twitching.

When our son passed into his third hour of unrelenting convulsions, I felt my confidence in his future fading rapidly. There were numerous phone calls exchanged between our emergency room doctor and Dr. Cokely, resulting in overdose amounts of medication penetrating Joey's IV. But his convulsions continued.

Since Joey's eyelids had ceased to lubricate themselves as they should, I stood at the head of the gurney and massaged his staring eyes. Then I allowed entrance of those familiar, haunting words to my near-panicked mind. "He could seize right into death."

I rushed from the room, swiped the admitting nurse's phone without permission, and called Dr. Cokely again. By the time she answered, I had reached full panic. "He's been seizing for three hours! His eyes are frozen in a fixed stare, and his whole body is jerking! It's never been this bad! Is he dying?"

"He's not dying!" she stated firmly. She continued speaking, but I didn't hear another word of what she said. I needed her initial sentence to keep pounding into my throbbing head.

Each hour I made a similar frantic call to Dr. Cokely. I wondered later whether my comfort came from her strengthening words or my brisk walk to the phone.

The emergency room doctor was not as confident of Joey's survival as Dr. Cokely was. He returned to the room after several of his medication consultations, and his lips were laden with perspiration when I heard him say, "I've never seen anything like this!"

By the fifth hour my panic had calmed to a silent depression. Through eye communication, Robbie and I admitted that we had lost the Joey we had tucked into bed the night before.

Dr. Cokely finally asked the doctor to try an anticonvulsant drug that could be given rectally. The paraldehyde enema successfully brought stillness to Joey's body—after *six hours* of an adult-strength grand mal seizure!

Everyone seemed relieved, but no one knew how far out of the woods we were. Marina Hospital did not admit critical pediatric cases, so while arrangements were made for a medical team from UCLA to transport Joey to their intensive care unit, I took a break to dress and disguise my emotions with a rosy blush.

Robbie was needed on the set of *The Karen Carpenter Story* to supervise a critical late-night shooting schedule. Having recently purchased a beeper for our emergencies, we agreed that I would contact him about any changes during the rest of the day, and that he would relieve me early the following morning. Robbie always shied away from emotional discussions, but when he was reluctant to release my hand, I knew our thoughts were together. As I watched him leave, I noticed that his thinning hair actually made him look even more handsome; or maybe it was just that over the years I could see more to love!

The ride to UCLA was considerably smoother since the ambulance was equipped with the staff and equipment of a mini-hospital. The team surrounded Joey's stretcher like a swarm of guardian angels as we marched down the UCLA corridor to ICU.

Saliva was oozing from Joey's mouth and loosening the tape that was holding the respirator tube in place. Noticing that Joey was stirring to regain consciousness, I assumed the function of the tape until the supervising doctor of the team asked me to drop back a few steps and help him complete his medical history form.

"Sure, but this tape is coming loose."

"Don't worry, the respiratory people will watch it."

I stepped back with a convinced "Okay," but Joey's guardians had become a little overconfident of how smoothly we were rolling along. Just as I started to answer the doctor's first question, Joey produced a

hefty cough, which ejected a major portion of the tube.

In the past I had felt blessed whenever Joey succeeded in spitting out the tube. It usually meant he could breathe on his own. This time the blessing was short lived. The doctors felt that his breathing was still too irregular to be left unsupported. As they shoved him into the closest room, I heard, "We'll have to intubate again."

I dropped myself heavily onto a chair across the room from Joey. My eyes then flashed to a picture that I would never be able to purge from my memory. Joey had regained enough consciousness to know he did not want the tube reinserted and, as usual, he intended to be heard. His angelic support team took on a more fiendish appearance as they tried to clamp Joey's body to the table. Even in his semi-conscious and totally exhausted state, he mustered a tremendous amount of resistance, making it difficult for six pairs of hands to hold him down.

"I can't get the damn tube in if you don't hold him still," the doctor shouted. I recognized his guilt and frustration from my gavage days.

From across the room I could feel the presence of that familiar headstrong character who had miraculously but undeniably survived the morning. Yet my joy for Joey's survival was dimmed by the sight and sounds of what he had survived to face.

One of the nurses sat down beside me, and we exchanged nonchalant bits of conversation while inside I churned with anguish. Then a tall, dark-haired intern entered, briefly observed the torturous scene in the corner, and, sorrowfully shaking his head, turned in my direction.

"Are you the mother? Considering how calm you are, you must have been through this before. Do you have other children?"

After three consecutive yeses, he compassionately continued.

"Listen, I've worked with these kids and their parents. I know what you're going through. For your sake, and for the sake of your other children, forget this one!"

I was unable to respond when he departed, still shaking his slumped head. His compassion was deeply sincere, but his understanding was incredibly shallow.

I looked across the room at the child he thought I could so easily discard, like one bad bean in the pot. How I wished it were that easy to release myself from the burden! But we were too tightly bound by that highly potent emotion of love.

When the tube was victoriously in its place, the sober parade to ICU continued. Before catching up with it, I made a few phone calls to

Robbie and our other anxious relatives. As I spoke to my sister I could tell from the boys' gleeful voices in the background that she was providing her usual bounty of gifts and goodies—overkill ran in our family.

Throughout the afternoon Joey slowly regained consciousness and struggled to escape his binding tubes. His big eyes resembled those of a frightened, trapped deer. Afraid that I might not be able to calm him, I started asking as many yes-no questions as I could think of. Finally, I hit home. "Are you upset about not being able to make any sounds?"

His struggling ceased, and tears streamed from both our eyes before he nodded his yes.

In the months prior to this hospitalization, Joey's pride in learning to say "Mom" had led to his successful mimicking of other sounds and partial words. But now the respirator tube in his throat took away even his ability to grunt. Clutching his hands and reading his eyes, I could feel the overwhelming devastation of his inability to communicate!

"Don't worry, you can't make sounds because of this tube. As soon as you're stronger, the doctor will take the tube out and you'll be able to talk again."

Spurred by his terror, I continued to chatter incessantly for hours, trying to express whatever thought or answer whatever question might be passing through his mind. Eventually the fear, which I had never before seen in Joey's eyes, faded to his normal inquisitiveness. My sorrow only seemed to become more intense.

By late afternoon, Joey was able to pull out his tube again. This time he was pronounced fit enough to breathe on his own. But contrary to my promise, irritation from the tube left him with laryngitis, which prevented him from vocalizing more than a weak whine.

I continued my consoling and reassuring until Joey reluctantly fell asleep for the night. Then I leaned against his bed and propped my head in a position that allowed me to become entranced again by the rise and fall of his chest.

I was not sure how long my trance had lasted; then a nurse walked over to check Joey's IV bottle, and I hesitantly reported, "I know this is crazy, but I think he's been skipping a few breaths. I'm really tired; I'm sure my eyes aren't functioning too well."

She did not listen to the disclaimers I attached to my discovery, but watched Joey intently. Then, with a "You're right!" she darted to her desk to phone the doctor.

I felt a wave of nausea come over me as I heard arrangements being

made for Joey's third intubation, this time under full anesthesia so that he wouldn't resist or try to remove the tube. My hand shook with uncertainty as I signed the consent forms.

It was close to midnight before the medical troupe withdrew again. I stared in a stupor at Joey's anesthetized body and tried to sort through all that had happened that day. It all seemed so unreal. I desperately wished it could be only a nightmare, but that ugly respirator kept asserting its reality with its obnoxiously loud noise as it pumped life into my son.

Once again we had taken one step forward and two back. In my mind I pictured myself stripped of all my bean-padded hope, huddled in a corner screaming, "I don't want to be right, I want to be crazy! I want a warm binding jacket, a dark room—peaceful solitude. Nothing to do but sleep. No responsibilities, no problems, no pain, no pressures, no Joey!"

No Joey? At first I was startled by my escaping subconscious thought. Then I just stared at Joey's beautiful face and contemplated how easy life could be without him!

No! After laying out the pros and cons of having Joey in my life, the thought of losing him was worse than the pain of watching him suffer. Strangely, though, I felt very relieved by having thoroughly examined the situation.

By freely facing my hidden feelings, I regained a sense of being in control of the course my life was on. It jarred from my memory a story related to me by a mother I had met once while shopping; she had recognized my infant's problem and stopped to share a moment in her life. When she had been given the news that her newborn child had Down's syndrome, she had spent most of the tragic day in tears. But then she asked herself, "Do I want to keep this child or institutionalize her?" For the remainder of the day she had considered a lifetime of pros and cons, then concluded, "I'll keep her!" With a wink and a twinkle in her eyes, she had walked away from me that morning saying, "And that has made all the difference."

I now understood why! As Joey continued his determined struggle against impossible odds, I knew we would continue to be there with him—because we *chose* to be there. Forget this one? It was impossible—he was our rose.

Chapter 10

Ahead with Horses
and Husbands

One must require from each one the duty which each one can perform.

AFTER a week of intensive respiratory therapy to open Joey's swollen airways, Robbie and I drove home with our son, who now had statis epilepticus added to his list of diagnoses. The label sounded less threatening than its meaning: uncontrollable seizures.

We were certain that Joey's intellect had remained intact, even though his ability to speak had been nipped in the bud. Had more damage stricken the speech area of his brain? Had his vocal chords been injured by all the forceful intubations? Was he merely stripped of his normal motivation? All the questions were, as usual, wrapped in "wait and see."

As I studied the innocent face of the child I cradled, I realized that my belief in life despite its problems had been shaken by this last seizure. I was not sure I should be as happy as I used to be about Joey's survival. Would he be able to recover enough strength before the next seizure? The seizures had a history of increasing severity. How could he top this last one and live? I still could not tolerate the thought of losing him, but now I was painfully haunted by the ugliest question: Had he survived only to die a more difficult death tomorrow?

When we saw our home and Joey's brothers running to welcome us, I was grateful that other responsibilities would limit my time to contemplate the unanswerable. Still, I knew it would be necessary to limit thinking time even further by increasing my involvement in some other areas as well.

One addition to my schedule, which I also hoped might strengthen

Joey's stamina, was a non-profit program appropriately named Ahead with Horses. The program, directed by Lou and Liz Helms, managed to survive on scant contributions in order to transform physical therapy for the handicapped into horseback vaulting exercises.

During our hospital stay, a friendly respiratory therapist had introduced us to the idea of equestrian therapy. She told us that European therapists had found it to be emotionally and socially therapeutic. I could see how a child would enjoy being outside on a horse, and I needed to see a lot of smiles on Joey's face to compensate for all the suffering I had seen there.

I was anxious to try this new technique, but I was slightly apprehensive when I arrived at scenic Will Roger's State Park for our first lesson. Since no degree of handicap was too much for Liz and her horses to take on, I handed her my floppy Joey and pensively watched his face for his reaction to being placed on a horse.

"He likes it!" I blurted out, feeling like one of the kids on that television commercial.

With a delighted grin, Joey instantly recognized he was on top of something big, something he had the potential to control. With Liz charmingly giving instructions from the ground and her assistant straddling the horse's rump in case Joey lost his balance, Joey exceeded his standard five-minute attention span and cooperated for the entire half-hour session.

Riding lessons soon became the main attractions of our week. Joey was given a uniform, and he was soon able to follow directions for simple vaulting exercises. In the year that followed that first lesson, he performed at several county fairs and appeared on a segment of television's *Real People* where he demonstrated his ability to crawl up the horse's neck and touch its ears.

In addition to lengthening Joey's attention span, our involvement with Ahead with Horses brought tremendous psychological benefit to our whole family. It helped us live with our little time bomb, who still sent us on frequent emergency rushes to the nearest respirator, by helping us focus on the quality rather than the quantity of his life. A quality life has to be filled with fun. We can all push beyond our abilities when we are doing something we enjoy!

When Joey was mounted on a horse, we could see on his face how he loved performing and, because of that, we loved watching him. His pride of accomplishment beamed through his smile, spilled over onto

us, and shifted our attention to all that Joey *could* do.

There is a need in each of us to demonstrate our abilities and receive recognition. Just as his brothers had their moments on the soccer field, Joey had his on a horse. He could now do something a lot of normal children could *not* do.

Since the horses showed us that Joey responded to fun, if his attention span was to lengthen, we had to increase his opportunities for other amusing activities.

Generally, children are entertained with toys. However, it took two or more assistants to enable Joey to play with even the simplest object. Someone had to hold his body while someone else held the toy. Even then his poor coordination made the play not worth the effort. I was convinced that the right equipment could compensate for any lack of muscle tone. Unfortunately, however, inventing and marketing playthings for the handicapped is too individualized and too limited in potential profit to attract the minds that could make the difference.

I never passed a children's store without entering, in the hope that I might find a toy that could easily be modified for Joey. I excitedly purchased anything that had the slightest potential, but I ended up with nothing but closets stuffed with trinkets that couldn't match up to his ability. I often felt like a child who hadn't grown up, trying to mother a child who couldn't!

One morning I discussed my frustration with Robbie, and was pleased by his eagerness to help. I had never seen him pick up even a hammer before, so when he headed for the garage, I was not very confident of what he might produce.

Robbie always had minimal patience for feeding Joey, yet he spent innumerable hours in the garage until he finally emerged with a way for Joey to play.

The invention looked like a simple bench, but customizing the bench to suit Joey had not been easy. Robbie had studied his son until he realized that Joey had better control of his head when he was kneeling. The bench's height had been adjusted accordingly, and a two-inch lip had been added across the front, for Robbie had discovered that this would enable Joey to stabilize his body with his elbows. After drilling assorted holes, Robbie attached shoestrings to tie various toys to the back of the bench. The tiny loops on pull toys were replaced with large dimestore bracelets that Joey could grasp, and all sharp edges were padded before we placed him in front of the finished product.

It was a marvelous moment as we watched our three-year-old son independently and successfully manipulate his first toys. When Robbie knelt down to play with Joey, I noticed the similar expressions of pride on their faces. I guess the desire to help can be equal in parents; it's just the area of ability to do so that differs!

Robbie's benches and the numerous additional aids he was able to create with his unskilled hammer convinced us even more that one can bridge a lot of developmental gaps with the right equipment.

Joey's excitement with the horses and with a small foot-propelled car to which we attached Robbie's modified wooded seat showed us that our son's greatest interest was anything that could give him mobility. So our ears perked when Dr. Howard and Ann, the physical therapist at UCLA, told us about a weight-relieving walker that was being developed at the research center of Stanford Children's Hospital. It sounded like a real door-opener for Joey.

My mother-in-law and sister volunteered to watch the three oldest boys so that Robbie, Joey and I could go to Stanford to see the new walker, and for weeks we looked forward to our trip. Our anticipation was boosted by the blind hope that Joey would be strapped into this walker and—bingo—he would walk. Realistically we knew that would not happen; but emotionally, walking was a hard hope to squash.

Robbie had just finished Tammy Wynette's story, *Stand by Your Man.* So we decided to add a little frosting to the trip by including a romantic detour through San Francisco. It looked as though a perfect weekend lay before us; but when I aimed for perfection, I usually fell a little short.

Plane and car rental delays made us long overdue for lunch, but we decided to pass on all snacks, as we did not want to spoil the succulent binge we had planned at one of Sausalito's famous restaurants. Hunger must have blurred our thinking, but we didn't realize this until the hostess had seated the three of us at a table in the center of the room.

Our Joey was not the typical patron of this sophisticated childless eatery. We could feel the horrified eyes upon us as we struggled to strap our twisting, toneless son into a highchair. More silence surrounded us as Joey accompanied his tray banging with his unique whining. I tried to pacify him with bits of cracker, but I knew he did not intend to eat anything without hearing the tape of his favorite song, "The Wheels on the Bus."

Robbie slowly lowered his menu and leaned across the table to

whisper, "I think we should have gone to McDonalds."

"You order. We'll each take a turn eating while the other pacifies him in the lounge," I concluded.

Starving, Robbie gave me a relieved nod as Joey and I made a quick but much-noticed departure from the table.

In the restaurant's lounge I found a very dark unoccupied corner with an overstuffed couch, and I balanced Joey in a standing position on my lap while he fiddled with a large bronze statue on the shelf behind us. Then, without warning, he arched his back and dislodged the statue that I had thought too heavy to move.

When I regained consciousness, we were on the floor. Blood was streaming down my face, and Joey was shrieking. At first I tried to talk him into silence while I searched for a pressure bandage for my head; but when I couldn't even find a used kleenex in my purse, I joined him in a good cry.

Meanwhile, Robbie had just taken his first bite of steak when he heard the sobs, and once again he felt the pressure of those surrounding eyes. They all knew whose responsibility needed attention! Robbie reluctantly left the table, but he quickly lost his appetite when he found us on the floor.

The paramedics arrived shortly, and our embarrassment grew beyond the possibility of returning to our meal. After spending the rest of the afternoon in the emergency room patching my head, neither of us regained our desire for food or passion.

However, after being heavily sedated with pain medication and settling into our hotel room in Stanford, it became easier for me to forget this flawed day and think about the excitement of the next. With a change of focus, I fell asleep wondering where a three-year-old child would want to go when first given freedom to move on his own.

In the morning, before Joey was fitted for the walker, we had an evaluation appointment with Dr. Bleck, the orthopedic specialist. Although Dr. Bleck doubted that Joey would ever be able to walk, he recognized the unusual twinkle of determination in our son's eyes. Dr. Bleck concluded that it would be a good idea to put Joey in this weight-relieving walker as often as possible, and see what would develop.

The four-wheeled metal frame we eventually saw had a center ring that was fastened around Joey's chest with velcro and connected to a padded bar that extended between his legs. Suspended by a screen-door

spring, this apparatus eliminated the need for most of the muscles nor-mally involved in walking by holding Joey in an upright position. Only minimal leg movement was needed for him to move forward.

After hours of adjustments, I witnessed the surprising answer to my previous night's question. Strapped into the new fully supportive walker and all hands released, Joey pushed off on his trip down the hall. Building momentum, he lifted his legs and let the walker make a glid-ing crash through a bathroom door. Before I could intervene, he hur-riedly wiggled his way over to flush the toilet!

Prior to leaving us alone, the doctor hinted that we should try to get our son into more appropriate practice, like walking the hall. Robbie and I attempted to redirect Joey's interest, but he kept lingering by the bathroom until we finally agreed to let him enjoy a few more flushes. In all the experiences we had tried to supply him with, we had completely overlooked a child's typical infatuation with the toilet. In an effort to cover all the bases, it is sometimes easy to slide past first.

Late that evening I was rocking Joey to sleep and talking aloud. "While I was thinking of the big complicated things you were being deprived of, you just wanted normal toddler toilet play. I guess today was a pretty clear sign that you're ready to start training. But am I?" I paused to reflect on our past attempt at toilet training. "How are we going to stabilize you on a toilet? How are you going to let me know when you have to go?"

It was then that my unsuspected listener interrupted with a grunt and pointed to his crotch.

"You want to use that as the sign for toilet?" I asked, surprised that he had been in on my conversation with myself. When he nodded yes, I knew his readiness was definitely too clear to avoid.

Nothing about this Stanford weekend had matched my expecta-tions. It would probably take years of practice for Joey to properly mas-ter his new walker, but the trip had opened the door for big steps in the more important directions of toilet training and communication.

When we returned home from Stanford I solicited the help of the UCLA therapists in order to find Joey a handicapped toilet that would support him better than the one I had already tried.

I was very pleased with Joey's ability to create his own sign for toi-let. It indicated the area in need, but since it was a little crude, I de-cided to ask Kit for the real toilet sign. Communicating with sign lan-guage had not been considered possible for Joey because of the ex-

tremely limited function of his hand muscles. But anything was worth one try!

"Joey, this is the real sign for toilet," I said, and I demonstrated a rotating fist with the thumb sticking out from between the folded fingers. He was obviously interested, and studied his own hand carefully after watching mine. He tried, but was unable to maneuver his fingers anywhere close to the proper sign. Not wanting to push for something too far beyond his ability, I planned to continue with his self-created sign. But in the weeks that followed I frequently saw him studying his hand intently. Finally I guessed, "Are you trying to learn the sign for toilet?" The nod was affirmative.

With minimal assistance and months of practice, Joey proudly demonstrated the correct toilet sign. We were all very pleased with his accomplishment. He alone loved the instant response his frequently used sign elicited from me! Being slow to outgrow his love of toilet flushing, he would only release small amounts of urine at a time. Thus he could increase his number of legitimate visits to the bathroom. Although I grew very tired of the trips, I felt it was important to placate his tricks in order to increase his desire to communicate other demands. Why talk if no one is going to respond to what you say?

Throughout our years with Joey, we had been forced to accept that walking, talking, playing, and good health are not standard equipment for all children. We also came to see that our stripped-down model had an unbelievable determination to live and to control people and things within his environment. His tremendous drive would always propel us to find ways he could fulfill that desire for control. But the greater task of finding ways he could communicate his feelings and make friends was still far ahead.

Dealing with Death
on the Doorstep

At some moment or other one is absent-minded, and that is enough! Or the sheep got out, without making any noise in the night.... Nothing in the universe can be the same if somewhere, we do not know where, a sheep that we never saw has—yes or no?—eaten a rose....

WHEN we returned from our Stanford trip, we discovered that our well-balanced four-year-old had acquired a bedtime problem. Each night we were away, Marty had informed my sister that he was afraid to fall asleep and needed her presence until he succumbed.

At first I thought the answer was simply Joey's absence from the room. "I bet you were afraid of being alone. Now that Joey's back to sleep with you, I'm sure you'll be fine."

"No, it's not safe sleeping with Joey."

"Why?" He had never mentioned this strange feeling before.

"Handicapped kids can't protect you if a robber comes into the room."

"Are you afraid a robber will come?"

"No."

"Then what are you afraid will happen?"

"I don't know."

For weeks I sat with Marty until he fell asleep, trying to get to the core of this newly developed fear. He came up with an assortment of responses before he finally blurted, "I bet I'm going to have a fever tonight."

I laughingly assured him he looked quite strong and should be able to repulse any germ attack.

"No," he continued, trying to mimic my laughing attitude, "I might have a fever tonight and roll out of bed and have to be taken away by the paramedics!"

The lightness left my voice. "If you have a fever, I just need to give you a little Tylenol. You *won't* roll out of bed and the paramedics *won't* need to come."

Then came the answer, "When Joey has a fever, the paramedics come!"

Marty had mispronounced the word "seizure," and no one had bothered to correct him. Since he had never asked any questions, I had assumed that our basic explanation of the phenomenon of seizures had been sufficient. After a belated but lengthy discussion of how he could get fevers but not seizures, we did not have any future bedtime problems with Marty. Joey, however, would soon add new dimensions to my description of fever.

In April Robbie started pre-production of *Crisis at Central High*, the true story of the conflict that led to the integration of an all-white high school. He was going to shoot the film on location in Little Rock, Arkansas, during the summer. Since he was able to find a hotel for the crew a few blocks from a hospital, he made arrangements for the four boys and I to travel with him. The excitement of planning kept me in high positive gear for the two months prior to the trip. My mood was also bolstered by an unexpected lack of seizure activity from Joey.

A week before our departure for Arkansas, I was alternating packing with keeping track of Joey. One check found him playing with dishes at his toy bench. Three minutes later he was lying on the floor with his jaw tightly clenched and his teeth chattering. Every muscle in his body seemed stiff, and his hands and feet felt like ice cubes. He appeared to be on the verge of freezing to death!

Convinced that this was a new type of seizure, I wrapped Joey in a blanket and ran to the phone for insight from Dr. Cokely. She didn't think that what I described was a seizure, and she advised taking his temperature, then having him seen by his pediatrician right away.

Before I was able to call the pediatrician, Joey's stiff shivering subsided. Yet his breathing was extremely labored, and his heart was beating too fast to count his pulse. The pendulum had swung in the opposite direction—his body was boiling!

I broke into a cold sweat, and had a hard time holding the thermometer still enough to see at what temperature the little dark line had

stopped. Then I realized the line hadn't stopped! It had filled the thermometer; Joey's temperature was over 108 degrees! I dropped the thermometer as if I felt the heat, and started ripping off Joey's clothes while audibly praying, "Please, someone, help me!"

As usual Robert, Shawn, and Marty scurried from various locations with their extra hands. With record speed we put Joey into a tub of water and dumped high doses of crushed aspirin and Tylenol down his throat. To avoid the sudden shock to his burning body, I slowly converted the trickle of lukewarm water to cold.

After half an hour Joey started to resemble a normally ill child, so I braved another look at the thermometer. As I waited out the four minutes, I chanted, "Please, God, let it be 105."

The boys let out a cheer when I announced, "105.5! We'll take that!"

"Should I call the paramedics, Mom?" Robert asked.

With a slightly relieved laugh, I realized we had not thought to seek help. "I think we've passed the crisis. We can take him to the doctor ourselves. You boys were more help than the paramedics would have been." It was difficult for us, but even more difficult for strangers to acclimate themselves to Joey's sudden extremes.

Dr. Cobley found no sign of infection that day, and by the next day Joey was back to his usual state of health. The pediatrician and the neurologist each felt this new problem fell under the other's jurisdiction.

Robbie, who tends to avoid considering the negative until it hits him in the nose, decided we should take our trip to Arkansas as planned. He has always been able to put these puzzling situations behind him before I finish examining all the pieces. I'm never sure whether he thinks he has solved the problem, or whether he is certain it will solve itself. But I agreed it would be easier to pack the additional unanswerable questions with the other "wait and see" mysteries and leave for Arkansas on schedule.

Tucked into the hills outside Little Rock, the boys and I found a new and little-used amusement park. With no lines, we hopped from ride to ride as if we were in our own back yard. We became daily visitors for the duration of our trip, because I also found that it is hard to worry about impending doom when you are constantly zooming down a water slide in a log!

To our advantage, we were beginning to cram more family fun into

the intervals between our traumas. This helped to ease our transition into Joey's new fever problem.

During our southern summer we were spared the upset of Joey's seizures, possibly due to his latest medication, Klonopin. Instead, we were dealt a mysterious temperature crisis every couple of weeks. With time and experience, I learned to give double doses of aspirin and Tylenol as soon as the chills began. Then by the time Joey switched to the opposite temperature extreme, the medication would have been in his system long enough to keep the mercury from rising above 106°.

The situation did not always run smoothly. Sometimes the chills would last for more than three hours. Many evenings Robbie and I would wrap Joey in blankets and sandwich him between us to create additional warmth until it was time to transfer him to a cold bath. Other times the crisis would come in the middle of the night. I would abruptly wake with the realization that the breathing I heard on the intercom was too fast. Frantically we would dash to Joey's room and grab his barely breathing body for the cooling process. All the while I wondered, if I hadn't wakened, how high would the temperature have gone, and how long could it have stayed there before Joey suffered more brain damage or death?

Once, when we had asked for an estimate of Joey's life expectancy, a neurologist had responded, "He could go into one of these seizures any time, day or night. You couldn't possibly catch every one in time, unless you kept a twenty-four-hour guard over him. Even then, it only takes one oversight. I wouldn't plan on his living too long!"

I never asked for another such estimate after Joey's temperature problem had begun. I had already learned the only answer from Robert and Shawn, back when I had had to clear two other hurdles in my life, the tube and smoking. "Just don't think about it," they had said. It was much easier to avoid thinking about words I had never heard.

Just as Joey's survival of frequent medical emergencies was miraculous, our awareness that he had started into one also showed signs of being more than coincidental. Joey entered many of his seizures and fevers without an auditory cue reaching anyone's ears. Often we just discovered the problem during one of our routine checks.

Then, too, there was always the question of how much he had survived without our knowing it. We lived in constant fear that just once we would find him after he had passed the point of no return. It could happen so easily! Robbie could be on the phone, I could be involved

with the boys' homework, and ten minutes with nobody checking Joey could whiz by in an instant.

After considering the stress, expense, and security of hiring around-the-clock nurses again, Robbie and I decided we would rather do the best we could within our family. Besides being an invasion of our privacy, nurses in the house would be a constant reminder of the likelihood of a death in the family. Our main survival tactic was to ignore this possibility. Having nurses around would be like trying to diet with an open box of See's candy on the kitchen sink. Even if it meant shouldering the guilt of not knowing whether we would discover an emergency in time, we wanted to live in a home, not a hospital!

The best way to ward off the guilt of possible slips seemed to be to remain as prepared as possible. Emergency numbers and information were prominently posted. Everything we might need for any type of problem was kept well stocked, in working order, and readily available. Checking Joey's medicines and machines became an automatic daily routine for me, and checking Joey became our family's alternative to television commercials.

Since the seizures began, we had been experimenting with a wide variety of apneic monitors. Our best solution for the night was a portable intercom kept as close as possible to Joey's face. This intercom magnified any alteration or cessation of Joey's breathing, and relayed it to its mate on my nightstand. In time, we managed to get up most mornings with an adequate night's sleep behind us, despite intermittent startled arousals or rushes to Joey's room for reassurance or action.

In addition to what could strike Joey, we also had to worry about what he might hit. Joey's confident attempts to stand up by himself were miles ahead of his ability. His inability to put his arms forward to protect his falling body meant that even simple falls could result in serious injury. We padded a major portion of our home and put a guard on Joey almost around the clock, and thus we spared ourselves a lot of emergency room visits. But when the inevitable unblocked fall from a standing height occurred, we were into Shawn's league of head injuries.

I was almost ready to call the boys for dinner when I heard the thud. I waited for the ensuing cry, but I knew what had happened when Robert's horrified "Mom!" reached my ears even before Joey was able to expel a scream.

Severe head injuries always produce a tremendous amount of blood, and an equal amount of fear that it will never stop flowing. Joey's head

injuries carried the additional apprehension of "more problems." Once again on the verge of panic, I piled the four boys into the car and began the tense drive to the emergency room.

To help ease the jitters, I coaxed them into chanting simple songs, and alternated verses of "The Wheels on the Bus" with medical instructions. "The Roberts on the bus, they press on the head.... The Shawns on the bus, they keep his arms down.... The Joeys on the bus, they hold so still.... The Martys on the bus, they stay so silent."

Even though Marty was always willing to help, he was too young to be actively involved in actually handling the problem. I only included a verse for him to avoid hurting his feelings by exclusion.

I appreciated what a well-rounded emergency team we had become when I started to herd the boys out of the car and into the hospital. Marty touched me with his sincerity when he said, "Mom, I want you to know that I wasn't just silent. I was doing the praying."

When Robbie joined us at the hospital, we all enjoyed a replay of Marty's transforming words. Afterwards we stopped at an ice cream parlor on our way home with our sutured Joey.

Despite all my preparations and my uplifting moments with my sons, I lived through hundreds more emergencies than Joey actually experienced. I often remember an observation made during one of our mothers' meetings at UCLA by the program's social worker, Nancy Miller. Since the UCLA prosthesis department was next to her office, she had noticed that the parents of amputee children had significantly less difficulty adjusting to their handicapped children than did the parents of the developmentally delayed. She attributed this to the fact that whether their tragedies occurred at birth or by accident, the amputee parents knew exactly what was lost and what remained. Parents of developmentally delayed children had to continually combat their fears of the unknown, fears that could add up to a lot of unnecessary suffering.

I had always known that death eventually catches us all; some just have the potential for darting into it or away from it more quickly. But I never imagined that it could just sit on my doorstep. I had to acknowledge that it could intrude into my life each day when I checked to see if Joey woke or went to sleep.

Every time death brushed too close, I pushed more diversion into my life in order to keep the door shut. Joey's brothers had to go to school, and his dad had to go to work; but I had to go with Joey most of the day. Accidentally, I had begun to realize during our traumatic

times with Joey that you can leave a lot behind you when you're moving. I had dabbled in exercise before, and it had seemed to be even more of an energy-releasing diversion than my beans were. Now I needed to make it a full one-hour per day commitment.

It was easy to decide what I wanted to do, the difficulty was in deciding how—a realistic, workable how. I had to experiment with a variety of forms of exercise until I found the fun model I could pick up like a toothbrush. In the beginning it was bike riding and aerobics, then jogging and Jane Fonda, then weights and walking. Exercises were like diets: The variety was endless, but they all had the same requirement for success—stick to it! Luckily, I got a lot of glue from a new quote which I added to the collection I had magnetized to my refrigerator:

Fate is what life gives to you. Destiny is what you do with it. If you are 5'4", you ain't ever going to be 6'2". If you have trouble putting the cap on your toothpaste tube in the morning, mechanical engineering is not for you.

That's fate.

But the way a person accepts the things he can't change and then goes 105 percent for the things he can, that's destiny. What most people tend to forget is that we have unbelievable control over our destiny.

Words, Bill Gove

I had always wondered if all those goons robed in floppy suits and Indian headbands jumping up and down in crowded rooms and racing around on the streets knew something I didn't. When I became one, I discovered they did—they got more than sweaty! They got a more handsome and healthier-looking body. They got the refreshing release that comes from physical exhaustion. They got renewed strength to endure or improve their lives. When I joined them, I got these things, too. Once I persevered until I got hooked on the highs of exercise, I *made* the time I thought I did not have!

After I made the commitment, Marty helped to eliminate the guilt I felt that my exercise time might be better spent on something or someone else. It happened one day when I had left the housekeeper on guard duty with Joey and was just about to embark on a bike ride with Robert and Shawn. My four-going-on-forty son decided to ask for my help in setting up a lemonade stand.

"I can't help you now, Marty," I said. "I have to get my exercise in before the day ends. I'll help you tomorrow," I added after seeing the disappointment he walked away with.

Hiding my feeling of impropriety, I slipped on a sweatshirt and herded Robert and Shawn toward the bikes, which were stored in the back yard. When we reached the front of the house, we saw forlorn Marty wearing his favorite overalls and standing beside his overturned wagon, which supported some paper cups and a pitcher. He already had the stand, he just needed the lemonade.

I rode off anyway, consoling, "Don't worry, Marty, I'll make some lemonade for you when I get back."

Robert and Shawn followed with, "And we'll buy some from you."

Behind us, we heard a casually confident, "Never mind. I decided to sell water instead."

The boys and I exchanged grins and a mutual commitment to get back and lend a hand before sunset. Nobody would buy water, especially after dark at the end of our unlit cul-de-sac.

Unfortunately, however, we had forgotten about the switch from daylight savings time back to standard time, and sundown came sooner than we expected. We pushed the pedals to get home, but we couldn't beat the falling sun.

I was really sick when the scattered remains of the stand became visible and Marty was nowhere to be seen. He had obviously suffered a devastating defeat in his first business venture because his mom was out riding *her* bike instead of supporting him. We sprinted inside and found Marty slouched into a chair, wearing his typical sober face while engrossed in a television show.

"Marty, I'm so sorry we didn't get back in time."

"That's all right," he said without even a tiny tang of any emotion.

I knew it wasn't all right. I was sure that it was sorrow and not the TV show that kept him from looking at us. As I tried to think of a way to heal the wound, Robert thought he'd give it a try. "Did you make any money?"

Tending to think alike, both Shawn and I gave Robert a glare of disapproval. That was not the question to ask, since we all knew we were Marty's only hope for making money. But before I could supply a buffer for the question, I heard the nonchalant answer, "Oh, yeah, I made lots of money."

We maintained silence and frozen expressions as Marty overturned

his paper cup and counted two dollars and twenty-five cents worth of coins.

"Where did you get all this?" I gasped.

Still without a change of focus from the television, he casually described the assortment of neighbors, repairmen, and joggers who had passed by his cup.

The suspense just kept rising, "How much did you charge them for the water?" I asked.

"Any kind of money but a penny."

Never having doubted himself, Marty continued to watch the show, and Robert and Shawn began plotting a similar stand for the next day. I headed for the kitchen to fix dinner with dazed uncertainty. Maybe my children didn't need all the support I thought they needed. Maybe my exercise time generated more for all of us.

Later we milked many moments of laughter out of Marty's success story. So much emotional upheaval had been crammed into the years since Joey's birth, and we had all survived more than I ever thought we could, primarily because we always strived to create enough joy to compensate for our close encounters with death. We had learned how to release steam and face the fear of one day being absent-minded. We dealt with our problems as a family by feeding off each other's strengths, running and filling our free moments with fun.

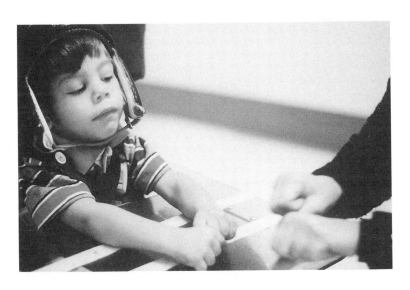

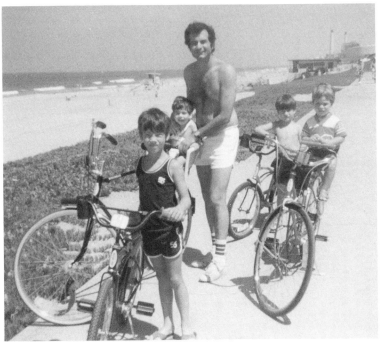

Above: Joey learns the sign for "more" (1980)
Below: Bikeriding at the beach (1979) with Robert (8), Shawn (7),
Marty (3), and their dad

Facing pages:
Growing up with Joey,
the Papazian brothers
in 1978, 1979, 1981,
and 1984

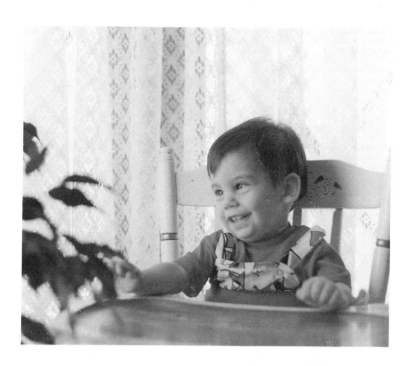

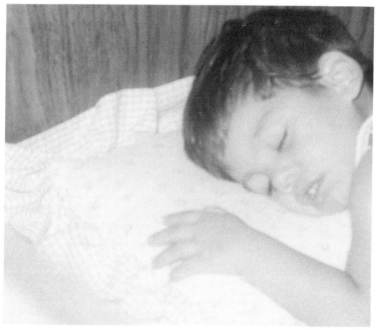

Above: Joey on his first birthday (1978)
*Below: Our "perfect" Joey, age 2, napping after an eventful morning
at the UCLA Intervention Program*

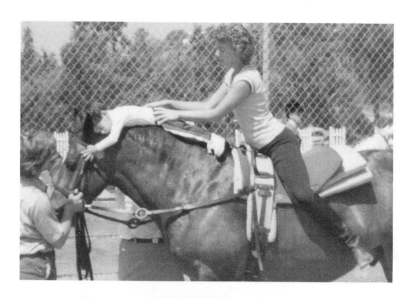

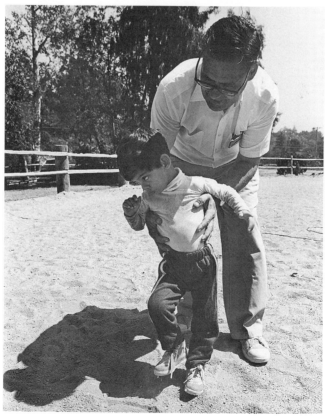

Joey in the Ahead with Horses program (1981)

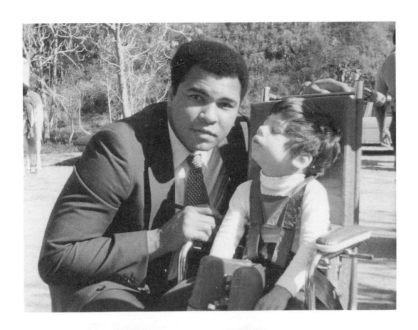

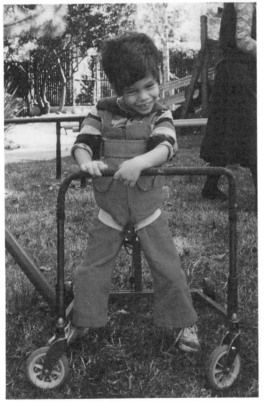

Above: Joey, age 4, with Mohammad Ali (1981)

Below: Joey in the weight-relieving walker designed at Stanford's Children's Hospital (1981)

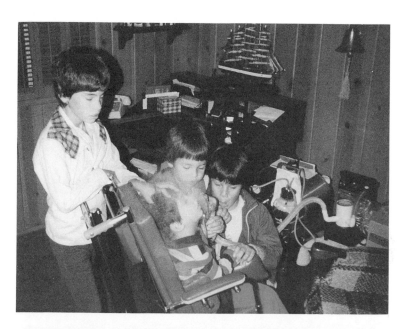

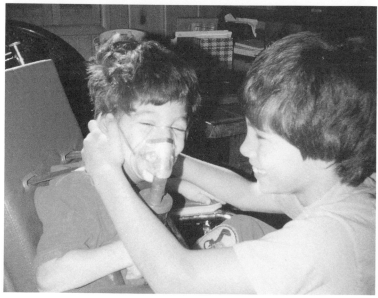

*Robert (10), Marty (6), and Shawn (9), help Joey (5)
put on his mask for another respiratory treatment
and "rocket ship" game (1982)*

Above: Joey and his brothers going for a go-cart ride (1982)
Below: One of Joey's favorite recreations—driving the family car (1983)

Above: Joey and I skiing (1983)
Below: Shawn (10) and Joey (6) listening to Marty (7)
describe his "excellent" skiing adventure (1983)

Above: Catching waves with Robert and Marty (1987)
Below: Swimming with Francia Bailey and her son, Michael,
at his tenth birthday party (1987)

Norman A. Plate

Geoff Maleman

Above: Our backyard slide, designed to eliminate the danger and difficulty of climbing a ladder (1989)
Below: Marty and Joey at a Challengers division Little League game (1990)

Above: Joey supported by his new Winzelite walker, learning karate
moves from instructor Tony Johnson (1987)
Below: Competing in Special Games at Loyola University,
supported by his Mulhulland walker, with Shawn (11),
Daisy's brother Max, and Marty (8) (1984)

Above: A peaceful moment (1989)
Below: Celebrating Robbie's fiftieth birthday (1991)—Shawn (19),
Robbie, Marty (15), Joey (14), Sandy, and Robert (20)

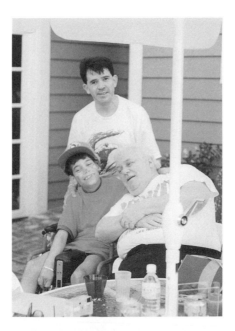

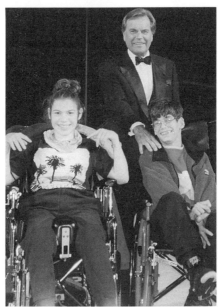

*Joey with Charles Durning and Armando, celebrating his fifteenth
Fourth of July party (1992)
Below: Joey and his friend Daisy visiting Robert Wagner on the set
of "Hart to Hart" (1993)*

Chapter 12

Why Walk....
Let's Communicate

*To you, I am nothing more than a fox like a hundred thousand other foxes.
But if you tame me, then we shall need each other. To me, you will be
unique in all the world. To you, I shall be unique in all the world....
One runs the risk of weeping a little if one lets himself be tamed.*

THE August after Joey's third birthday, I took advantage of a short visit from my mom and left her babysitting while I did my weekly grocery shopping without the troupe. Whenever I returned home from any outing, I always had to combat a cold sweat, as I anticipated the tragedy that might have occurred in my absence.

This time, I could hear the shrill protest coming from within the house as I pulled into the driveway.

"What happened?" I asked while taking a sobbing Joey from my mom's arms.

"I don't know. He started crying and I couldn't seem to find anything to make him stop. He's been crying the whole two hours you've been gone. He hasn't carried on like this in years!"

Robert, Shawn, and Marty had also been involved in trying to console their brother and were equally confused.

"Joey, please stop. Help me figure out what's wrong." Exhaustion probably forced him to obey, and his head drooped onto my shoulder while I questioned his brothers.

"Exactly where was he and what was he doing?"

Communicating with this non-verbal child was like playing charades; you needed the background information before you could start

guessing in the right direction.

"We were watching TV and he was just lying on the floor pulling the string of his balloon. Then he started kicking his legs and crying," Robert explained, but he was visibly bewildered by his inability to come up with an explanation for his brother's sadness.

Looking across the room at the deflated balloon, I had a flash of remembrance of picking Joey up from school that day. Kit had described the exciting time he had been having with his helium balloon. Whenever it floated to the ceiling, he had enthusiastically struggled until he was able to grasp its long string and pull it back down. Then he had released the string in order to repeat the activity.

"Your balloon wouldn't go up?" I guessed. He nodded, and appeared to be comforted by having his frustration understood. With a firm hug I massaged his head while I explained the missing pieces of the puzzle to my mother and the boys.

Joey smiled his acceptance of my conclusion, "I think we all need to take a ride and get some fresh helium into this old balloon."

The boys unloaded the groceries before we started out on our refueling trip. As I adjusted the rear-view mirror while backing down the driveway, I watched Joey laughing and exchanging kisses with his brothers. I could never snap back from these painful moments as quickly as he could.

I thought of all the energy, effort, and equipment I had used to further Joey's walking ability, when his most crucial need was to communicate. Walking isn't really that important when you consider that most of us give up this activity at an early age in favor of anything motorized. During that trip I made up my mind to find some way Joey could tell people his balloon wasn't going up!

Communication has to begin with the ABCs. Since Joey was now over three, we were eligible for educational assistance from the school district. But with only nominal speech, eye contact, head control, fine motor ability, and attention span, there was little proof that Joey had enough academic ability to require assistance. We had only UCLA's support of our instinctive belief that there was someone behind all these disabilities.

In California there are completely different programs for children who are orthopedically handicapped and for children who are considered mentally retarded. Of course, the program for the O.H. children is far more academically oriented. I feared that if the school district con-

cluded that Joey was mentally retarded, professional assistance to help him reach his full potential would be greatly diminished.

Since I did not know how to approach the school district, I jumped at the opportunity to attend a weekend seminar offered by the Team of Advocates of Special Kids (TASK), a non-profit corporation formed by and composed mainly of parents of handicapped children. This seminar focused on making parents knowledgeable about their rights in the area of special education. The weekend not only opened my eyes to our rights, but also showed me how hard some parents had to fight for those rights.

I also learned that when you first contact your local school district, you are told where to go to see a school psychologist, who can give your child a variety of tests to assess his particular needs. Then a meeting is arranged between the parents and school district staff members. It is during this conference that educational goals for the child are written into an Individualized Education Program. The IEP contains the school district's recommendation for the child's placement within one of its special education programs, and must be approved by the parents and reviewed at least annually.

If the parents do not approve the IEP verdict, they have a solid legal right to appeal for a fair hearing. However, I did not feel I had the time or temperament to handle even my battles at home, much less to take on the state.

Joey's UCLA teacher, Kit Kehr, was very supportive in helping me plan my strategy. But I still lacked the courage to approach this first IEP, so I decided to pad my support team a little more. I called and invited my counselor at the Westside Regional Center, John Burndt. The Regional Center is a tax-supported agency whose purpose, like that of TASK, is to provide a central source where families of a disabled child can obtain information about available programs and services.

As usual, John complied charmingly. "I'm so glad you called. One of our main functions is to help parents find appropriate educational opportunities for their children. Let's make an appointment to discuss the goals and objectives we want to incorporate into Joey's IEP."

With very positive letters from assorted UCLA staff members and with John and Kit planning to be with Robbie and me on the big day, I called the school district and set up the assessment and IEP dates.

On the morning of our IEP meeting, Robbie and I tried to ignore our developing depression as we walked down the corridors of

McBride, the special education facility for our school district. It was overwhelming to see so many "problems" housed under the same roof. By the time we reached the room designated for our IEP, our determination to be difficult was obvious.

The principal, the psychologist, the teacher, the doctor, and the nurse sat officiously on one side of the table, and Robbie and I were seated across from them with our advocates. We stated that with multiple handicaps and minimal attention span, Joey would not be able to learn in a group. The principal said the school district was not able to provide one-on-one tutoring within their program. We parted with shared antagonism and an unsigned IEP.

We were halfway home from that battle when I realized we had won the real war!

"Robbie, Joey's intellectual potential was never questioned. Look," I cried, after finding the appropriate box on my copy of the papers they had given us. "Their recommended placement was with the orthopedically handicapped."

"Then why didn't we sign the papers?" Robbie was irritated about being late for a hectic day of shooting on *The Ray Mancini Story*, and having nothing to show for it.

"Well, that would have meant that he would start school at McBride. Joey gets almost constant attention at UCLA and at home; what do you think he would do in a class with fewer teachers, more kids, and no way to tell anyone anything?"

We exchanged an expression that said what we both knew. He would sit in a corner and cry.

"Sandy, why did we go to this meeting this morning?"

Realizing we had not previously discussed our objectives, I admitted, "I don't know. I guess I just wanted to see if they could come up with something I hadn't thought of. I finally have him fed and breathing; but I don't know how to educate him. With all his handicaps, he can only learn with one-on-one help—and a lot of it."

"Why can't he just keep going to UCLA?"

"The program stops at age three. Joey's already the oldest in the group. They stretched the age limit to let us stay on an extra year because they knew he had no place else to go. There isn't a private school for normal or handicapped children that will take on Joey's degree of problems. We have to come up with something before he's four. We can't keep forcing ourselves on UCLA. Our only choice is

McBride...and I'm not ready for that yet."

"Neither am I." But refusing to accept a dead end, Robbie suggested, "Why don't we just start our own school? I'm sure you could get enough mothers to join you. I'll find a way to finance it, and you can run it."

"Somehow your part always sounds easier." Our eyes met and we smiled, but he didn't agree.

Since Joey's fourth birthday was still months away, I spent several days rehashing the details of that unsettling IEP meeting, then I decided to sign myself up for another seminar. Sponsored by the Regional Center and entitled Forward by Design, this course was intended to help parents of handicapped children become more organized in order to compensate for their extra burden.

In my effort to check out support systems, I didn't overlook many! None of them was a perfect panacea, but if I did my homework I could squeeze the most from each.

During the Forward by Design seminar I was able to learn techniques for analyzing and understanding my desires and behaviors, which was a vital part of effectively communicating with others. Now, recognizing my role in the IEP friction, I rehearsed how I was going to approach the next confrontation. Only then did I call Jane Waterhouse, the principal at McBride, and arrange a time for a private chat.

After a friendly greeting, I confessed, "I feel I approached our first meeting with far too much hostility. I have a great deal of confidence in my son's potential, but also a great deal of frustration about how to reach it. I need as much professional help as I can get, but don't know where to get it! My mother used to say, 'You can't squeeze blood out of a turnip,' and I don't want to spend a lot of wasted time trying. But is there any way the school district can help us educate our Joey?"

Thus I disarmed her hostility with my plea, and she presented her side.

"Mrs. Papazian, we try to do the best we can with what we're given. We didn't choose this profession because we wanted to be the bad guys! There simply are not enough funds or teachers to cover the needs of the children and the demands of their parents.

"Wait a minute," she interrupted herself for a moment of thought. "We do have a home/hospital program for students who are too ill to be in a classroom. Maybe Joey's medical problems would make him eligible."

She made several phone calls which eventually led to Joey's enrollment in the Carlson School for four hours a week of home tutoring, starting in January.

We exchanged a warm hug at the door. When our eyes met with a mutual "thank you," I realized we equally appreciated the way we had both won.

Naturally, I was very apprehensive the morning Joey's teacher from Carlson School was scheduled to arrive. It was difficult for strangers to recognize Joey's intellectual ability. Was this teacher going to be able to see through all of his physical problems?

I decided not to handicap her with my own doubts, so I introduced Linda Thorsen to Joey, strapped him into his wheelchair, and left the room.

Linda looked frazzled when she was ready to leave, and had to release a politely worried, "I've never worked with a non-verbal child before. I don't know if I'm the right teacher for Joey."

She was wrong! She proved to have an innate ability to hear the silent, and to add fun to learning. Within months we were both sure that Joey could recognize his written name.

A few weeks after Joey's fourth birthday, I was relieved of the headache of having to start my own school. Dr. Howard agreed to enlarge the UCLA Intervention Program to include a three-to-five-year-old group. Since the Intervention Program subsisted only on private contributions, grants, and fund-raisers, she did not really have the staff or funds for the expansion. She is just one of those people who have a way of avoiding stumbling blocks until they are well past them.

One day, at the beginning of that school year, Kit scheduled a field trip to a typical nursery school. When we arrived, the non-handicapped children bombarded us with questions ranging from the intimidating to the touching. Even if the questions were hostile, like "Why does he wear that ugly helmet?", they were still better than the stares.

One little girl, who introduced herself as Monica, captivated us with her curiosity. "How do you know when he's hungry if he can't talk?"

"He speaks with sign language. Joey, can you show Monica how you tell me you want to eat?"

Joey cooperated by bringing his fingers toward his mouth while he supported himself by leaning against my legs. Monica continued questioning me for more signs. Since Joey seemed to feel her approval, he

continued to cooperate with the correct demonstrations.

Monica abruptly changed the subject when we had covered the few basic signs Joey knew. "Does he want to go look at our rabbits?"

"Well, I don't know. Why don't you ask him?" I held my breath as she repeated the question directly to Joey.

Her hand reached out to join his after his head nodded affirmatively. On the way to the rabbits, I realized I could hold him up while he walked beside his friend, but I could not do what it had taken to get Monica's hand to reach out to him. To communicate with others, he would have to control his own head and also contribute his own thoughts to the conversation.

We returned home from UCLA that day just as Linda was arriving. While Robert took Joey for a go-cart ride, I related the Monica story to Linda, then confided, "I just feel so much pressure to find a way for him to communicate...I don't even know where to start. He can say a few essential words, but he really doesn't have enough ability yet to master speech, signs, or computers. Computers are the hope for the future, but he needs something for *now*. He's showing enough awareness to reach out to people, but he needs more tools to grab and hold their attention—other than hair."

She laughed. "What do you mean?"

Since Linda was such a good sounding board, I continued to unload all my frustrations on her.

"Oh, I haven't told you about our little hair-pulling problem. It started as an occasional slip; now it's guaranteed he'll strike every day. Kit even had someone sit in the classroom just to observe Joey. Sure enough, every time he tried to get someone's attention and they ignored him, he pulled their hair!"

"Do the kids dislike him?" I heard her worry.

"On the contrary, they love him, but once he locks his fist, there is a lot of pain until his fingers get pried loose. They scream when it's their hair, but it's the big novelty of the day to see how much time can elapse until Joey gets into trouble. It's like *Dallas*. I guess we all enjoy watching the devil perform!"

"He does manage to be heard," Linda injected with a chuckle.

"He always has," I continued. "For years, every time I finished the hassle of getting him and his travel chair into the car, his foot would jam into the hinge before I could shut the door. I used to think this was some kind of automatic reflex, until his smug smile exposed him."

After a few more lighthearted reflections, I said, "All kidding aside, we have to give him a more acceptable way to communicate, before he alienates the whole school."

Linda suggested I organize a meeting with all the therapists and teachers who were working with Joey and try to develop a multi-disciplinary approach to communication. Kit liked the idea and suggested adding Cathy Jackson, a signing specialist, to the team.

At the meeting, we decided to concentrate on recognizing and responding to any sign, sound, gesture, or grunt that Joey was able to produce. More response from more people might mean more effort from Joey. Cathy showed us how she could modify a few signs, molding them to Joey's ability, while still staying within the range of standard sign language. We concluded that each of us would record the progress and bottlenecks of our efforts in a book, which I would attach with velcro to Joey's travel chair. In this way, we could all stay on the same course.

With the combination of Cathy's signs, Linda's home program, and Kit's patiently pacing Joey's participation in small group activities, we hoped that Joey would one day fit into a normal group learning situation.

Being over-anxious to get a peek at our possibilities, I enrolled Marty, Joey, and an aide in a regular Sunday school class for First Communion preparation. Since the children in this class seemed a little frightened by Joey's condition, I decided they needed to see a *Let's Be Friends* show.

Let's Be Friends was a puppet show written by TASK members for classroom presentation. It explained basic handicaps and corrective equipment in terms that children could comprehend. The star is a handicapped doll who is able to form a friendship and find ways to play with her "normal" neighbor. The puppet show is followed by a hands-on session with equipment used by the disabled, such as wheelchairs, walkers, Braille books, and artificial limbs.

I spent considerable time personalizing and perfecting my version of the show. Then we all went together to Sunday school, including Sherry, so that we could present ourselves to the children as a family similar to but slightly different from their own. The class did not stir, but remained expressionless throughout my performance. When I concluded, I was applauded by Robbie and the teacher for a "very well-done job."

On the way home, everyone was full of praise. My red-haired sister, being taller and more extroverted than I, had always been our family's head cheerleader; she continued her hurrahs all the way home.

During the first lull, I decided to prompt Marty into piling on a little more praise, so I asked, "Okay, what did you think of my presentation?"

At first I was taken aback by his hesitance. "Well...." There was a prolonged pause before he continued. "You just kind of went past Catalina, if you know what I mean."

"Past Catalina? No, I haven't the slightest idea what you mean."

"Well, if you had blown up on the way over, it would have been terrible. If you hit right on Catalina, it would have been terrific. You just kind of went past."

"Are you tying to tell me I skirted the issue?" I whispered.

Seeing my disappointment, Marty enthusiastically added, "But that's okay, Mom."

I decided not to press for any more compliments. But I remembered the conversation several weeks later, when Joey was in the hospital recovering from another seizure. He had been propelling his walker up and down the corridor, when he suddenly stopped and pointed to a poster on the wall near the nurses' station. The poster gave a pictorial description of how to perform CPR. I usually commented on everything Joey pointed to, but this time I unwittingly ignored his grunting signal. But as usual, Joey persisted. He moved closer to the poster and kept rotating his index finger from the picture of the patient to his own chest, glancing back at me until I was forced to acknowledge, "You think that looks like you?"

I felt an uncomfortable chill when Joey nodded. I'm not sure how long we both stood staring at that poster. I didn't feel capable of moving. I had *never* talked to him about his seizures! How could I have recognized his blossoming awareness through the years, and all the while been so sure that he was totally ignorant of these horrible events that were such common occurrences in his life? I didn't want to know that he knew. I preferred the comfort of pretending he was unconscious of the terror and torture he had survived so often.

Now I could feel the weight of all those questions he must have wanted to ask and knew I ignored. I could not continue to sail past this problem. It was time to put what was easier for me behind what was best for him.

"Do you want Mom to talk about your seizures?" Not needing to wait for the sign I knew had already come, I led him back to his room. I unstrapped him from his walker, lifted him onto the bed, and lay down beside him. I wanted to watch his face as I asked, "Do you know where your seizure started last night?"

He raised the correct arm as he nodded. I explained that we did not know why these seizures happened, but that we were trying different medicines until we could find one that would stop them. My explanation was brief, but it was a beginning. It seemed enough to satisfy him for the time.

I felt overwhelming relief in confronting my repressed feelings and finally saying what Joey had long needed to hear. I had let myself be tamed, but being someone else's voice was a much heavier responsibility than I had anticipated. It would never be easy to hit Catalina, but the eventual landing was better than the pain of going past!

Chapter 13

Staring at the Ground

Whether volcanoes are extinct or alive, it comes to the same thing for us.
The thing that matters to us is the mountain. It does not change.

IN October, after consultations with all the doctors involved, it was decided that our four-year-old Joey should be hospitalized for gastrointestinal tests. We still could not completely prevent his seizures, but maybe we could find an explanation or even a cure for his high-temperature traumas.

The first day went by quickly. Joey's apprehension of what was in store for him kept me busy as I tried to keep him preoccupied. When the lab technician came in for the routine blood test, I had her draw extra blood to test for the drug levels, as I knew they would decide to do later. I had learned to get the most out of each prick for blood, and I no longer waited to be forgotten! By now I was quite familiar with medical jargon and hospital confusion, but whenever I came upon a newcomer, I remembered how difficult that familiarity had been to acquire.

Next to us, a woman sat beside the bed of an infant who was missing both arms and had an unusual heart disorder. This mother reminded me of myself in years past. As the stream of residents and interns drifted past her daughter, I knew she saw in each of them another chance for answers to the unknown. During admittance, UCLA tries to explain clearly that they are a teaching hospital; but they do not understand that a novice to "problems" does not want to hear this in the beginning. It is hard to face the unknown. The doctors have to learn more answers, but parents have to learn that no one is ever going to give us all the answers up front. We have to find them along the way.

By late the next afternoon, initial laboratory results had revealed that Joey was regurgitating some stomach content and then aspirating it into his lungs, but he was also aspirating lots of mucous. Klonopin, our most successful seizure-block to date, had the side effect of producing extra mucous. Therefore, Dr. Cokely and the gastrointestinal specialist felt that trying a different seizure medication, before additional tests or corrective surgery, might be considerably easier on Joey. We appreciated their conservative advice.

Dr. Cokely also suggested that we keep Joey in the hospital, since a seizure might be triggered by the change of drugs. She would have to substantially decrease his old medication for a few days before he could start the next.

Sleeping in the hospital and caring for Joey was not easy, but any discomfort we might have had was soothed by the strength and alertness we saw increasing in our son as his drug levels went down. He was just as delighted with his new self as we were. His freshly found ability to move and to control his movement kept a beaming smile on his face, and kept us on our feet keeping him out of trouble.

The main focus of Joey's attention was the oversized hospital door. After persistent trial and error, he was able to close the door while swinging his walker around, so that he remained either in or out of the room, as he wished, after the door was closed. He was particularly thrilled when he could trick us into remaining on the opposite side of the door.

Since we did not want to smother the energy emanating from this newly emerged person, Robbie and I planned to talk to Dr. Cokely about discontinuing the medicine permanently. She had always given us the same answer to this suggestion in the past. "Without the medication, he could have a seizure any time he falls asleep." But we still felt there might be a hidden possibility that these medications were not necessary. That night, however, a small tremor shook our confidence, and the aura of apprehension never left Joey's room for the remainder of our stay.

The next day, Dr. Cokely started Joey on his new regimen of medication. She said she hoped the previous night's incident would be the worst we would see. Her choice of the word "hope" made us decide to temporarily abandon our desire to discontinue the drugs.

Sherry, who was close to my age and temperament, always came to our rescue during extended hospital stays. While she took an afternoon

shift, I went home to fix dinner and give instructions to the boys' sitter. Once I was back at the hospital, the rapid chattering of my more self-assured sibling diverted any apprehensive thoughts for a while; but when she left and evening approached, a superstition that doom follows dark started to entwine me.

Joey, who was fussier than usual, seemed to share my fear of what might happen when he fell asleep. After the incident with the CPR poster, I knew his awareness encompassed areas I had hoped would always remain beyond him. Now, thankful he could not ask for the assurance I could not give, I just held his squirming body tightly.

As we rocked and waited together, I realized that this was not the same as dealing with long-range fear. Yet my fright was mounting out of proportion to what could happen. There could be no undiscovered seizure or arrest this night, and there would be no need for a chaotic ambulance ride. We were already in the hospital with a nurse's eyes seldom off us. The worst that could happen could not be as bad as what I had already been through dozens of times. So what was my problem?

My self-analytic thoughts led me back to the childhood memory of all the cowboy-and-Indian films I had seen with my father, who was a devout western movie fan. Every film had one common characteristic that I hated—a serene scene abruptly interrupted by Indian heads popping up. The director's visual shock was heightened with music, and of course I cooperated with the desired effect by jumping out of my seat. My dread of impending doom was always beyond what was justified by the actual events. And so it was now. Maybe this would be the night Joey would not come back. While I was trying to pretend that it was the next morning and we were waking up, I wished I hadn't seen all those westerns!

It wasn't long before my thoughts were interrupted by the anticipated pop of Joey's hand. This time, since I had already overly rehearsed the scene, my heart started fluttering in sync with his limbs, and I wondered which would stop first.

"He's fine now," I released an enormous sigh as soon as the seizure stopped and Joey threw me one of his precious smiles. All of him had come back again, and he was safe until tomorrow.

"He only has one incident and then sleeps peacefully through the night," I flatly assured the nurses. The doctor in charge checked Joey, and then everyone left the room, confirming that my judgment was correct.

While rubbing Joey's head as he drifted contentedly back to sleep, I started to wonder if he was falling asleep too fast. But the suspense was short-lived. During the next hour of few spoken words, the ambu-bag and suction tube alternated over Joey's face several times. Each time the procedures ran more smoothly than before, even though the intensity of the seizures and the length of the arrests increased considerably with each new assault. In the peaceful interims, I resumed stroking Joey's head and let my mind click to the same blank state as was visible on my face. I knew I couldn't handle thinking about what was happening just then.

After midnight, when Joey was obviously too drugged to seize again, I allowed myself to remember an earlier talk with Dr. Parmalee, the head of the Child Development Department at UCLA. He told me that parents of handicapped children often have trouble adjusting to "the death of the child that could have been." He felt that the difficulty was caused by the constant reminder of that death as these parents struggled daily with the child that remained.

No matter how well I thought I had adjusted, a day seldom passed without one small glimpse of what could have been for our Joey. A child riding a bike, running to catch a ball, or chattering about his experiences too often resembled our could-have-been child. Some families cannot let go of the hope of getting that lost child back, just as we could not let go of the dream of getting Joey off the drugs. I spent that night mourning the loss of the Joey we had found, but whom we would have to hide with medication every day.

At noon the next day, Robbie snuck away from the set of *To Catch a Thief* to relieve me for a few hours. I would have preferred to trade places and spend the afternoon submerged in fantasy while watching classic Audrey Hepburn and charming Robert Wagner glide through their scenes of a romantic comedy. Instead I spent an hour in my own bathtub trying to wash off the effects of too much stress and too little sleep. I comforted myself with tons of Chanel lotion and the thought that at least our days would be seizure-free.

Arriving back at the hospital freshly perfumed, I learned that I had been wrong again. Joey had suddenly fallen asleep after I left and had gone into another seizure, which had been stopped by another shot of phenobarbital. I slipped his walker back into the corner, not wanting to be reminded of how cute he had looked opening and shutting his door. Today I would only have to watch him sleep off the effects of the meds.

Joey's seizures were odd, but they had substantial similarities to one another. In the past, I had learned to derive consolation from knowing that the seizures occurred mostly at night, and with at least a two-week hiatus in between. Every time Joey deviated from his norm, it was very awkward to get used to dealing with the "new" problem.

The one-week hospital stay we had planned had now stretched to almost five. Several attempts to go home had only subjected us to the additional trauma of an emergency return. Despite my hatred of hospital life, I became afraid to leave its security.

However, from all the tragic times with Joey, I had learned the value of even trivial improvements that anyone can add to his or her day. So, as the weeks of hospitalization dragged on, I tried to occupy my quiet time at the hospital with captivating books and needlepoint projects. Either my sister or Robbie would relieve me to go home for my ritual bath, after which I would spend time with Robert, Shawn, and Marty, running errands and shopping for food, household items, or just for fun. I frequently bought new makeup to experiment with, and always made a point of going back to the hospital looking better than when I left. Thus, I felt better.

One day my claustrophobic feelings peaked before the relief shift arrived, so I decided to take Joey out on a hospital leave. The freedom would be well worth the lack of safety for that period of time, and Joey would have a chance to play with his brothers while I bathed.

Joey seemed to share my appreciation of the fresh air, but he waited until I was halfway home before he hit me with a yawn. I could not believe the adrenaline that surged through my system from that simple yawn. Nothing else happened, but I rushed back to be imprisoned in the security of the hospital, chanting all the way, "I can only deal with what is, I can't waste time on what could be."

The next day I decided I might benefit more from a solo retreat. Hoping to reinstate my exercise routine, I bustled the boys through dinner so that we would have time for a bike ride before I had to return to the hospital.

Along our regular route was one very steep hill. Whenever I approached it, I always focused on the top, but I could only make several wheel rotations before thigh cramps inevitably forced me to walk the bike most of the way up the hill. On this day, I happened to watch our sure-footed and street-wise Robert zoom up the hill ahead as if it were level.

To kill time while waiting for me, he returned to the bottom for another attack. "Robert, how can you get up that hill so easily? Don't your legs hurt?" I asked.

"Yeah, but I just don't look at the top," he advised. "I just stare at the ground in front of me until I get there. Try it, Mom!"

I was so intrigued, I had to.

"You're right!" I beamed after reaching level ground.

Since the possibility of losing Joey constantly loomed ahead of us, the thing that mattered was being able to move forward despite the threat. I had always known that misery has a way of popping into everyone's life at unexpected times. But by allowing myself to concentrate on the possible outcome of frightening events, I could be stifled before the catastrophe actually struck!

Pedaling to keep up with my sons, I finally understood how I had survived all those medical emergencies with my silly chanting and thoughtless staring. They kept me from defeating myself! When I forced myself to focus only on what was immediately in front of me, somehow I eventually wound up on top.

Chapter 14

Silent Sufferers

And is it not a matter of consequence to try to understand why the flowers go to so much trouble to grow thorns which are never of any use to them?

OUR hospital stay was pushing past a month when I stumbled upon a different puzzle. On one of my routine home breaks, I sensed guilt from Robert, Shawn, and Marty. But it took several rounds of individual interrogation before the pieces came together. I had thought that our latest live-in sitter had enough stamina to stimulate the boys and thus could more than adequately cover for me. On the other hand, my mom's favorite quote generally pans out. Sometimes "God writes straight with crooked lines." This spirited sitter had given the boys a lesson in rolling marijuana cigarettes, then threatened to accuse them of smoking if they tattled; but when we abruptly fired her, we were forced to attempt another homeward venture.

Knowing how short the tranquil time could be, I swiftly slipped back into my regular routines and accepted an invitation to a swimming party at Daisy Hunt's house. Daisy had been Joey's adorable cerebrally palsied classmate since they were both two years old. Her brother, Max, was Marty's age, so they had developed their own friendship during prior get-togethers with other families housing handicapped children. Anxious to explore each other's home ground, Max spent the night before the party at our house.

The following day, on the way to the party, Marty and Max were comfortably sprawled out in the rear of our stationwagon, engaging in a 'been-through-the-war-together' kind of conversation.

Normally, I blast my car radio in order to drown out the kids, but a few comments from the back seat had me turning down the radio and eventually turning it off. What one didn't know about muscles, the

other did. They exchanged information until they arrived at a solid five-year-old understanding of life with a cerebrally palsied sibling.

"Talk about handicapped. Joey's really handicapped! He can't do nothing."

"Daisy can't do much, either."

"You know, if you or me rolled out of this car, we might be in a little bit of trouble, but if Joey rolled out, he'd be mushed. Handicapped kids have yucky muscles and really get hurt easily," Marty concluded.

"Swimming's real good for their muscles," Max chimed in. "They can loosen up lots...but not too much," he added, probably remembering Daisy's stiffness.

"Yeah, Joey loves swimming, but he never wants to get out."

"I know!" Max emphatically interrupted. "Last time he went swimming at our house—you weren't there—he stayed in too long and got so cold he was really shaking. I've never seen shaking like that. They had to put him in boiling water. Then they had to take all the toys off the blankets so they could wrap him up, and he was still cold!"

From the look on Marty's face in the rear-view mirror, I knew this story worried him.

"Mom, I don't think we'd better let Joey in the big pool. Max and I will play with him in the little plastic pool," he said, unaware I had been listening to the discussion.

When he received my nod of approval, he continued the pow-wow as if I had dropped out of existence.

"When I grow up, I'd like to have a handicapped kid," he said, fishing for Max's feelings.

"Yeah," Max agreed. Then, after a pause, "But not too many because they *can be* a problem. You have to carry them around all the time."

"Yeah." They were together on that feeling, too.

When they were close to exhausting the topic, Max concluded, "Well, I'm glad we have Daisy, at least she can talk."

Marty ended with, "I'm glad we have Joey, at least he's fun to play with."

How were they able to filter through all those problems and arrive at such a logical, loving, and positive view? Where were their support groups and counselors? Normal siblings seldom take center ring when a handicapped brother or sister is in the show, but we all need to have our feelings heard.

Robbie and I had learned from Marty's transposing of the words "fever" and "seizure" that siblings can suffer from many misunderstandings about the handicapped member of the family. It saddened me to think of how much Joey must misinterpret because he was unable to ask questions. But then, even children with speech often remain silent about their deepest troubles.

Not long after that swimming party, Robbie had to fly to San Francisco to scout locations for his upcoming television movie, *The Rape of Richard Beck.* During the middle of my first night without him, Joey had an aspiration attack. After hours of forcing myself to stay awake to ensure his continued breathing, I wondered why I was allowing myself to suffer through this alone. I woke our new housekeeper and gave her instructions for the morning, then drove to the hospital and checked Joey and myself in for a little professional assistance.

In the morning, when Joey was comfortably breathing the mist inside his oxygen tent, I called my other sons and assured them we had improved with our relocation. I also did what I thought was an adequate job of regulating the boys' home activity throughout this Saturday.

Then late that night, Sherry, who was a flight attendant and often rescheduled her trips to accommodate our emergencies, offered to spend the night at the hospital so that I could go home and sleep. I expected everyone to be asleep when I arrived. Not only was Robert, our sensitive oldest, awake, he was unusually chatty.

In the middle of an unrelated sentence, his striking blue eyes started to water and he changed the subject.

"Why didn't you wake me when you left last night? You should always wake me up whenever Joey has a seizure or a temperature. I waited in the house all day to find out how he was. What does the tent look like? I kept thinking it might cave in on him if you left to go to the bathroom. I just woke up in the morning and you were gone. I thought Joey was dead!"

I was not able to say much during his outpouring. I couldn't believe all he had stored. I consoled him as much as I could that night, then early the next morning piled all three boys into the car for a trip to visit their brother. Even if we had to sneak past the nurses, they needed to see Joey alive for themselves.

Of course, they all insisted on stopping for stuffed animal gifts for Joey. Marty included a pack of gum and a nickel with his present. We

were in the elevator before I realized that our pet hamster was also along for the ride, because the fur in Robert's pocket moved. "I know Joey misses him," Robert confessed.

Our oldest was the first to reach Joey's bedside, and as he leaned to whisper into the patient's ear, I overheard, "I think about you all the time." Lately I had noticed that Robert was less loving than usual when he was able to be with Joey. Witnessing this fresh display of tenderness aroused my curiosity.

When Sherry was ready to leave with the boys, Robert approached the bed again for a parting embrace. Joey, who closely resembled Robert, responded by putting his arms around his brother's neck. But then, with a big smile Robert did not see, he arched his back. The older one promptly pulled away from the hug, and I saw what had been happening.

"Robert, Joey really enjoys your hugs."

"No he doesn't, Mom," came the hurt I had suspected. "He always pushes me away!"

It was upsetting to think how long Robert had lived with this misconception and how easily it could have remained undetected!

"I'm sorry, I thought you understood. It's very difficult for Joey to isolate individual muscles. When one moves, they usually all move. When he puts his arms around your neck to return your hug, his back automatically arches and his head turns to the side. That's the way he hugs." Not sure that he understood, I continued, "Watch. Shawn, come over here and give Joey a hug."

Always overly affectionate, Shawn cooperated with a demonstration that said more than I could have in another hour of discussion. Shawn had always gotten the same repelling thrust, but since he was unable to be intimidated by anything, it had never bothered him.

Robbie and I learned to have many discussions with all of the boys about Joey's handicaps, hoping to reach any submerged fears or false impressions they might have. Nevertheless, I'm sure there were a lot that we missed, and a lot that they had to work out on their own.

The boys' hidden sufferings were still on my mind a few evenings later. We were awaiting Robbie's return from San Francisco, when Joey started what looked like a mild seizure. I decided I would try to minimize my raving, hoping to reduce the fear absorbed by the boys. Joey's latest seizures had not been as prolonged as in the past, but anticipation had subjected all of us to far more stress than was called for. This time I

would plan on a petite mal seizure with minimal snags.

With this new approach locked in mind, I calmly told the boys to stay with Joey while I phoned the paramedics. After reaching 911, instead of starting with my high-strung "He's not breathing!" I articulately explained, "My son is having a seizure and he needs to be taken to the hospital immediately, due to possible respiratory complications."

The man on the other end of the receiver continued to listen quietly for my address and phone number before he said, "Lady, who's with your child now?"

"My other children," I replied, surprised that he was taking the time for questions.

"Has this happened before?"

"Well, yes," I hesitantly answered, wondering why he was questioning me. No one had ever questioned my hysteria.

"Lady, I think you should try to do something about this! Have you taken him to a doctor? You know, there are medications that can prevent this!"

This totally abolished my new calm approach.

"You idiot!" I sourly scolded. "He's going to stop breathing any minute. Will you please stop this chitchat and get that ambulance here?" I slammed the phone back into its cradle, then returned to my familiar frantic state for suctioning.

By the time the paramedics arrived, I knew this was far from a mild focal seizure. We were well on our way to the big time! I spouted the customary medical history and ended with "We'd better transport him right away."

Ordinarily, this was the question-and-answer period, but this team seemed almost overanxious to follow my instructions. They clearly misread my composure! I had a momentary urge to toss Joey to them and run to lock myself in the closet. Instead, I reluctantly rushed into the ambulance for another emotional ride. As the door was shutting, I asked a neighbor to watch for Robbie's airport taxi and relay to him what had happened.

The man who climbed into the ambulance after me was having too much difficulty getting the suction machine to operate. It was then that I noticed he was shaking more than I was.

"He's about ready to arrest; you'd better get the ambu-bag ready," I said, starting to feel a little uneasy about all his fumbling.

Both of my hands were occupied with suctioning when I realized

that my companion was just holding an apparatus above Joey's face. The mask needed to fit the face tightly in order to prevent air from leaking while the bag was compressed to inflate his lungs. I also noticed that this mask-and-bag ensemble looked different from the ones we had previously used.

"What is this?"

"It's oxygen," he said defensively.

"Don't you have an ambu-bag?"

"No."

Our eyes met, and I realized that even if he had one, he wouldn't have known what to do with it!

"This is just an ambulance?"

I knew the answer I didn't hear. My hysterical cry of "He's not breathing!" was what had always summoned the paramedics. Fully aware now that I was not supported by the proper equipment or expertise, I glanced down at Joey's bluing face and felt close to having a seizure myself!

When the pandemonium in the rear spread to the driver, his wild Code Blue zigzags complicated my panic-stricken medical procedures even more. I was way too zealous with my puffs of air! Then, all at once, the driver made a sharp turn, I inserted the suction tube, and Joey suddenly began to vomit. I knew from his gasp that he had aspirated some of the vomit.

Just as we reached the hospital, I muttered breathlessly, "I think we made it."

Joey was pale and even weaker than usual, but he had stopped seizing and was breathing on his own.

I walked through the emergency room doors behind his stretcher, feeling at home and in desperate need of the comfort that came with being there. But even before the doors closed behind me, I realized that I was far from a welcomed guest!

The E.R. doctor took one look at me, and said "Oh, no, not you again," threw up his arms, and retraced his steps to his office.

I had encountered this doctor on several previous visits. He adhered staunchly to the policy "parents in the waiting room," which I vehemently opposed. Talking to him about our conflicting interests had been on my list of things to do since we last met. Oh, how I regretted my procrastination now! I wasn't in shape for a fight, so I took a deep breath and followed him into his office to try a friendly approach.

"Please, let me have a moment with you. I had hoped to come over to talk to you before…but as you can see, I didn't make it. I understand! A berserk parent around can prevent you from keeping their child alive. But please see my side! These emergencies are a way of life for my son. You have to examine the psychological effects of this on both of us. Traumatized parents are also your patients. His life would be considerably less traumatic for both of us if you'd let me comfort him through this."

"Your son comes in here in a comatose state. My only concern is to try and keep him alive."

"Please," I continued my softened plea, "can't we compromise? I'll leave the room while you are examining him, but let me stay with him while the nurses are there." The words came out faster than intended as I continued. "I can help them. I can keep him calm. I won't interfere. I have always been told that I helped! Ask the nurses!"

Then, inadvertently, I grabbed his arm while raising my voice "Please, compromise with me!"

When he noticed I was starting to lose control, he pulled away and left the room, stating, "I'm compromising enough by letting *you* stay out here! I need to be with your son."

I was crushed by his cold rejection of what I thought was a fair solution to our conflict.

Joey, too, had been calm when we arrived, but there was no way he was going to cooperate with strangers sticking needles into his arms when no mommy was in sight. As I listened to his shrill complaining from the adjoining room, I felt my anger swelling beyond control. How unnecessary it was for him to have to endure being alone, after all he had been through!

I must have been spurred by the subconscious memory of a quote I had recently read on the boys' karate instructor's bulletin board: "And the day came when the risk to remain closed in a bud became more painful than the risk it took to blossom."

I even shocked myself as I lunged towards the door in front of me, roaring, "He will not be alone!" Then, oblivious to all the verbal resistance behind me, I charged into the room ranting, "It's all right! Mommy's here!"

The sudden return of my voice instantly stopped Joey's screams. He relaxed into a soft sobbing, allowing me to hold his arm down for a nurse's fourth attempt to insert an I.V.

I completely refused to acknowledge the continued protests about my presence as I whispered consoling words into Joey's ear, but I heard the doctor leaving the room with a huffy, "I'll be back!"

Within minutes, my attention was diverted and my courage shattered as I looked up to see the head nurse and three uniformed security guards marching in my direction. They obviously intended to remove me from the room by force.

Then I seemed to get taller before exhaling with, "You can't touch me! I haven't signed the consent papers for all this!"

God must have been moved by the unfairness of the situation and allowed this weapon to come out of my mouth. To this day I don't know how else my overtaxed mind could have produced something so effective!

After a glimpse of the bloodstained sheets from unsuccessful I.V. insertions, they suddenly stopped their advance. I was a Leo, although no one would have believed it before Joey came into my life.

Now, as I resumed whispering in Joey's ear in order to prevent my aggressive adversaries from seeing that my face was more awed than theirs, I felt the tingling surge that comes with power! Robbie was right! He had always said power was just topping the other guy's intimidation.

The ready-for-action opposition remained in the room. I could sense the tension of their presence and was unsure how long the threat of a lawsuit would hold them back. At least Joey was relatively relaxed and cooperative.

Then I felt the power fade as Robbie made his entrance into the room, saying, "I signed the papers." His tone indicated that he thought he had done me a favor and was anticipating an appropriate welcome.

"Why did you do that?" I snapped with the shock of being stripped of my cover.

"The nurse met me at the door and asked me to sign," he replied, uncertain why his action needed justification.

Before I could continue, the same nurse interjected over Robbie's shoulder, "Now you can get your wife out of here!"

My anger started to rebuild rapidly. "I'll explain later," I said to Robbie, then snarled with the added courage that came from no longer being alone, "I will not leave this room, and I want Joey transferred to Santa Monica Hospital right now!"

Robbie was still too confused for words when the doctor returned

and reminded me, "You said you would leave when I'm here."

I started to object, but my more sensible side told me that maybe this was his way of accepting my proposed compromise. Also, I could hear a slight shuffle from the security guards.

"Joey, Mom is just going to step outside the door for a couple of minutes." I said. "I'll be right back, as soon as the doctor checks you. You'll be all right!"

But Joey didn't believe me, and screamed throughout the entire exam. Robbie pacified my rage by phoning Dr. Cokely and asking her to arrange our transfer to Santa Monica Hospital. When the doctor had completed his tests and okayed Joey's stability for transporting, no one blocked my return to the treatment room. Maybe a nurse's favorable words or Joey's stabilized condition had disarmed the doctor. Or maybe he realized that I was more stubborn than he about this waiting room policy. I could respect his medical competence. I just wished he could recognize our gray area.

When we arrived at Santa Monica's emergency room, I heard the paramedic report to the physician on duty that he had been picking up a few irregular heartbeats.

"He's never had any heart problems before," I said, hoping the doctor would pass it off as unimportant. He didn't. He quickly listened, then confirmed, "He does now."

With my teeth clenched to keep from vomiting, I stood behind the paramedics and silently took in this new problem. Satisfy the stomach, stop the seizures, save the lungs—and now the heart. There was not much left to go wrong!

I thought I had enough to contend with; but then my husband started having chest pains! The doctor decided to admit Robbie for an examination after learning of his tendency to internalize stress and his family history of heart problems.

Before long, I found myself standing between two beds. The sight of Robbie hooked up to his own EKG machine must have been too much for me. With a dumbfounded expression, I kept mechanically shifting my gaze from one patient to the other.

Struck by my gawking, Robbie chuckled, "So, what's wrong with you?"

"Trust me! The next time we head for the hospital, I'm going to be the first to grab a gurney!" I hadn't intended to let these selfish words slip out, but this barb of wit was enough to puncture our negative mood

and release our nervous laughter.

"I'm sure God has made a little mistake here and plans to rectify the error soon," I concluded. "He couldn't have intended all this to happen in one night to only one family."

Fortunately, this time Robbie passed his exam, and the emotional release that came with the giggling carried us through the rest of that night. When problems piled up to the point of being ridiculous, we always found humor to be the only way to get out from under it all.

In the morning, Dr. Cokely assured us that Joey's heart was still in "just watch" condition, and did not require special medication. Apparently, all the arrests were starting to take their toll, not only on Joey, but on the rest of the family as well. Since several different combinations of medicines had not proven successful against Joey's seizures, Dr. Cokely felt we should return to Klonopin. She would try combining it with Tegretol, hoping to keep the Klonopin dosage and its mucous complications lower. Since X-rays confirmed my suspicion of aspirated pneumonia, she referred us to a respiratory specialist, Dr. Ocher, who headed the Cystic Fibrosis Department at UCLA.

We left the hospital with a pulmo-aide, ultrasonic nebulizer, and postural drainage instructions for a professionally modeled home respiratory treatment, which was to be given to Joey every four hours. As with the beans, I was able to drown my fears in activity for a while.

Sterilizing and setting up the respiratory equipment seemed to eat up most of the free time I had between the sessions of actually using it. Moreover, during this therapy an oxygen mask had to be held over Joey's face for twenty minutes while he inhaled concentrated steam from a medicated saline solution. Understandably, his patience with this procedure was short lived.

But then I was unexpectedly blessed with indispensable help. Robert, Shawn, and Marty, who were delightfully fascinated with all of this hospital equipment, watched the treatments religiously, and soon I only had to deal with the postural drainage. They took over the beginning steam section and made it a space game. Joey found it difficult to be bored while his brothers ran about the room suited in their own oxygen masks, preparing for a rocket departure!

Unfortunately, I did not have the time or energy to give my three other sons all the support they must have needed while Joey was in the hospital. Many nights they had to fall asleep unsure of how many brothers would wake up.

But like Joey, they somehow found ways of surviving. I learned of one shortly after this last hospitalization. Our eight-year-old, Shawn, decided he was going to "write a story on our new typewriter." He had never used a typewriter before, but since he was always set on completing anything he started, he pounded the keys for most of the day before he handed me his results:

THE CREATOR & THE BUG
by Shawn Papazian
for Joey Papazian

Once upon a time their lived a bug. He was walking down a dirt road one morning and he bumped into something. It was the creator of the universe. (God) The bug said, "Hello, my name is Mr. Bug."

"My name is God."

"Please to meet you, God," said the bug.

"Would you like to take a walk?" God asked.

"Why certainly," said the bug.

Days went by, even weeks. But Mr. Bug & God had fun during those weeks. One day God & Mr. Bug went to a park to have a picnic. They had their lunch, then they both went home. But Mr. Bug wasn't feeling good, so when he got home he took a nap. When he woke up a doctor and his friend were at his side. The doctor said, "You have a very bad disease." It was called "Tabic." And they only have one cure for that disease. And that is a leaf from an evil tree. If anyone took it they would die, unless they went from behind it.

So God went forth to get the leaf. Then right in front of him was the plant. It was the most beautiful tree he ever saw in his life. But the evilest tree in the world. So God went behind the tree and got the leaf. Then he ran to the doctor as quickly as he could. Then the bug ate the leaf, and he was better again. And they lived happily ever after.

Like Robbie and I, our older boys tried but never could fully understand these neurological disabilities that were a thorn in everyone's side. Yet, knowing that this little one could not protect himself, Joey's brothers constantly checked for seizures, assisted in emergencies, and

administered his treatments. All three of them only saw a cute, clever, and courageous brother when they lifted his floppy head. They always seemed proud of their ability to make him laugh, as if his laughter eased the pain of knowing what he suffered, or what they would suffer if they could not hear his laughter again.

Chapter 15

Living with a Fixed Cube

...All you need to do is move your chair a few steps. You can see the day end and the twilight falling whenever you like.

OUR prolonged hospitalization was the forerunner to a downhill trot to Joey's fifth birthday the following July, with only a Christmas reprieve before the arrival of the chicken pox, which stayed for an unexpected two months.

Shawn was the first to blossom, and spent the weekend in bed with a fever and swollen glands. Monday morning, Robert and Marty were pleased to show me their spotted tickets to a week off from school. I wondered why they didn't get as sick as Shawn. Then, two weeks later, both came down with more spots and more severe symptoms. I almost thought Joey had been spared, but he lagged behind only to wind up topping the others in the severity of his illness. Most of the skin on his thin body was blistered!

On the second day of Joey's affliction, Robbie arrived home from work and greeted me with a gasp, "You look terrible, and he looks even worse! As a matter of fact, he looks the worst I've ever seen him."

My 101-degree temperature from a flu buffered my reaction to the 106 degrees Joey had spiked. Robbie took over the sponge baths and aspirin and was able to lower Joey's temperature a little. However, later that evening, since Joey's breathing remained quite labored, Robbie decided we had better transport him to the emergency room for a check up.

As we readied ourselves for the trip, I remembered that a few weeks earlier Marty had happily said, "Gee, now I'm the most sick...I'm even sicker than Joey!" These words had slipped out while I was rubbing him

with Calamine lotion and getting him ready for his cozy bed on the couch with Seven-Up and snacks close by. With my pounding headache and chills, I found myself longing for the pampering that had made Marty's illness more enjoyable. I secretly wished I could be "sicker than Joey," too.

Following a brief exam, the E.R. doctor said, "This is the worst case of chicken pox I've ever seen!" After a pause he added, "I think he has pneumonia, too. We'd better get an X-ray."

After the X-ray confirmed that Joey had pneumonia, the doctor recommended that he be hospitalized and given intravenous fluids and medication. I examined Joey's totally blistered arms and was nauseated by the thought of the approaching taping-and-needle ordeal. The doctor appeared to be unsure of our hesitation until Robbie studied the situation and asked him to step outside for a private consultation.

Not even reacting to their departure, I continued to stare at Joey as he fought for each breath. I was blinded by an anger beyond my past experiences. "This is enough, God!" I almost ruptured from the excess air I inhaled for this silent protest. "He's had more than his share. What has he done to deserve all of this? Pull a few hairs? Maybe he had to have the most minimally functioning muscles. Maybe he had to have those unheard-of seizures. But there is no reason he has to have pneumonia on top of the worst case of the chicken pox!"

For the first time in my life, I had no desire to converse any further with my private friend. I had to have a target for all the fury brewing inside me, and there was no one else to blame but God!

Devoured by this outrage, I was unaware of the I.V. nurse readying her equipment, until she softly uttered, "You take all this so well!"

I must have looked like Jack Benny as my eyes bulged in disbelief; but at the time, I was unable to see a single spark of humor. Having passed too far beyond tears and words to comment, I was only stumped again by the frequent misinterpretation of my silence as some kind of superior coping strength.

Robbie convinced the doctor that with our own respiratory equipment and prior medical experience, we could competently care for Joey without hospitalization. Then he signed the release papers with skepticism, picked up the antibiotic, and carted us back home.

Robbie and the boys pitched in more than their shares and saturated Joey with respiratory treatments. Intermittently, I propped up his floppy body and kept him hydrated by literally pouring fluids down his

throat. His forced swallows must have been painful, since very little of his mouth and throat was free from sores. He only cooperated because he was too weak to protest. Every time he gulped something down, I combated my guilt with the thought that the pain of an I.V. would have been worse.

By the next evening my temperature had subsided, but Joey's condition remained the same.

Then my mom called to check on her grandson, and ended our conversation with, "You just won't let him die!"

I resumed my position beside Joey, but I realized I did not have the same pride in my own effort that I had heard in her words.

Overcome with anger and sorrow, I finally felt incapable of bearing the terrible fear and helpless frustration of continually witnessing Joey's undeserved and unnecessary suffering. Why did God allow him to survive if he was only going to continue these torturous battles with death? If he was meant to die, why didn't he? If he was meant to live, then why couldn't he get more than a step away from death? It was almost as if God couldn't make up His mind.

Then another aspect of the conflict struck me. I had overlooked the role that Robbie and I had played. We had a tenacious thread that tied us together. If one of us weakened in dealing with Joey, the other was there for backup. We had intercepted his death countless times. Then a thought occurred to me that I wish I had never had: Were we just setting Joey up to be tackled again?

I had a pet superstition that Joey would not be able to go to sleep unless I told him about some fun things that were in store for him the next day. I wanted him to fall asleep with positive thoughts. If an evil seizure were to grip him, I felt he would be able to muster more will to live for that future fun. How much belief can a small child have in his mother's words? Maybe I had been convincing him that his life was worth coming back for!

This beautiful and innocent child had endured more hardship in his four and a half years than most people encounter in a lifetime. As for the future, it didn't look like too much would ever come his way easily. How many times could he be knocked down, and still smile and pick himself up for more? How many times could I watch him?

Maybe I should stop filling his head with all those illusions of good times to come, I thought. Maybe he should know he hasn't been blessed with the best of lives. Maybe he should know I lied all those

times I distracted him from the pain of the needles. Those needles do hurt, even when you're trying not to think about them.

Suddenly, my throwing-in-the-towel ceremony was interrupted as Joey opened his big blue eyes, which always forced me to bury my negative thoughts about his survival. Immediately the balance shifted, and the pain of the thought of losing him once again outweighed the pain of watching him suffer.

"I know you feel real ucky now. But tomorrow you're going to be much better. All you need is a good night's sleep so your body can fight off all these bad germs. I bet you'll feel like taking a go-cart ride with Robert tomorrow!"

Apparently Joey didn't notice my tears or cracking voice. He lifted his head slightly, plopped his cheek onto his hand, and was swept back to sleep with a smile on his face. I fell asleep guiltily chanting my familiar prayer, "Please, God, let him live."

When I woke the next morning I discovered that Joey had already shimmied over his sleeping father and crawled to his toy bench. Miraculously he looked all right.

Someone kept responding positively to my prayers, but, as I watched Joey play, I wondered if it was right for me to pray for his life if his life wasn't right for him. Maybe someday I would regain the confidence I had lost during this round. In the meantime, I changed my prayer to, "Please, just make his life work for him, and our lives work with him."

We were never able to devote all of our prayers to Joey, since his brothers always managed to compete for the spotlight. Only a few weeks passed before resourceful Robert, while exploring the hillside behind his school, captured the pet he had fantasized about owning for years—a four-foot snake!

Copying a carnival act he had once seen, he proudly wrapped the prize around his neck and agilely leaped onto his bike. He was frantically racing for home when his new friend turned on him, embedding its four hefty fangs into Robert's chin. Our daredevil continued to pedal toward home with this dangling goatee, until he almost whizzed past his science teacher, who, naturally, was not unduly traumatized by the sight and perfectly able to grab the creature and dislodge its fangs. In the scuffle, the snake was able to scurry out of sight, and Mr. Steele escorted Robert home.

When we arrived at the UCLA hospital for treatment, the staff

promptly remembered Robert from a previous visit for blood poisoning, which had developed after he self-stitched a deep cut on his shin. The relayed message "Rambo's back," attracted a lot of curious spectators as we were led down the hall. Of course, I repeatedly babbled the story of the snake, and everyone marveled at how well I was taking it. They didn't understand that I was simply delirious with gratitude that Robert had not reached me with that snake still attached!

The next day, after securing the boys, I found myself wandering through the mall for one of my solitary "therapy sessions." Ignoring the strange looks, I always wore sunglasses on these special trips to cover any signs that my thoughts might reveal. True, I no longer needed a quick doctor to drop in and eliminate my need to think. Nevertheless, no matter how many times I encountered one of my children with a seizure, a stitchable wound, or a snake bite, I always felt the same horror at the sight, terror en route to the E.R., and sorrow that it had happened.

I could always squeeze fortification from the humorous and inspirational plaques and cards in novelty shops. So I sauntered into one such shop, unconsciously looking for something to reinflate my phony coping ability. Then I saw it! It was tucked into a corner on the top shelf, but its bold black-inked title caught my eye: *How to Solve the Cube.*

Almost every time I had seen Shawn since Christmas, he was twisting the Rubic's cube he had found in his stocking. I now regretted putting it there! I admired his perseverance, but the cube's solution seemed beyond him. I frequently got frustrated for him.

"How can you keep doing that?"

"I'm going to fix it," was his cool, steadfast response. His eyes never left his nimble fingers as they manipulated the cube.

I hated to take away Shawn's glory in a single-handed solution to the cube, but I doubted this would ever happen. Surely he wouldn't mind sneaking a look at the book for a few hints. The excitement of finding the answer to his exasperating dilemma made me forget mine, and I hurried home with what I believed to be the perfect gift.

"Shawn, look what I found for you," I exclaimed, unprepared for the aloof response he gave after casually glancing at the book's cover.

"Oh, I don't need that now, Mom. I fixed my cube."

"You fixed your cube? Let me see it!"

I forgot my flattened feelings and swelled with parental pride as I

followed him to his room. I thought back over all his hours of fiddling and realized he had really stuck to a difficult task until it had been solved. Since someone had to write a book to help all the failures, my child had obviously accomplished something that required above-average ability!

As it should have been, the cube sat in the midst of Shawn's other trophies. I was anxious to learn all the details of the final moment of arrival.

"Wow! How did you do it?" I sighed as I respectfully studied the color-coordinated sides.

"Oh, it was easy. I just moved the stickers."

"You *moved* the stickers?" My mouth hung open as Shawn continued with a simple explanation of his accomplishment.

"Sure, they come off easily. See, if you start at the corner and peel it back carefully, it won't tear. You can stick it wherever you want. See, you can't even tell." His excitement elevated as he demonstrated each sentence.

"But I know how you did it," I mumbled.

"So?" He shrugged nonchalantly before changing the subject. "The kids are waiting for me, Mom. Will you put it back on the desk when you're finished looking at it?" I heard his self-assured "Thanks," as he left the room leaving me with the baffling puzzle.

That night when I put the boys to bed, I surreptitiously studied Shawn's face as he picked up his cube. He gave it a swift turn and a pleased smile before returning it to its place. He really was taking this as well as he appeared to be. He didn't seem to be thinking about his unorthodox solution or the crinkled corners of the stickers; he just told himself he had a fixed cube!

I was still chuckling when I reached the bedroom where Robbie was organizing the clothes in his closet.

"You seem happier than I've seen you in a while," he said, aware of the downhill slide I couldn't get off.

I stretched out on the bed and related the story of Shawn's cube, but ended on a more serious note. "It reminds me of how I handled Joey with my beans. Now even I can laugh at my obsessive belief in the beans, but I'll always value them for the months they insulated. I wish I had some kind of gimmick to sustain me now," I added, raising my voice to be heard over the clinking hangers.

"Why don't you get back into your beans again? I actually miss the

aroma," Robbie commented without slowing his sorting process.

"But you would never eat them," I sneered. "And Joey lost interest when he found McDonald's."

"He loved the beans!" Robbie exclaimed. "Why did you have to introduce him to McDonald's?"

"I was thrilled when he recognized the golden arches and gave me his sign for 'eat,' so I stopped. Once he started dabbling in other tastes, I couldn't get him interested in broccoli and beans again. Actually, it might have been a blessing; the diarrhea was getting out of hand!"

"It's been months since Joey's had a bad seizure," Robbie said. He could never understand why my mood after an emotional battle didn't swing back as swiftly as his did.

"Sure, he isn't having seizures every day, but I'm still expecting them. There is no safe time. Even when he makes it through a day, something is bound to come up with one of the other kids."

"You're just letting it get to you. You've got to force yourself not to think about it." Robbie tried to rub some of his strong will onto me, as he shuffled through his shirts.

"I know all the tricks of talking yourself into things, but they don't always work that easily. Last week, when I went shopping with my mom, we passed a Winchell's donut shop. My mother immediately said, 'I could never eat those donuts with all that grease!' I'm sure she doesn't realize it, but every time she sees or hears 'donut' she says the same thing. I get furious every time I hear it. She simply talked herself into hating donuts. I can inhale a dozen without a single thought of grease! Sometimes you just can't program yourself the way you'd like to."

With a slight smile, Robbie indicated he was listening, then opened his sweater drawer as I continued.

"I keep myself busy enough during the day to stay at least one step ahead of my fear; but I can't get my nights together. Too many nights that Joey sleeps through, I stay up anticipating problems. Other nights I wake up intermittently with terrible guilt that I've missed the crisis. I was half watching a not-too-thrilling movie recently that had a wonderful line...." I paused to correctly remember, "'You have to learn to live with the things you hate in order to have the things you love.' If I could just sleep soundly through one night, that might...."

"Why don't we have Joey sleep with us all the time?" Robbie interrupted, realizing my rambling could go on all night without pause for

his response.

"I've considered that," I acknowledged. "He already ends up sleeping with us so often. But I don't sleep very comfortably with him between us. Anyway, I hear his breathing better over the intercom than when he's right next to me."

"Maybe we can get more sensitive monitors," Robbie continued, always convinced he could hit any problem if he fired enough solutions at it.

"I can already hear changes in his breathing when he has a temperature. You have to turn on all the lights for that video monitor to work. Most of his seizures are too silent and motionless for *any* monitor. I need to be alerted *before* his heart stops."

I hadn't even taken another breath when Robbie shouted, "I've got it!" Then, directing his eyes toward mine, "We'll decorate him with those big Christmas bells you had around here! We can pin them to the sleeves and feet of his pajamas." He continued with the smirk he always wears when he sees the bulls-eye. "If we hear one jingle, he's just turning over. But if we hear jingle, jingle, jingle—big trouble!"

Looking wide-eyed at each other, we laughed out loud almost simultaneously. Hopping over the pile of rejected clothes, we rushed out of the bedroom, rooted through the boxed Christmas ornaments in the garage, and were soon pinning clusters of bells onto our sleeping Joey.

I did not want to think about the bells too much, for fear of uncovering a flaw in the idea, but for the time being, they were the trick I needed to overcome my dilemma. Even if they didn't work, my belief in them would make them work for me. Confident that the slightest jingle of trouble would wake me, I fell soundly asleep for the night.

I picked up a lot of stamina from several consecutive nights of sound sleep, and it carried me through the next three months. But although I tried to ignore it, Joey was sinking during those months, as he continued to pass from one medical crisis to the next. He swiftly snapped back after every tumble, but each time with a little less strength. The seizures were few, due to a high level of medication, but he eventually regressed back to diapers and minimal mobility. His decreasing muscle control left him even more vulnerable to frequent aspirations. I kept pumping him with vitamins, fortified blender drinks, and my mother-in-law's homemade Armenian soups, but they could not compensate for the energy that the aspirations drained from him.

Nor could all the pounding of postural drainage take the place of one hefty cough.

Sick of his being sick, and afraid I wasn't doing all I could to save him, I set up a consultation with another UCLA pediatrician.

After updating her on the current happenings in our family, I continued, "He just passes from one weird medical phenomenon to the next. His mysterious afternoon naps are the latest. It takes me almost an hour of constant jiggling and cold towels to wake him up. His fifth birthday is approaching. When I remember him at four, I realize he has gradually regressed during this year."

"Sandy, what is the worst that could happen?" she asked, feeling my stress.

I reluctantly released the words, "Well, he could...die."

She softly cautioned, "You should also consider that maybe the worst is...he could live."

She could tell by my stunned silence that I still could not accept that possibility, so she advised returning to around-the-clock nurses, and arranged for me to have another consultation with a neurologist who was doing research at UCLA. Maybe he could give us some insight on how to turn our situation around.

After reviewing UCLA's volumes of medical records on Joey, the neurologist concluded, "We have to prevent all these aspirations. There is a limit to how much damage the lungs can survive, and he is rapidly approaching that limit. My recommendation is to tie off the stomach opening and insert a gastrostomy tube. This will prevent regurgitated stomach content from going into the lungs."

"Gastrostomy tube?" I could not disguise my revulsion. I pictured myself opening a flap on Joey's abdomen and siphoning his birthday cake directly into his stomach.

"But what about the mucous?" I asked. "A gastrostomy tube won't prevent his aspirating the mucous, most of which is caused by the Klonopin. We haven't been able to find a substitute for the Klonopin, which can control his seizures. It's a vicious circle."

"I know," he sympathized. "That's why you have to start someplace. I think the gastrostomy surgery is the safest start."

I seemed to drift away from the conversation. I was awed by his casualness as he presented the positive aspects of his decision. "It's a simple surgery, and the tube can always be taken out. Mothers are usually opposed to the idea at first, but the children do so well with it.

They become happy and content, finally getting adequate nutrition and gaining weight."

I felt a growing bitterness toward his strictly medical attitude as he continued.

"And it's wonderful for the medicines! You can keep the amount of medication in the blood more stable, because the kids can't vomit the pills."

When he had finished his side of the scenario, I was too upset to discuss it any further. I fumbled through a brief excuse and left quickly for home.

I went blindly through the remainder of my daily routine, engulfed in an exhausting mental conflict: Fight for life regardless of the cost? Or fight for a quality life at the expense of its quantity?

On one side, I knew this doctor's opinion was medically very sound. I had first heard the term "gastrostomy" when Joey was an infant, and thought it a freakish way of eating. Now, after years of exposure to a multitude of medical problems, I considered it a fabulous life-saving discovery—for some.

But for my Joey? My precious Pinnochio who had always fought against binding equipment in his determined struggle to be a real boy? Joey, who pulled out his I.V. tubes the minute you turned your back? This son, who grabbed spoons from your hand to feed himself, and whose persistence at anything was never lessened by his unsuccessful attempts?

I recalled the stress of Joey's infant gavage sessions, when it sometimes took over three pairs of hands to hold my tiny infant still enough to insert the gavage tube. Was my feisty five-year-old, strong and hyperactive when well, going to lie sweetly still while I pumped food into his stomach tube?

I fondly remembered all the times he stiffened his spine with pride as he pranced on his wobbly legs to his horse. He always seemed so self-assured and oblivious to the support I provided at his armpits. He was the one always "taking it well!" No matter how mixed up his medical problems were, he always saw himself as "fixed." He always found ways to make his life work—his way. How could I steal some of the stickers from his cube while he was anesthetized?

Then there were all the little complications that could be caused by this "simple surgery," like anesthesia and infection. We were veterans of many medical battles, and had persevered because we were fighting to

increase normalcy. This proposed surgery could save Joey's lungs and prolong his life; but I could not help thinking that it was just the beginning of keeping a lot of tubes alive! Gastrostomy tube, then trachea, then breathing machine, then...where were we heading, and when would we pull the plug? In this age of wonderful medical advancements and new abilities to prolong life, I felt that Joey's dignified desire to be a "real boy" might sometimes be left a few paces behind.

By the time Robbie came home from work, I was completely drained. He listened silently as I hit just a few of my thoughts about the morning's consultation. Then we had one of our typical in-depth discussions.

"Absolutely no surgery and no tube! End of conversation!" Robbie always seemed to reach home without touching all the bases that I needed to cover! For once, I was pleased with his authoritative brevity. I liked the freedom from full responsibility for the decision.

Later that evening, I approached Robbie again. Robert was assisting Robbie with one of his uniquely modified respiratory treatments. Robbie held Joey's feet and hung him upside down and gave him a few back slaps to loosen mucous, then twirled a rolled-up Kleenex in his nose until he sneezed. The technique was a little unorthodox, but it brought forth more mucous than twenty minutes of conventional postural drainage.

"Robert, will you give Joey a piggy-back ride while I talk to your dad?"

"Sure, Mom."

I waited until Robert and Joey were out of hearing range before I said to Robbie, "We have to make a decision, and the only other choice is messing with the meds again. Do you think he's strong enough to survive another severe seizure?"

"Look...why don't we just stick with Dr. Cokely; she hasn't steered us wrong in the past. Call her in the morning and see what she has to say about all this. Let's just take one step at a time."

Actually, Robbie was avoiding taking any steps at all. Whenever he encountered a complex problem for which he did not have a speedy answer, he tended to stand back and give it lots of room to resolve itself. Somehow, his strategy worked more often than not.

I phoned Dr. Cokely the next morning, and she came up with a much easier next step. "Considering Joey's neurological condition, I certainly wouldn't subject him to any surgery. I'm not too anxious to try

lowering the Klonopin again, either. Let's see what happens if we reduce his Tegretol." She gave me a step-down drug plan with instructions to call her with daily reports.

Even by the next day, the results were amazing! Joey, who had lain motionless throughout the previous morning, was now trudging in his walker toward his classroom.

On the way down the hall, I happened to notice a quote someone had added to the parents' bulletin board:

The hardest thing to learn in life is which bridge to cross and which to burn.

Words, David Russell

Joey's alertness increased enough for him to thoroughly enjoy his fifth birthday party. After we helped him blow out the candles, he dropped his face into the decorated frosting and came up with a huge mouthful of cake. As I watched the whipped cream drip from his nose past his glittering grin, I knew we were on an upswing.

We had thought that Joey's year of regressing health had been due to lung complications. To the contrary, three weeks later, his blood levels revealed that he had actually been overdosing on Tegretol, even though all his earlier blood tests had shown only a negligible level of that drug. This was just another strange side effect of his seizure medication.

With Joey's improving health, life began to look good for all of us again. Robbie's film *Stand by Your Man* was nominated for an award from the Academy of Country Music, and a month later he was honored with a Christopher Award for producing the acclaimed *Crisis at Central High*, with Charles Durning and Joanne Woodward.

Robert, Shawn, and Marty had the fun of appearing in Robbie's spring project, *Take Your Best Shot*, a movie about an actor struggling to make sense out of his life. Soon after their scene we coordinated a vacation with Robbie's brother and his family, and rented giant trailers for a week of camping on a seemingly isolated beach that was really only minutes from a hospital.

When we returned from vacation, I looked forward to the upcoming Academy Awards. Even though any event on our calendar could only be penciled in, there wasn't time for one bit of depression when I was consumed with the burden of finding a dress. I loved seeing excit-

ing moments shimmering in my future, and I put them there on purpose. The anticipation was almost as therapeutic as the actual event!

The heavy questions were left behind to emerge at a later date. I knew we had just moved the stickers on the cube again, and I had no idea how long the glue would hold this time. Fortunately, I was learning how to enjoy the moments of living with a fixed cube!

Settle for a Splinter

*It is the time you have wasted for your rose that
makes your rose so important.*

I had always thought I could make up the difference for Joey by car-
rying him up any number of stairs and onto every amusement park ride.
I never thought he'd live long enough to become too heavy for me. But
he did, and sooner than I could accept!

During one of our frantic ambulance rides, I had clobbered my el-
bow, damaging the ulnar nerve. I tried to ignore the injury for a few
months, but finally numbness in two fingers made a doctor's visit un-
avoidable. I spent the summer with a cast, and with the threat that if I
didn't curtail lifting Joey and his equipment, I could permanently lose
the use of my left arm. Undoubtedly, I would have to find new activi-
ties for Joey that required less of my physical involvement.

We did have an assortment of battery-operated cars and motor-
cycles, which Joey loved and always managed to operate. But these ve-
hicles moved too slowly on the carpet, and Joey had outgrown most of
the toys we could tie to his bench, so we were running short of indoor
activities for him.

One day I brought home a Creative Playthings slide and set it up in
the center of Joey's room. At first I was very pleased with how inter-
ested Joey was in the slide, but it made me too nervous to watch him
dangle on the ladder as he persistently shrugged off my attempts to
help him up. Thus, I padded the area on the floor around the slide and
left the room.

Joey seemed to have an insatiable appetite for repeating things until
he mastered them; somehow, he seemed to know what was within his
abilities to master. In the weeks that followed, I could tell from the

thudding and banging sounds I heard on the intercom that he was working on the slide.

One afternoon I discovered Marty outside Joey's bedroom door, intently studying his brother's activity.

"Wow, Mom, I think we should send Mrs. Keenan a thank-you note!" I peeked at what my first-grader was observing, and saw that Joey had learned to grip, climb, and maintain his balance as he slid down the slide. We both stared in awe as Joey repeated the feat, and Marty revealed his assessment. "Mrs. Keenan has the whole class pray for Joey every day. We ask God to help Joey become big and strong. These prayers are really working—look how much stronger he is! I think we should write Mrs. Keenan a note and let her know she's doing a good job with these prayers!"

As we were composing Mrs. Keenan's note, I gently suggested, "You know, along with the prayers, there are lots of other things we can do to help Joey get stronger."

"Like what?" Marty asked, seeing more potential in his brother.

"Well, you know how he tried so hard to say 'o' the other day? Well, the more we keep encouraging him to say 'o,' the easier it'll become for him."

I still can't believe how much success that tiny suggestion stimulated. That night, Marty formulated what he called "the family 'o' game." Starting with "Let's see who can say the best 'o,'" he would give each of us a turn, wait patiently while Joey tried to produce something similar to an 'o' sound, then loudly proclaim, "The winner is...Joey Papazian!" We would all clap as Joey squealed with laughter.

It is not always easy to spark a child's interest in his sibling's therapy, but when you do, his time becomes invaluable. After weeks of Marty's encouraging game, Joey's 'o' was perfect enough to legitimize his winning.

Joey was thrilled to show off his accomplishment when Linda arrived the next afternoon for his tutoring session. Linda had been as persistent as Marty in encouraging Joey to speak. She insisted that he attempt the words for the various things involved with their ritual of making her cup of coffee, until "open" and "out" became recognizable words.

That day, since I knew Joey could make 'm' and 'o' sounds, and since he seemed to recognize most of the alphabet, I ventured to ask, "Joey, can you spell 'Mom'?" When he combined the three sounds cor-

rectly, I knew we were on the road to full communication!

Linda could not be as elated as I about this instantaneous achievement, for she had been overseeing its tedious development. But after devoting herself to Joey for an hour, she joined me in the kitchen and allowed me to bombard her with bursts of bragging about my son's split-second spelling success.

While I continued to prepare dinner, she casually brushed off my compliments about her contributions and probed, "But to whom do you attribute most of Joey's progress?"

I paused while the full realization hit. "You know, there have been so many people who have helped us along the way, I can only make guesses as to who has been the most effective. One thing I am sure of—Joey is the real key to himself. We all may have encouraged and motivated and prayed for him, but it is his drive that has kept him moving forward. Sometimes the praise leans too much to the therapists, teachers, and parents, and overlooks the tremendous human drive to overcome limitations...and some people are more endowed with this drive than others."

"Surely you must be proud of what you've helped him accomplish?"

I had to consider Linda's question a while before I could explain. "I'm proud of him for making his life work. I'm proud of myself for making my life work *with* him."

I wasn't confident that she had understood, so I elaborated, "I merely showed Joey the toilet sign; he trained his hand to do it and pressed people to respond to it. It took me years to reach the conclusion that I needed to live my own life, not his. I needed to be proud of my own accomplishments, not his. If he walks, that's his success. When I walk the track improving my health and endurance, that's mine."

After Linda left I continued to ponder the question, only now more from my perspective than from Joey's. Knowing that the contributors and their scales can vary, I was certain that whatever successes were achieved belonged to the one being weighed. Still, I realized that the opportunities for me to live my own life would always be too few to result in much success, unless I could find a way to limit my involvement in the needs of others.

Throughout that fall I gave Joey respiratory treatments only when he truly needed them. Fortunately, he didn't really need them very often, for he was making slow but steady progress, with fewer life-threatening stumbles. But despite this step forward, I failed to heed my

doctor's warning about weight lifting, and during the winter, I landed in the hospital to have surgery for an abdominal hernia. Recuperating became another opportunity to dig down to the core of what was still eating my time. Of course, Joey flashed instantly into the foreground.

One can spend several absorbing years with a toddler; but then, children normally outgrow their dependency. Joey never would. My elbow injury, and now this hernia, had forced me to see that I could not carry him through his later years. I loved him dearly, and I wanted him to be free to open whatever doors were within his reach, but even if I were strong enough, I did not want to spend a lifetime holding him up. I wanted to provide him with enough padding so that we *both* would be safe to climb our own ladders.

In the past I had always benefited from writing down everything that was contributing to whatever pressure I felt I was under, and then studying and distilling those things into their simplest form before developing a plan of attack. I fumbled through the hospital drawer for a pen and paper. It took me more time than I expected, but the final draft proved to be well worth the effort. I had isolated columns of what I felt were the most important things to concentrate on for Joey.

Next I listed all the things I did in a typical day of mothering three normal children plus a handicapped one, and to my dismay I discovered it added up to more than twenty-four hours. At least now I understood why I always felt under pressure. There was not enough time to even scratch the surface of what had to be done for Joey!

It took a good fifteen minutes just to take Joey to the toilet each time. I had to balance him against my legs while I kept his hands from grabbing whatever was in sight; talk him into a sufficiently relaxed state to release his bladder; wait patiently as he repeatedly struggled to snatch the toilet paper, then wipe himself, put the seat down and flush the toilet. Finally, we moved to the sink for soaping, rinsing, drying, and disposing of the paper towel. If I tried to intercede with too much help, he would angrily grunt while clutching his arms to his chest—his sign for "I want to do it myself!"

Naturally, he had to use the bathroom often, since he always loved an opportunity to participate in anything. How could I shorten the time he needed to do all this? What could I cut out? Maybe I could teach him to flush faster? Then I thought, maybe I should just flush the whole list.

I remembered a story Linda once shared with me. She had sug-

gested to another mother of a handicapped child some "simple little daily things" the mother might do that would greatly enhance the girl's academic progress. To Linda's surprise, the woman started crying and confessed, "I don't do anything with her. I don't have time. All I can handle is getting her dressed, fed, and toileted!"

Someone who has never dressed, fed, and toileted a handicapped child would not understand that by the time you get through these three big basics, there is little time left for the "simple little daily things." And in addition to the teacher, the physical therapist, the occupational therapist, the speech therapist, the ophthalmologist, the neurologist, the orthopedist, the pediatrician, the pulmonary specialist, and whoever else sees your child have all given you lists of "simple little daily things." Sometimes doing nothing is the result of trying to cram that oversized list into what little time remains of your day.

I tucked Joey's columns away and chose to concentrate on rebuilding my own strength before trying to find a solution to this plight.

A month later Joey started his last summer session at UCLA, and I was again able to attend the weekly mothers' meetings. During one gathering, Nancy Miller arranged for us to watch a recent television movie, which starred Cloris Leachman as a woman who chose to adopt a child whose severe brain damage left him with only the prospect of institutionalization. The woman devoted her life to providing the child with as much stimulation as possible. After more than fifteen years of her magnanimous effort, the boy was miraculously able to sit up and play the piano.

At the end of the movie, the average person would have to be captivated by the family's glorious moment of triumph and inspired by all their years of dedication in defying the impossible. I thought it interesting that the parents of handicapped children seemed to be more intimidated. Some wanted to rush out and buy a piano; others, like me, just bought more guilt.

There is so much guilt wrapped up in raising handicapped children, primarily because their needs are insatiable. Even though you know you can't compensate for what they lack, the thought always haunts you, "Maybe if I did more, he could do more!"

Uplifted by the movie's ending, it was easy to overlook that the child was still extremely handicapped. Furthermore, there is a big difference between choosing to adopt a handicapped child and choosing to make the most out of what you are given. This was Cloris' character's

chosen career, not her cross to bear.

At home, I found my first solitary moment of household peace, fixed a cup of coffee, and locked myself in the bathroom for a little crying break. Most people have an occasional medical emergency during a lifetime; our family didn't seem to take two steps without running into another hospital!

When I was freed from pressing medical problems, I felt the pressure of Joey's predominating goals of mobility, self-help, communication, and education. I had to suffer through the emergencies, so I wanted my free time to be filled with *fun,* in order to be fortified for the next crisis. I didn't want to invest all my leftover time in the hope of long-range happiness for only one son, in areas that might never materialize. I wanted immediate gratification for my efforts! I wanted to see a smile on Joey's face every day, because smiling was the only ability he had that helped me feel the rightness of his living.

I *chose* to be there for Joey, but I also wanted something for myself. I did not want to play Cloris' role. On the other hand, I could not see how I could relieve myself of the pressure that I should. I desperately needed to find a way to balance Joey's needs with those of the rest of the family—including my own. But somehow Joey's needs always tipped the scale.

Eventually I decided to hibernate in the bathroom and cry until the next inevitable emergency occurred. But my break was cut short when six-year-old Marty came into the house sobbing. I reluctantly dried my tears and went out to see what I could do about his. I found him lying on the couch, drenched in his own depression.

"What's wrong?" I asked, after a casual check for blood.

"Well," he said, and then paused for a deep breath. "I have so many problems with my body! My head hurts...I can't keep my feet on my skateboard...my leg has this big scratch on it...most of the skin is off my elbow...and now, I have a splinter in my foot!" He resumed his sobs after hitting the scale-tipper.

"Well, let me see if I can get the splinter out," I said, trying to sound as concerned as he was.

"But you can't! It's going to hurt too much!" he hollered.

I understood his fear when I discovered that the splinter was the size of a twig, but I was sure his actual pain was not as great as the anticipation of removing the intruder.

"I've got an idea. Why don't we turn on the TV? You can concen-

trate on a cartoon. Then, when you're not thinking about it, I'll quickly pull the splinter out. As soon as it's out and your foot is bandaged, I bet the pain will go away."

Since Marty always leaped at a chance to watch television, this remedy intrigued him.

When I returned with the tweezers and was ready to proceed, he restrained my arm and spit out a last-minute request, "I'll tell you when to do it, Mom."

Barely breathing, he stared at the screen with self-hypnotic intent while I held his foot, aimed the tweezers, and waited for his cue.

Then, without a blink of focus, he grimly said, "Okay, do it."

Fortunately, the splinter slid out easily.

"Wow! It didn't hurt," Marty shouted with relief when he saw the empty wound. He continued his delighted jabbering while I bandaged his foot. "This was a good idea, Mom. We need to do this whenever I get a splinter. This not thinking really works! Thanks, Mom!"

Marty jumped up and ran for the front door, but turned back to leave me a swift, slobbery kiss and another, "thanks, Mom!" He had obviously forgotten all the other problems with his body. He was outside before I realized that *I* should have thanked *him!* But then, he probably wouldn't have understood why he had relieved my splinter too.

Looking back over the past, I realized that the pressure of Joey always became unbearable when I concentrated on the distance we were from where we wanted to be. I could never do all the simple daily things that were necessary to keep him far enough away from death or close enough to independence, but somehow, by little sips and inches, we had found a comfortable spot in between.

Sometimes the answers to heavy, complicated problems were so simple that I overlooked them. I couldn't wait to find the list I now knew I didn't have to flush. I needed the comprehensive list to help me see the direction I was heading. I didn't need to allow myself to be intimidated by well-meaning professionals who couldn't see the whole picture. It was only necessary to pick a few of the things that I felt were most important and that I knew I could accomplish. Then, tuck the rest back into the drawer until it was time to reevaluate my progress and priorities.

Now I don't waste time with guilt. Whenever it creeps up, I remember that just removing a splinter of a child's problems can make it easier for both parent and child to live with what remains.

Chapter 17

Color Your Own Life

Grown-ups never understand anything by themselves, and it is so tiresome
for children to be always and forever explaining things to them.

WITH Kit's concentrated help during our last year at the UCLA Intervention Program, Joey regained his lost toilet training and improved his classroom cooperation. The school district acknowledged his normal intelligence and his need for a full-time classroom aide, so in September, Joey, now six years old, started the first grade at McBride Elementary School for Handicapped Children. It was a big step away from the sheltered atmosphere of UCLA, but we both needed to try to make it on our own. Our mother/child bond had been woven tighter and longer than the norm, and the separation soon forced me to get involved with as many projects as I could to ease the transition.

I knew I wanted Joey as a son and not a career, but it was difficult to adjust to dropping him off at school every day. The school district offered to provide transportation, but I chose to decline this convenience. I was still finicky about leaving Joey in the classroom; I could not fancy letting a cold, ugly bus take him there.

Every day, on the way to and from the classroom, I had to wheel Joey past the tarnished buses in front of the school. Each time, his pointing finger indicated his desire to ride, but I ignored it, hoping his interest would fade. Then one morning when the protesting became too much too ignore, I reluctantly asked, "Do you want to ride the bus?"

It was uncanny what perfect head control Joey had when he wanted to emphasize his yes.

"All right," I conceded. "I'll see if we can arrange to try it for a day."

The transportation people were very cooperative, but we had a lot of scheduling problems due to the system's overload of students and

lack of buses to accommodate them.

Initially I was pleasantly compensated for the hassle by Joey's glee-ful excitement when one of his brothers shouted, "The bus is here! Put on your listening ears, it's time to go to school!" Joey pantomimed at-taching his ears as he passed out kisses to each of us. It took three of us to get his wheelchair, tray, walker, books, and lunch out to the sidewalk, a task which I had previously tackled alone.

After the bus driver warmly greeted Joey, she let him hold her keys while he rode the lift and pretended to control the event himself. The bus rides turned out to be the highlight of his day. Their dull yellow color looked brighter to me, too, as I recognized the physical relief and time-saving convenience they afforded.

Now that Joey was at school part of the day, it was easier to plan dinners, and set up sitters and nurses for the boys so that I could visit their father, who had been on location in Kansas City for over a month. Robbie didn't have much time to spend with me, since he was in the middle of producing *The Day After*, a difficult and depressing project about nuclear war. Although I seldom took advantage of the opportu-nity, I always enjoyed the novelty of exploring the shooting locations and getting a close look at the movie-making process. Since Robbie was busy, I was also free to reflect on a persistent personal problem that re-mained unresolved.

I was learning how to control my own life, but I was still unsure whether I was allowing Joey enough control over his. Did he want to live as much as his family wanted him to? I kept pumping him with food, pills, and air, but during all those years of watching him suffer, skepticism had slipped into my belief in the value of life despite its problems.

I had been toying with the idea of writing a book. It would be a great diversion, and perhaps while writing I would stumble upon the conviction I had lost. I never thought there could be a single answer to all of life's controversial questions. I just wanted to be sure that Joey agreed with the choices that had been made for him.

In a quiet moment, I proposed my idea to Robbie. He didn't exactly shower me with encouragement, but the next evening he presented me with a briefcase full of stationery supplies and his simplistic assurance, "Now all you have to do is start."

After I returned from my relaxing trip to Kansas City, I was quickly reminded that quiet moments were never easy to find in our chaotic

home. Thus, when my birthday approached, I asked my relatives to take over the household for me instead of buying me gifts, so that I could check into a local hotel for a long weekend of writing.

It worked well. Joey seemed to enjoy the novelty of my telephoning for our regular nightly pep talks, and with frequent calls I could coordinate other home routines as well.

Luckily, I had enough time to set up a book outline before my hideout was invaded by the rest of the family. When I responded to a gentle knock on my door, they all filed in with kisses and a cake, and proceeded to check out the room. My sister apologized for her unsuccessful attempt to block the plan, but, she said, "The boys kept insisting, 'We know my mom misses us!'"

Marty stretched out on the bed, inhaled deeply while clasping his hands behind his head, and softly confided, "You're right, Mom, our house is too noisy. We need breaks like this."

During the time I was able to squeeze it in, I was uplifted by my writing project, and slowly I began to see clearly our lives since Joey's birth.

Hoping to acquire information I could use in my book, in the early fall I went to a meeting for past and present parents who had attended the UCLA Intervention Program. The UCLA staff had arranged presentations by representatives of the three most recognized therapies for the cerebral palsied: Bobath's neuro-developmental treatment, Jean Ayres' sensory motor integration, and Doman-Delacato's patterning. Having been involved at different times with all three, I felt like a graduate from the school of hard knocks as I listened and reminisced.

When Joey was between the ages of one and two, the idea occurred to me that he might progress faster with additional home therapy. We had a lovely, well-qualified therapist trained in the Bobath method come to our home twice a week. She helped me understand a lot about cerebral palsy, but eventually I had to admit that her visits were frustrating me. She tried to properly position Joey's limbs for exercises that would increase the tone and strength of his muscles, but at that time Joey's attention span was very limited, and so most of her energy had to be devoted to working around his irritability. This made me feel like I was wasting money and everyone's time.

It was difficult for me to let her go—not only because I was fond of her, but because I felt guilty in doing so. It occurred to me that I might be blindly cutting off something that was helping Joey. I soothed myself

by adding another quotation to my collection on the refrigerator door:

> Leaves are like ideas in the mind. They come when
> needed. They flourish and give life, light and wisdom. When
> ideas have served their purpose they need to be swept away. We
> must constantly sweep out the old to make way for the new.
>
> *Words*, Jan McKeithen

Every time I eliminated something, I refilled the resulting gap. So when I heard favorable reports about the Jean Ayres' therapy, I promptly put it at the top of my list of things to try.

After Dr. Ayres tested Joey, she explained that she didn't usually accept children as young as three, but she agreed to make an exception for Joey. She was intrigued by his determination to move despite the severity of his palsy.

Dr. Ayres' program used students for in-service training, so each child was dealt with on a one-to-one basis, under Dr. Ayres' supervision. Parents were usually asked to wait in the lobby, but because it was so difficult to control Joey, I assisted the staff.

The sessions were held in a room that looked like a combination gym and playground. There were riding toys, trampolines, and a large assortment of hammocks and various-size platforms suspended from the ceiling, all of which were designed to improve balance and coordination. Joey's favorite was the hammock, but he seemed to be excited just being around all that motion. The student therapists braced him in different positions, then they swirled him back and forth again and again. Joey thoroughly enjoyed every moment.

I was deeply impressed by Dr. Ayers' dedication to her theories, and even more by the flexibility in her approach to them. Even though I never could grasp how and why this therapy was supposed to work, I somehow felt that Joey's insatiable appetite for mobility indicated that he needed it.

Nevertheless, after a year of twice-a-week visits, I began to realize that I could do a lot of this at home and save myself the money and the ninety-minute commute.

Dr. Ayres was sympathetic. She helped me assemble the right kinds of hooks, hammocks, and floor mats to build a mini-gym in our home. I stuck my "leaves" quotation back onto the refrigerator door, and

helped simplify my life by setting up a small therapy corner in our den. That way Joey's brothers could have fun spinning and swinging him while they watched television. Actually, it was a toss up as to which Joey preferred, the movement or the attentions of his brothers.

Then there was patterning. For years I had heard of people making trips to Philadelphia for extensive all-day therapy sessions that involved the entire family. I never felt it fair to cripple the other boys so that Joey could walk; but as an ardent believer in the value of stimulation and in sampling everything available, I had always hoped for a chance to test Joey's response to intensive patterning therapy.

Opportunely, just before Joey turned four, I learned that Robert Doman, Jr., had started the National Academy for Child Development in Palos Verdes, California. This was a modification of the Philadelphia program; Dr. Doman reduced the parental pressures characteristic of the eastern program, and widened the focus from the severely disabled to include patients of all ages and abilities. The NACD was founded on the theory that we can *all* improve with frequent intense mental or physical stimulation over a long period of time. Since I had already reduced my chores by discontinuing the Ayres program, I swiftly signed up all four boys for the summer.

The children were divided into groups, and with parental assistance, rotated from one type of activity to the next—smelling, tasting, twirling, creeping, crawling, working with flash cards, and using computers. The patterning exercise was reserved for the immobile, and its purpose was to attempt to reprogram the child's brain through the proper developmental stages by moving his limbs to simulate crawling.

On the padded patterning table, Joey would lie chest-down, with me standing at one end of the table to rotate his head while two other helpers on opposite sides of the table rhythmically moved his arms and legs. We all coordinated our pace so Joey's body moved in a correct crawl, a motion his damaged brain had prevented him from performing alone.

Joey was always a welcomed visitor at the patterning table. Since it is very tiring to move stiff, spastic limbs, Joey's tonelessly flexible body was a refreshing breeze to the volunteers. But each time we would all get into a nice rhythm, Joey's limbs would suddenly stiffen, jarring everyone's drifting attention back to the table. I would hear comments like, "He must have had a spasm that he couldn't control." I didn't think he had spasms, but I didn't have a better explanation. Since the

patterners alternated, they never suspected what I began to see: each spasm also brought that same little smug smile to Joey's face! We thought we were manipulating his limbs, but he knew he was in control of the situation.

I loved this little trait of Joey's! Despite its hindrance to the therapy, I could not intervene with appropriate discipline. So I kept my discovery a secret, and outwardly seemed to agree with the spasm theory. Joey had always been determined to have some degree of control over whatever was happening to him, and I wasn't going to block an ability I admired.

We all benefited from the summer. The boys had a good tutoring program combined with exercise. Joey had a lot of stimulation and playtime with Mom—who was exhausted, but able to see the effects of the consistency and intensity that this program provided. Joey had gradually progressed in his ability to give the correct signs for stacks of picture flash cards.

When all the therapists had concluded their presentations at that UCLA meeting, I felt I had matured with the reminiscing. But then one of the younger mothers came over to ask me why I was not involved with any of these therapies any longer.

"Actually," I replied, "nowadays I'm into normalizing myself!" Since I had not intended the truth to slide out so bluntly, I followed it with a silly giggle, which cut short our conversation.

Being unable to trust what could pop out of my mouth unedited had kept me painfully shy for most of my life. Undeniably, after years of speaking for Joey, I had finally developed the courage to open up, speak my mind, and face the consequences. As this mother continued on her way to the refreshment table, I could tell from her expression and newness to the handicapped world that she did not understand my selfish statement. But, then, she did not have behind her years of hearing Kit's favorite answer to everything: "It's whatever works for you."

In the search for what worked for me, I had developed firm opinions along with my willingness to express them. I do not believe in handicapping parents in an attempt to normalize a child; and I do not believe in aiming for a "well child" at the expense of the family's happiness. Instead of focusing only on making the child function, I think we should concentrate on making the family function with the child. That way everyone has a better chance for a better life.

Driving home from that reflective evening, I realized that my

flippant answer to that mother might have been a little misleading. I still wanted to involve Joey in as much professionally grounded stimulation as our family could juggle, but I had already graduated from the novice handicapped parent's beliefs. Sometime during all those years of scurrying from one therapy to the next, I had stopped looking for the cure and praying for the miracle! Maybe the threat of too many losses had made me concentrate on being happy with what I could hold on to. I could easily identify with all the interest these newcomers had in the therapies presented, and all the enthusiastic questions they asked. Whenever I hear of a new therapy that "lots of people are having lots of success with," it still sparks as much excitement in me as a fifty-per-cent-off sale. Maybe I'm going to get twice as much progress with half the effort!

But I have learned to hesitate before I leap into line. I remind myself I'm getting into *possible* benefit, not *positive* cure. Nothing is free, so first I always try to check ahead and assess whether I can afford the time, energy, and disappointment.

If I decide to take the plunge, the next difficulty is knowing when it's time to bail out. I try to sift the best from the therapy and sort out what works for me and what works for Joey. If Joey isn't happy, it doesn't work for either of us.

Therapy for a handicapped child has to be cleverly worked in with professional guidance until it becomes a way of life. Actually, I think it would be more beneficial for the professionals to work with the parents rather than with the child. You don't go to a weekly Weight Watchers meeting and lose weight. You have to apply what you learn on a daily basis.

It took me a long time to recognize that I could provide Joey with encouragement and therapists, but I could not control the effect these two had on his muscles. My efforts were never directly proportional to his gains! Once I had accepted this, I turned to developing control of my own muscles. Over the years I had learned how to modify the therapies so that there was more time to work on myself and the other boys.

I think of Bobath when I balance Joey on a beach ball while he reaches for the sand, and of Ayres when I ride a tilt-a-whirl at the amusement park. I love to incorporate anything therapeutic for Joey into having fun with *all* of my children.

I think of Doman every time I make barbecued chicken. I set out

all my ingredients on the counter by the grill. Then, with Joey standing on a chair in front of me, I can balance his body while assisting his hands to combine the ingredients. Somehow he manages to stand up straight when he's doing something he enjoys. We read the labels, and smell and taste the ingredients before mixing. Next Joey picks up the chicken legs, dumps them into the sauce, and drops them onto the grill—a wonderful grasp-release exercise! I've learned tricks for minimizing the mess, and it doesn't matter if he doesn't make tremendous strides in this therapy. There is no wasted time. I have dinner for the family, and a lasting memory of fun with my child!

I've depleted a lot of the normal guilt associated with rearing a handicapped child by recognizing the therapeutic value of activities like going to the beach, or a park, or having a barbecue. When I look back over a busy week, I don't have to feel like "I don't do anything" for Joey. I've learned that I cannot make his life perfect, even by ruining mine, and I credit myself in the therapy column for standard mothering.

On the night these assorted therapies were presented, Dr. Howard summarized the evening by explaining that the UCLA staff had tried to present the variety and allow the parents to make the choices. Then she concluded by sharing a thought-provoking little story, probably to caution people like me about possible overdose.

A mother who had once been in the UCLA Intervention Program enrolled her daughter in a Brownie troupe. To acquaint the girls with her daughter's affliction, this mother decided to have the daughter assist in an introduction speech.

"Now, can you tell the group what your condition is called?"

"Terrible palsy."

"You mean cerebral palsy," the mother corrected what she thought was an accidental slip.

"No!" the girl decisively replied. "I mean it's terrible, and I've got it!"

I am certain Marty would consider this a direct hit on Catalina. Cerebral palsy is terrible for the parents and terrible for the child. Why add more terrible to the palsy by involving the child with a lot of therapies or therapists that are plainly no fun? If the child is happy with a particular form of therapy, he or she will work. If not, the child will work at wasting everyone's time. I think we diminish the value of arriving if we don't enjoy the trip!

I know I compulsively try to add colorful excitement to my family's lives. At times, it compensates for a lot! On the other hand, I also try to keep in mind another mother's story of how vehemently she fought the Disneyland management to allow her C.P. son to ride the Matterhorn. Then the child, who actually wasn't as anxious as she about his need to ride, vomited all over her good intentions.

Sometimes I force what I want or what I think will be beneficial, and overlook what my children want or what really benefits them. Just as the bus that looked like dull mustard to me was bright yellow to Joey. Children often color a picture differently than their parents do. We all should have the right to choose our own colors.

Chapter 18

Fry Your Own Bacon

It is much more difficult to judge oneself than to judge others.

BLESSED with a terrific teacher and a competent classroom aide at McBride, Joey was adjusting to school better than I ever imagined. He was somehow getting his messages through to others, and no one who had had sufficient time to get to know him questioned his intelligence. When Joey was strapped into his weight-relieving walker, he could even stand alone.

But Joey still could not sleep unguarded. Lately he would shift into a strange pattern of rapid breathing, tachycardia, and skipped heart-beats. We did not know if this was a new type of seizure, or another side effect of his medication.

I eventually put in an SOS to Dr. Cokely. My reluctance to risk changing Joey's medication was softened by the fear of his having a cardiac arrest. Dr. Cokely felt it was time to tackle the Klonopin again, replacing it with Tranxene. She set up a two-month schedule for the switch, hoping to avoid another hospitalization.

As usual, things got a lot worse before they got better. Since the seizures were scattered throughout the night, Robbie and I decided to have Joey sleep between us until he became more stable. I discovered that keeping my hand on his cheek and draping his legs over mine guaranteed that I would wake up when he started to shake. At the first twitch of trouble, I stimulated Joey with cold cloths and shouted com-mands like, "Open your eyes! Give me your hand! Joey, kick your leg!" Often this seemed to jar him back into a normal sleep with minimal interruption of ours.

Years of practice enabled both Robbie and me to survive with scant amounts of sleep. I never understood how Joey could dangle so danger-

ously close to death at night and then manage to be so full of life during the day. Generally, we tried to follow his lead and continue with our days as if the nights had not happened. In the throes of moving and renovating our new home, this became more a necessity than an effort.

When I was recuperating from my spring surgery, Robbie had completed his movie about herpes, *Intimate Agony*. Before getting entangled in *The Day After*, he had decided to refurbish my mood by purchasing a house we had been considering because of its remodeling potential. Unable to find a home built with four boys in mind, building one ourselves seemed a more likely way to get exactly what we wanted. Only other remodeling fools know how you can live to regret this decision.

Our start was delayed for months because every night one of us would come up with a "better idea." We spent days arguing about which way a door should swing. The plans were an endless puzzle of possibilities, and as soon as we got one part together, another didn't fit.

Because we were so indecisive, our current house sold and had to be vacated before the remodeling of the new one was completed. Therefore, at the end of October, we found ourselves jammed into a rapidly decaying rental with antique appliances and only one bedroom. The boys loved sleeping on army cots in the tiny den surrounded by their ant farms, hamster cages, and old English sheepdog, but even a modestly stressed mother would have been a little shaky in this kind of situation. I knew from past experience that the combination of high stress and little sleep would result in a slow deterioration of my support system, unless I could push myself around the corner in time.

One afternoon, when I returned to this makeshift home after a doctor's appointment, I snapped at Robert, "The next bone you break is going to mend without me."

Later, to appease my guilt, I agreed to let him concoct cookies in a corner of the kitchen while I prepared dinner and phoned a plumber about the toilet that had overflowed that morning. Since the stove was on an island that protruded into the narrow room, I could cook, talk, and watch Robert, who was on the opposite side of the island. He was sitting on the floor in the midst of all the necessary ingredients with an unblemished cast on his elevated right ankle and soiled fiberglass on his left wrist, which had been broken a week earlier.

I had had almost enough time to schedule an appointment with the plumber when I saw a tablespoon go into the box of baking soda and

realized Robert had misread the recipe. The cord of the wall phone was long enough to reach him as I stretched to save the cookies, but it coiled under the boiling pot of chili, severing my connection to the plumber.

After dinner, I was trying to shut a warped bathroom door when the screws loosened and the knob slipped off. So, before I climbed into bed with Robbie and Joey that night, I stuffed down all the leftover cookies while I jotted a few more things to do into my organizer.

The next morning I awoke with the same pressure I had gone to sleep with: Christmas was coming, and I wasn't ready! Every year my Christmas list seemed to get longer and my shopping time shorter, but I still kept looking for the perfect gift for everyone.

I had hoped to get a little shopping done this particular day, but Joey's school was having a Halloween carnival and needed extra parents to help. The McBride School staff had overextended themselves and set up the schoolyard with an assortment of activities. When I entered the classroom, I could feel the excitement.

Joey's teacher, Diana, greeted me warmly, then she hesitated before asking, "Would you mind being responsible for Lester today?"

I followed her glance to a face that looked like Alfalfa's on *The Little Rascals* but was partially hidden by an oversized football helmet.

"It's very difficult to keep him with the group. He has frequent seizures, so I don't want him to be alone. Would you?"

"Sure!" I lied heartily, unsure what I was taking on. "Is he able to speak?" I asked, realizing I'd never heard him say a word.

"He does have speech ability. He just seldom uses it. We're not sure why." She turned toward the expectant classroom. "Okay, it's time to go outside!" Diana was only halfway into the sentence when my charge was out the door. As I ran to catch up, I knew I hadn't had enough coffee to take this on.

Not saying a word, Lester raced from one activity table to the next, clutching the prizes he won.

When I realized he was hoarding more than he could handle, I suggested, "Lester, let me hold those for you."

He acknowledged by shoving them in my direction before darting to the next event. I lingered behind to pick up the things that did not make the sloppy transition.

When I caught up with him at the haunted house, I was surprised to see him standing still. Suspecting he might be frightened, I volun-

teered, "Would you like me to go in with you?"

Still without responsive eye contact, he grabbed my hand and pulled me through the door. Inside, I heard his first laugh when the ghost that popped up startled me more than him.

It was a short but welcome break when we reached the makeup table. We both sat down while one of the teachers put theatrical clown makeup on my character.

"Wow, you look terrific, Lester!" He did not acknowledge my compliment, but gave himself a proud grin in the mirror before dashing to the cookie decorating table.

As I watched Lester's dirty fingers push assorted toppings onto his cookie, I realized I had really enjoyed my exhausting day. Even though he was oblivious to my existence, I liked being with Lester. I liked his spunky spirit and his enthusiasm for cramming as much as possible into a short time.

He paused for a second to admire his masterpiece while I laughed to myself. He had spent more time on this cookie than on any other activity, and yet with each new topping, his treasure looked more inedible.

Just as I completed that thought, he proudly pushed in another chocolate drop, then promptly turned, and looked directly and deeply into my eyes.

"This is for you."

"Oh, Lester...."

He was gone, leaving me with unexpressed gratitude and frosting oozing through my fingers. Children never overindulge sentimental moments.

My cookie sat on the dashboard as I drove home. It looked too good to eat! I had learned a lesson that morning at school: Allowing myself to expect even a crumb would diminish the effect of the cookie that might come my way.

It finally became clear to me that Christmas was too much of a pressure because I was trying to put too much into the gifts. Instead of expecting more time to miraculously appear, I should make better use of the little I had. My priorities had changed, and there had to be a limit to the time I would spend picking out gifts—gifts that would undoubtedly be the wrong size, or short of the receiver's expectations. My circuits were overloaded, and I had to cut back in a lot of areas.

Christmas was a starting point, but I also needed to gain some

ground with Robbie when he came home from work. In order to be there for Joey at night, I had to have more time for myself during the day. Surely, my day before had to be a bigger disaster than his *Day After*!

Many times over the years, medical stress had spread to marital stress. Our love of all our sons forced us together, despite our attempted splits. Even though I knew Joey had an equally firm grip on both of us, I always felt I shouldered the heaviest part of the medical responsibilities. Many a morning, I longed for a job that would take me out of the house. Life would be more bearable if I only had to live with sadness on evenings and weekends.

Now the time had come when Robbie would have to do more, because I needed to do less. Coincidentally, he was currently working on a film about a woman disfigured in a car accident which was entitled *Why Me?*

"Robbie," I started gently, "I need your help. I know you are already doing more than most normal fathers...."

He nodded in agreement to the praise, but looked a little concerned about the set-up.

"...but we're not a normal family. You don't understand what it's like dealing with Joey around the clock." That word "understand" blows it every time.

He angrily interrupted, "What do you mean, I don't understand? Why do you think I produce movie after movie without a break?"

This time I didn't try to out-scream him, but listened. He was saying something I had somehow never heard before. He had hoped to compensate for the daily emotional support he was unable to give by making the money to finance whatever therapy or equipment I ventured to try.

To grasp this conflict I had to step out of myself and look at things from Robbie's angle. I recalled the years with hundreds of thousands of dollars in medical expenses and readjusted my thinking scale. Being on a movie set was not just his opportunity to become lost in a fantasy; for him, it was being submerged in the endless stress of making ideas come to life.

Once I recognized this, I could see that Robbie had been behind me all those nights I thought I walked the floor alone. He just wasn't there in the way I expected him to be, so I failed to acknowledge his presence! I could seldom get far enough away from daily pressures to

consider the future. From the start, Robbie had been shouldering the long-range responsibilities of establishing Joey's financial security.

There were a lot of times during my life when expectations only seemed to expose me to disappointments. I often recall with special fondness a day I shared with a very wise college friend. Mel and I spent many Saturday afternoons walking and eating hot dogs in the park. This particular Saturday he sensed my sluggishness was not from food, and kept drilling until I eventually confided the reason.

My roommate was living through an emotionally difficult time of her life, and I was overexerting myself with support. Her depression and lack of attempts to stabilize her life had gone on longer than I had expected.

Instead of the consolation I anticipated, Mel asked, "Did she ask you to do all this for her?" When I said no, he continued with, "Why did you do it?"

"She's my friend. I wanted to help her." I felt more words would justify my feelings. "I don't expect an overwhelming display of gratitude. A tiny thanks would be nice. I could even do without the thanks if I could just see her trying to do at least a little for herself. She's stuck in the depression, but I'm the one who's frantically spinning my wheels."

I was frustrated when Mel would not concede my right to count on even microscopic returns. He just kept calmly repeating, "But you chose to do this. You shouldn't have given more than you could afford. You defeat the purpose of giving if you expect a return!"

I never had acknowledged the gift Mel pounded into my head that day. Nevertheless, I had reopened the thoughts that came from our conversation many times over the years, when I would again fall prey to some prospect. Just as I had planned for Joey to match my idea of normal, I had expected Robbie to match my expenditures of energy. It was difficult to see that we had each been carrying a different end of the same cross.

Sometimes little stumbling blocks were more help than hindrance. In order to survive, Joey needed twenty-four-hour supervision, and I needed sleep and a longer break from my duties. For years I had been unable to bear the thought of taking a step backward to all those old nursing headaches, but I never realized that I had meanwhile moved forward in my ability to work with them. Now, I had learned to holler for help; I just needed to change the direction my plea was heading.

The next morning I put in a call to the Regional Center. Instead of telling them how well I was doing, I told them how I was *really* doing. The truth resulted in their finding us a qualified nurse and agreeing to pay for fourteen hours per month of respite. Within a month, Robbie and I were free to enjoy a dinner and a movie almost every weekend. Our nurse, Jane Noda, with her vibrant personality, always arrived wrapped in jeans and a sweatshirt, which made it easier for me to forget that she was a nurse.

The center also gave me sources for locating a daytime guard and playmate for Joey. If I hired someone to work on some of the tedious long-range goals, I could save the less-taxing and more fun targets for myself. When I remembered the moment Joey had first demonstrated his ability to spell, an additional advantage became clear. By screening myself from a little of the daily toil, I might more often be able to enjoy what appeared to be instantaneous success.

With this in mind, I contacted nearby Loyola Marymount University's placement center and described the type of person I wanted. I was referred to Dr. Graff, the head of Loyola's Education Department, who helped me set up interviews with students interested in special education. Our past housekeepers had lacked any prior experience with the handicapped; this looked like it might lead to a big improvement.

Within a week we had hired a part-time aide, Jackie Blain. With Jackie at Joey's side during our active weekends, we were able to function more like a regular family. I could limit the lifting my doctor had told me to avoid; my daytime attention to Joey did not have to exceed the attention I gave his brothers; and I did not have to worry about having to get stitches every time Joey pulled himself to a stand. Together we could keep the smile I needed to see on Joey's face throughout the day.

To keep a smile on my own face and to elevate my energy level, I constantly had to create little or big "things to do" *just for me!* I had wasted more than my share of time on that old cliché "I don't have time to do things for myself" before I discovered that it was never a problem of time—it was a priority problem. When getting to the track for a three-mile speed walk with my Sony finally became more important than getting to the Little League game, both got done!

Through my years with Joey I had learned to find what made me happy, and what made me work harder to keep my thoughts positive. If

I lost it, I fell back and found another motivator. By simply being aware of what made me stumble and what set me straight, I could sometimes avoid stumbling; but I could always control the straightening. If ever I forgot this, I just found my fresh starts quote. It consistently pushed me into taking the first step:

> Perhaps the best reason for having calendars, and for marking life in years, is that the cycle itself offers hope. We need fresh starts and new chances, the conviction that beginnings remain available, no matter how many we've blown. And the yearly clock can start anywhere along the line.
>
> Loudon Wainwright

We all should have the right to live our own lives—and the sense to avoid wasting time on how others are going to make things happen for us. Even though I still frequently have to remind myself to move my expectations back onto myself, I have learned by experience that I cannot sit back and expect someone else to tell me it's my turn for a rewarding break. I need to move myself to the front of the line!

This became more apparent to me one morning when Robert decided he was going to fry bacon for breakfast. Most of Robert's genes had been inherited from his dad, and his culinary skills had developed over the years in order to placate his hyperactive metabolism. Robert fried lots of strips of bacon and summoned all of the family several times. But bacon doesn't linger long at our table, as Marty discovered when he staggered into the kitchen late.

Marty's choice of clothes always looked two sizes too big, since he only liked to wear his older brothers' rejects. So that morning, he yanked up his jeans and sat down before waking with a startled, "Where's my bacon?"

There was a moment of silent guilt at the table before Robert said, "I tried to wake you up, but you just grunted. Maybe tomorrow if you get up in a better mood, you might find bacon waiting for you."

Emphasizing each word with a tauntingly sweet smile, Marty slowly delivered his verdict, "Well, Robert, if you'd said, 'Marrrty, your baaacon's ready,' I would have gotten up!"

Stress without relief in sight is exhausting. We can all manage to get up if we know our bacon is waiting on the table. On the other hand, if we want to guarantee that there is bacon, we need to fry our own.

Chapter 19

Just Get Excellent Again

It was from the words dropped by chance that, little by little everything was revealed to me.

OUR mornings started to look brighter as Christmas approached once again. We had intensified the rays of sunlight by planning an after-Christmas trip to the mountains to celebrate a milestone in Robbie's career. His production of *The Day After* had been rated the most-watched television movie to date, and had received twelve Emmy nominations, including one for best picture.

This would be our first family skiing venture, so we were a little apprehensive about what was in store for us. The day before we were scheduled to depart, I was busy packing the red van, which was a little worn but still working.

Our new home had not yet passed the framing stage. Thus I was frantically digging our gear out of boxes when I happened to come upon an old jewelry box that contained a worn-out copy of a poem that had been a favorite of mine since teenage years. There was a stiff coldness that came over me as I read it and recalled the events of the most pivotal day of my life, six and a half years ago:

> *Two roads diverged in a yellow wood,*
> *and sorry I could not travel both and be one traveler,*
> *Long I stood and looked down one as far as I could*
> *To where it bent in the undergrowth;*
> *Then too the other, just as fair*
> *Because it was grassy and wanted wear.*
> *Though as for that passing had worn them really about the same*
> *And both that morning equally lay*

In leaves no step had trodden back.
Oh, I kept the first for another day.
Yet knowing how way leads on to way,
I doubted if I should ever come back.
I shall be telling this with a sigh
Somewhere ages and ages hence:
Two roads diverged in a wood, and I—
I took the one less traveled by
And that has made all the difference.

How different our lives would have been if Joey had peacefully passed away all those years ago.

I did not have a choice when I reached that crossroads in my life. But what if I did have a choice? Which road would I have chosen, knowing what I now know of the one I took?

I flipped through a lot of real and imaginary pages of life before I decided. From that end looking forward, I'm sure I would have taken the easier way. But from this end looking back, I know I took the best road for me.

There had been so much life and so many encounters with death along the road I took. I didn't choose the road, but I had a lot of choices along the way. I hated the sadness I would always have to carry, but with supportive people and gimmicks, I would keep going and make what I saw in front of me look better than what I left behind. Now I can say that I like who I am better than the person I was at that crossroads, and better than who I probably would have been if I had been able to choose that other road.

Gazing out the window, I watched the boys taking a football break from their packing chores. Close at hand, Joey was strapped into his walker practicing opening and shutting the door of the van. It was wonderful how soft-hearted Shawn could make minor assists for Joey an automatic part of every play.

Our life with Joey had not been easy. God had not sent us a 'meek and mild child,' but this child had added a special compensating visual acuity to our family. This had helped us to look beyond imperfections and limitations and see the lovable and workable in others and in ourselves. Our mutual love for Joey had strengthened our love for each other and tied us together through all the tragic times. I was sure I could speak for Joey's brothers and dad in saying that his living had

been better for us, but the old question still haunted me...had it been better for Joey?

Stumped again, I noticed my reflections were close to making me late for Joey's regular blood-level checkup. I carefully folded my souvenir and tucked it back into the jewelry box.

After stuffing in the supplies for any possible catastrophe, I strapped Joey into his travel chair in the back seat of the van. I used to have him ride in the front seat, where I could more easily watch him for seizure, or aspiration problems; but when he learned how to manipulate the gears while I was preoccupied with the road, the risk seemed to be less with him behind me.

With full concentration on freeway lane-changing to make up for lost time, I was not aware that Joey had managed to worm his way out of his harness and roll down the window. He then decided to get the full benefit of his accomplishment by dangling out of the open window. His muted squeals drew my attention just in time to grab one of his legs, which were still inside the car.

I pulled Joey back into the car too quickly, twisting his body into a position that might break one of his limbs, and neither of us could disentangle him. I looked like I was trying to rope a calf as I wrangled the car to the closest off-ramp.

After lecturing Joey and locking him back into his chair, I resumed driving, with my free hand firmly clamped on Joey's ankle. I knew that once he had mastered an escape from some piece of equipment, he would have no intention of letting it imprison him again. My lectures never seemed to instill in him a fear of danger. To this child who could do so little, the works "you can't" were just a spur to try again!

To add more complication to my day, the only parking space I could find was in a large parking complex two elevator rides and five congested blocks away from the lab. Our travel chair had a broken wheel, but I had taken along Joey's battery-operated motorcycle, hoping that I wouldn't have to carry him.

I transferred Joey from his chair to the motorcycle and secured his red helmet before I released him. With me trailing behind, he started a head-down race to the elevator. He looked like a perfect match for Evel Kneivel, but a little off-color for Beverly Hills.

Joey rounded the corner and made a perfect entry through the open elevator doors—then came to an abrupt stop, with the help of another passenger's shin, while simultaneously signaling me with a grunt that he

needed to be lifted to push the down button.

When the doors opened at street level, all eyes shifted to Joey, politely assuming he should exit first. My handful had his legs stiffly bolted on either side of the cycle, and his hands solidly gripped the handlebars, while he was loudly mimicking his favorite racing motor sounds.

"Let's go, Joey," I quietly prompted. Then, sounding more like a prayer than a plea, "Joey, step on the gas."

Seeming to enjoy the spectator pressure which made me perspire, he improved his motor tone with each of my requests.

"Please, Joey, step on the gas." While speaking, I tried to hoist him and the motorcycle, but his hands and feet bolted the cycle beyond my strength.

"All right, Joey," I sourly whispered in his ear, "You can do it yourself, but do it *now!*"

He paused a few seconds more. Then, confident the drama had been pushed to its peak, he released his locked knees, stomped on the gas pedal and exited as briskly as he had entered.

"Stop right there," I said while holding the back of his motorcycle until the audience vacated the set. I needed to give a less-inhibited lecture before we hit the streets.

In spite of the elevator scene and a few horrified sidewalk spectators, I was really pleased with Joey's ability to maneuver his motorcycle through the congestion of cars and people. Although no one saw more than the top of his red helmet, I knew the face it hid was beaming with pride. Maybe he had heard a few words of the lecture.

When we eventually entered the medical building and our last lift to the lab, I considered not declaring our floor until the elevator emptied. Fortunately we only had a few fellow passengers this time, and they were all getting off before us.

In the home stretch, my eyes bravely confronted the other pairs of eyes that were focused on us, as usual, and we all exchanged friendly grins. Stares don't seem so hostile when you face them head on with a smile!

To my surprise, my smile elicited a question from a pleasant-looking elderly man who stood next to me.

"Do you mind if I ask your opinion on something that has bothered me for years?" he ventured.

"No," I hesitantly returned, feeling a little too frazzled to focus on any topic that required thought.

"I'm a doctor, and early in my practice I was able to save the life of a brain-damaged newborn. Ever since then, when I've watched parents like you struggling with a handicapped child, I wonder..." he paused, "...if I did the right thing."

The elevator door opened on his last word, and he started to depart as if he were afraid to wait for my answer.

Since the door would soon shut off the possibility of a prolonged discussion, I swiftly shouted after him, "I think you did!"

Staring at the solid metal in front of me, I recalled a conversation with another doctor. I would always remember what she said when I had revealed my fears for Joey's future: "Maybe the worst is that he could live." I had considered her statement many times. Now it had dropped in front of me twice in one day. Because of my intimate involvement with the issues, I felt that I should have an unwavering opinion.

In the early years of Joey's life, keeping him alive was all I ever considered. For me, his living had been a heavier sorrow than his death at birth would have been. Still, I had learned along the way that weight of sorrow does not have to make things worse, as long as you constantly keep shoveling a balancing amount of happiness into your life.

On the other hand, through the years I had kept a tally of all the traumatic pain Joey had endured, and all the physical abilities that would always be either difficult for him to attain or permanently out of his reach. The sum still made me wonder if it had been right for me to selfishly not want that smile of his out of my sight.

The elevator door opened once more. This time, without an audience, Joey limited his pre-departure sound effects and my time to debate my own dilemma.

Going out of our way to this Beverly Hills laboratory was always worth the hassle, since Mr. Brown knew where to find Joey's best vein and how to get in and out as promptly and painlessly as possible. As usual, Joey extended his arm and his tearless cooperation to the blood test, and we headed for home with only thoughts of our next day's trip.

By morning we had finished cramming the van with all the things we would and wouldn't need for our trip. To do some of the extra mothering Joey required, we brought along his aide, Jackie. We also invited her boyfriend to enhance her enjoyment of her job, and left with the ingredients for a good time.

The previous year we had snuck away for a less complicated vaca-

tion with only the three older boys; but Joey's hearing was excellent. Of course, he had known what was going on and he had been disappointed to be left behind. When we returned, he refused to kiss me. Leaving his room with a "come" signal, he crawled into the den and pointed to the family portrait hanging on the wall. He only used four of the ten words he was capable of uttering, but we all got the message.

"Mom...Dad...four...boys."

This year, the cabin we rented from our neighborhood pharmacist proved to be clean, well equipped, within walking distance of the slopes, and only a few blocks from a hospital.

We skipped the boring unpacking and went immediately to sign up for skiing lessons. Since Marty was confident he could handle more than the bunny hill, we padded his seven years and had him included in the nine-to-eleven-year-old group with Robert and Shawn.

Joey's lesson was scheduled first. Initially, he was reluctant even to let us attach the awkward skis to his boots, but once he was upright, he was quick to grasp the potential of these sticks. As always, he was eager to try anything that would give him mobility. I placed my feet in between his skis and side-stepped him up the bunny hill. Then the instructor and I sandwiched him with support as we all slid back down to where we had started. One trip to the bottom and Joey's face lit up with full comprehension of the sport.

When I began to burn too many calories, Robbie took a shift with Joey while I recharged with a Diet Coke. I had taken only a few sips when a woman who had been observing us approached, with apparent good intentions behind her gruff voice. "I bet those doctors tell ya not to expect your son ever to walk."

"That's right," I replied, unsure what had precipitated her anti-medical attitude, but very sure I did not want to start a debate with this two-fisted character.

"Well, don't you believe anything those doctors tell ya, honey. You keep working with your son. He'll walk!" she exclaimed. Her twang of conviction couldn't be swayed, but needed to be confirmed. "Don't you agree?"

"Well, it would be wonderful if he did, but I don't expect him to be able to walk. I...." I was about to excuse myself, but she persisted with her point.

"Dear, don't let those doctors take away your hope. Kids like this would never be able to do a thing if someone didn't believe in them."

"Oh, no, I didn't mean that I would ever give up my hope or my help. I just don't combine my desires with expectations, because I want to enjoy what he's able to accomplish."

As I left for my next turn with Joey, I could tell by the woman's expression that she did not understand. But, then, she probably never had a hotdog with Mel, or a cookie from Lester.

Joey rapidly dropped his reluctance to leave the slopes when Jackie and her boyfriend arrived with the sleds and a brief description of their afternoon plans for him.

After one solo sled ride down a small slope, the expression on Joey's face clearly related that this was more his speed. He was in complete control of his crash. Actually, I had thought he would prefer skiing with us, but Joey was always better at choosing his own least-restrictive environment.

Confident that he could have a great time without me, I headed off to track down the other three boys, whom Robbie had undoubtedly stuffed into snow gear and turned loose. I found them on a level patch of snow awaiting their lessons, looking like the Three Stooges trying to ride on water with a skateboard.

It didn't take me long to realize that my falling down with them would not enhance their stability. Instead, I suggested they crawl to their instructor, and I left to join Robbie, who was renting our equipment.

After trying on several pairs of ski boots, I discovered that they are not made to accommodate tight calf muscles and weak knees. As I sloppily balanced the skis and poles on my shoulder and painfully tried to walk on the snow with my boots still unlatched, I had serious doubts about my skiing ability. But as I watched all the bodies gracefully flying down the picturesque slopes, I was seized by an overwhelming desire to be one of them!

That evening we all gathered our aching muscles around a cozy fire and relived the highlights of what turned out to be our most fantastically fun family experience to date. By chance, our articulate Marty was so excited he could not stop chattering.

"Well, I really munched it a lot in the beginning. I began to think I was never going to be able to do this. But then," he paused with an adorable grin to emphasize, "I got excellent!"

Robert and Shawn threw me glances that indicated that Marty had been far from excellent in their eyes. But his bragging was too cute to

criticize. Even though all three boys were athletically inclined, they had surprised both Robbie and me with the speed at which their awkwardness had blossomed into agility far beyond their age and skiing experience.

As I listened to the boys justifiably brag about their triumphs on the slopes, I realized that I was also feeling an inner exuberance I had never experienced before. Watching Robbie as he contemplated his own success and puffed cigar smoke over his sons' heads, I realized that we might be a tarnished *Brady Bunch,* but we were a real family! Together we had survived a lot of ugliness to reach this beautiful day. Maybe that's what made it seem so wonderful.

But it was more than this that made me feel as I did. It was more than the glow of the fire and the sips of wine. It was more than being proud of my sons independently mastering a sport. It was more than knowing that with a little extra padding for Joey, our family could finally function normally. It was even more than remembering my husband's hilarious tumbles on the slope as he boldly charged past my cautious conservatism. More even than the bouquet of roses with which Robbie had crowned my day.

It was more: I had put my pain and fear behind me and traversed those slopes all day without munching it! I silently chuckled as I imagined what an experienced skier's expression might be if he heard what I was saying to myself: I got excellent, too!

My middle-aged and multi-stitched body could accomplish something I had been unable to do at twenty. I was better than that person behind me. We all need to reach for our own brand of excellence, without letting it be measured by anyone else's scale!

It was similar to how I felt when I was able to give up smoking, except that with smoking it had taken longer to reap the rewards, and the success had been harder to sustain. Now, within one day, I had been able to staunchly reinforce the conviction that the more I was willing to push beyond my actual ability, the more exuberant I could feel. It was worth *any struggle* to get to a moment like this.

With that thought, my eyes seemed to zoom in for a closer look at Joey. With his large blue eyes, thick coarse hair, and thin rigid body, he always reminded me of the animated character Pinnochio. At this moment he was lying on his stomach, feet twirling in the air, hands supporting his chin. He was encircled by his brothers, and listening to their every word. When all of his extraneous movement ceased, his

handsome face became more prominent. He seemed to be identifying with everything they were saying. He looked just like one of the boys!

Suddenly I felt a surging release of pressure as the stubborn pieces of the puzzle moved into their proper positions. It had always been obvious that Joey had inherited his dad's fearless drive and devilish sense of humor. At present, though, it was instantly obvious to me that Joey had always been able to reach more than his share of these moments of excellence. It was only now that I was finally allowing myself to fully experience the same thing.

I had previously thought abrupt turnabouts only happened in the movies; but suddenly, I could believe that it wasn't my selfish tenacity that had kept Joey alive. There were no "crinkled corners" here; I could see clearly that he himself had always known that moments of excellence were worth the struggle to reach them again.

It was then that I felt my answer. I could not be as certain about the elevator doctor's newborn, but I now knew for sure that Dr. Kirksey had made the right decision in fighting to keep Joey alive. I could finally see that despite the suffering and handicaps, it was better for *all* of us that Joey had lived. My tragedy had reversed itself, as any tragedy eventually can. We could all move forward now!

"Marty, are you going to stay on Number Two slope tomorrow?" Robert asked as he planned the next day in his mind.

Marty, lying on his back with his legs crossed and his arms pillowing his head, casually replied, "No, I think I'll try Number Four."

"Oh, you won't be able to do Four!" Robert and Shawn sharply chimed in with parental concern.

"Well," Marty paused, realizing that his boasting might have extended slightly beyond his abilities, "I'll probably munch it a lot in the beginning, but...." He stretched with a pride that could not be marred by anyone's skepticism. Then, with a casually confident yawn that aroused Joey's affirmative nod, he added, "I'll just get excellent again."

As the fire dwindled and the excitement mellowed, I sipped my wine slowly and continued studying the faces of my family. Whatever fate would bring us in the future, it could never take the memory of this moment from me. Moments like this are fleeting. I would probably have to work my way back through the ranks to reach one again, so I intended to savor every speck of what I had now. I believe in the saying I have framed on my bedroom wall: "God gave us memories so that we might have roses in December."

Joey's life was not what I wanted for him. I wanted him to have all those easy things in life, like running down a hill, talking on the phone, watching television, or writing a letter. All those things the rest of us take for granted, and that I knew he would appreciate so much. But that is *my* sorrow, and I have learned how to live with it. Even without these abilities, my son has a sparkling smile which spells happiness to the many hearts he has won. His life seems to suit him.

Naturally, he was born with the secret. Making life work is a continual struggle for all of us, until we discover that enjoying the struggle is what makes it work.

Chapter 20

And Then They Came

At that moment I caught a gleam of light in the
impenetrable mystery of his presence.

THE warmth of that Christmas memory was needed a year later. We had finally settled into our custom-built home, and Robbie was on location in Mississippi for the filming of *North and South Part II,* when Joey woke at 2 A.M. ready to start his day. By 5 A.M. I was convinced that further attempts to con him back to sleep would be futile, and I conceded to let him play with his train.

Without a warning, Robert dashed from his bedroom, still dressing and reporting, "I'm late for my paper route." He was already outside before I could return a comment.

Robert seemed so independent for thirteen. Why did I feel that Joey needed twenty-four-hour supervision? It had been over a year since his last seizure, and his room was fully padded and filled with stimulating toys. Any eight-year-old, even Joey, could surely be left alone for a short period of time. That thought seemed to drive me up the stairs and back into my bed without even deciding on a safe length for this little nap.

Robert returned at six, slamming the door and jolting me out of bed. Before he could cover the fifteen feet from the front door to the bottom of the stairs, I was leaning over the railing above, and I caught a glimpse of the only patch of the pool visible through the living room French doors. Mysteriously, I seemed to know before I saw it, and I shouted, "Joey's in the pool!"

Robert's response was even swifter than mine. He sped down the hall, out the back door, and was at the pool in a flash. He reached deep into the shallow end, and hauled in Joey's drenched body. Then he

stepped back in shock when he saw his brother's blue face.

"Call the paramedics!" It was a relief to scream, and it was also a way to separate Robert from this paralyzing scene. I ran outside and slumped to the bricks beside Joey, fully convinced that it was too late for help. But like a robot, I automatically started mouth-to-mouth resuscitation.

Always able to remain level-headed during an emergency, Robert called 911 and then ran next door to summon Dr. Cokely. The discovery that Dr. Cokely was our neighbor had been one of the best benefits of our new home. That morning she conveniently happened to be in her front yard retrieving a newspaper.

Within minutes I could hear Robert returning with the doctor, and at the same time I heard a gargling noise in Joey's throat. Our fragile son suddenly vomited, then began a strange seizure.

We ripped off Joey's pajamas and wrapped his icy body in a blanket. I kept repeating "He's alive," but I know I didn't believe it was enough to rejoice about.

The paramedics arrived and began loading Joey and Dr. Cokely into the ambulance. I sprang upstairs for my purse and a change of clothes. On my way back down I saw Joey's three brothers waiting by the door, looking at me in desperate need of reassurance. I started to lie, but I realized the truth was already on my face. "I'll call you!" I said, and I dashed out the door.

Robbie flew home that same day, for my initial phone conversation with him was riddled with guilt and doubt about Joey's future. But shortly after we arrived at the UCLA intensive care unit, Joey's condition had already stabilized. By early afternoon it was clear that he had suffered no additional brain damage.

Apparently, Joey's lack of muscle tone and his abnormal thermostat had saved his life. He had been unable to swallow enough water to infiltrate his lungs, and hypothermia had slowed his circulation enough to keep him alive until Robert came to the rescue.

The intensity of this trauma surpassed any of Joey's prior seizures, primarily because I felt so overwhelmingly responsible for it. I am not sure whether it was guilt or my background in criminology that forced me to relive every second of that morning thousands of times. It was uncanny, but I kept arriving at the same conclusions.

The boys assisted my forensic recreation of the accident. They dropped assorted weighted objects into the pool, but from my bedroom

I could not hear any of them hit the water. We duplicated noises Joey might have made as he unlocked the back door, but they too were inaudible from my location. Until that critical morning, I had not even known that I could see any part of the pool by stretching over the upstairs railing. If Joey had not fallen into that two-foot area of the pool that was visible from the top of the stairs...if Robert had come home one minute later.... There were a lot of possibilities and unanswered questions, but there was only one thing of which I was absolutely certain: I knew Joey was in that pool the second Robert shut the door, and before I leaped off the bed!

Why did Joey decide to dive into the pool? Had he misinterpreted my constant bragging that "Joey can swim all by himself"? He could never tell us the actual reason, but the end result of all my analyzing was that I miraculously felt relieved of responsibility for the accident. Even though I sensed that there had to be a meaning to his chaotic life, a meaning I was still unable to grasp, I could now feel certain that the control of Joey's living was beyond me. Actually, when you are able to move the proper stickers in your mind, reality becomes irrelevant, because the problem is *fixed!*

Although I was thus able to give myself absolution, several years later, when academic and delinquency problems led us into family therapy with Robert, he unexpectedly confessed the guilt he had been carrying ever since this near-drowning episode. Everyone had always assumed he was proud of his role, but eventually, he confided that he had only experienced guilt, for he originally looked at Joey's lifeless face and thought, "I'm glad it's finally over." Now that he was able to expose this view, we were able to assure him that his feeling was merely a natural response for anyone constantly battered with the possibility of a sibling's death. This was a big first step but it was not enough to turn Robert's life around. Months of counseling culminated in a decision to send him to Boston for his last two years of high school. Landmark East, a school located a few miles from several of Robbie's relatives, was highly accredited for dyslexia, and it enabled us to separate Robert from his current companions and curriculum while he struggled to make a fresh start. It was not easy for any of us, but it worked.

We barely had Robert settled in Boston when Joey started indicating with his assortment of signals and sounds that I needed to come to his school. By chance, his clues led me to an unannounced classroom visit.

I could hear Joey's seething shriek when I came in the main entrance to McBride. I was alarmed, but I noticed that none of the people in the offices I passed were the least bit distracted. Crying is a normal sound in a school with only mentally and physically handicapped children.

Following this frightening sound to an open door, I felt stripped of all the security I had found with Joey's former instructor, Diana, when I saw that his teacher for the previous month was simply writing at her desk while the students were mesmerized by the event at the other end of the room. Joey's new aide had used several velcro straps to attach him to a regular wooden chair, without additional pads or supports! After pushing the chair into a corner, she had placed a six-foot tall partition in front of it to isolate him from the others, while screeching at him, "I've had it with you!"

I had intended to properly protest this practice of "time-out for misbehavior," but when I asked her to please step outside so we could talk about it, she instead confronted me with how uncontrollable Joey had been that day, which, of course, completely blew my composure. I am not sure what I said, but Joey's serious expression and complete co-operation when I transferred him to his wheelchair seemed to indicate his agreement both with my words and with the way we abruptly separated ourselves from this school.

In time I had to concede that it is understandable how people can become so distraught when trying to placate a hyperactive child who can only communicate with body language. I did not want to single out this aide for retribution, because it was actually the system of segregating handicapped children that I saw as criminal. How could these students ever adjust to adult life in an environment from which they had been isolated since childhood? I believe that staff burn-out can be reduced, and all students can be enlightened by scattering the burden and integrating children with special needs into normal schools.

After sufficient time out for tears, I realized that I could not solve all the complex problems of special education, but I could use this episode of what I considered child abuse to our advantage. I had learned how to deal with people rather than waste time defending my rights, so I politely requested a reevaluation of Joey's Individualized Education Program. But before the meeting I attempted to find an answer to any objections the school district might come up with when asked to consider Joey's transfer to a "normal" campus.

I checked out several possibilities before focusing on Katie Webb's

orthopedically handicapped class at Richmond Elementary School. Katie was a large woman with a heart to match, who remembered having seen Joey at McBride and having recognized his spark of intelligence. After a lengthy discussion about her reluctance to admit Joey and our willingness to help, she agreed to give it a try, if the school district would approve the transfer.

When IEP time rolled around and it was mentioned that Richmond had no emergency intercom, Robbie quickly volunteered to supply the walkie-talkies he used on sets. Then, at the appropriate time, I promptly agreed to provide transportation in order to minimize complications. (Actually, Joey's excitement about being on the bus was fading.) With a sizable stack of supporting letters from medical professionals and with Dr. Howard from UCLA at my side—and without a word about the abuse at McBride—the IEP ran smoothly in our favor.

Joey was even endowed with Jackey Ross, a medically trained health care assistant who, to Joey's delight, insisted that he tackle things on his own and clean up his own messes. My son instantly bonded to this warm, jovial lady with her "right-on" expectations.

Mainstreaming a non-verbal child has multiple complications, so we expected some initial turbulence. But with Katie and Jackey on our side, within weeks the transfer that had been considered impossible began to work.

To ensure our forward motion, around this time we came upon Dr. Laura Meyers and her computer expertise. We had long hoped that computers would one day become important communication tools for Joey. But we had never been able to find a way for these machines to capture his interest, nor for him to operate them. But then Dollie Meyers presented her KeyTalk software, and suggested that Joey write a book about his daily experiences and feelings. He was immediately intrigued!

Dollie began by helping Joey construct sentences that she thought he might want to say. She insisted that he try to sound out each word, and made sure his spelling and grammar were correct. He demanded that she wait patiently until he could stabilize his body and slowly maneuver his fingers to the proper keys. His coordination always improved when he tackled something of his choice! She pushed and praised until he became proud of the sentences he produced. We *never* expected the speech that slowly blossomed out of this approach!

Joey, who always loved his brothers' playful teasing, was now de-

lighted to have an opportunity to return the tricks. One of his favorite sentences was, "Shawn, get out of my room!" Since Shawn never passed Joey's room without stopping to kiss or tickle his brother, it was easy for him to oblige with countless entrances, so that Joey could enjoy rejecting him by pressing the correct buttons.

In an unbelievably short time, Joey had heard the sentence so often that he would laugh aloud and then pronounce the words himself before the computer could do so. We were all thrilled when *People Magazine* thought the accomplishments of this teacher and her student merited coverage in one of their weekly issues.

My special fantasy came to life when Joey was able to recognize my frustration with coordinating his helpers. He crawled to sit beside me before commencing the most memorable conversation I have ever heard.

"Hold...on...Mom!" He always prefaced any comment with this command, emphasizing it with sign language, in order to ask people to be patient with his slow ejection of words.

"I'll...tell...you!" After this, he proudly proceeded to organize who should come, and when. "Linda...Monday...Wednesday. Dollie... Tuesday...Thursday. Clarine...Saturday...Eileen...Sunday!"

Naturally, a smile gleamed through every pause!

Then the worst happened. One night, after Joey's aide had absent-mindedly left, I forgot my routine check of the pillbox, and Joey went to bed without his evening meds. The next morning during a seizure, my son slipped into a coma that left him speechless and sightless. It also zapped every speck of his ability to lift his head or control his limbs. But he was still alive!

The hospital bed was slightly elevated to prevent aspiration and promote breathing, and Joey was surrounded by pillows that propped up his toneless four-foot body. Noticing how the white sheets complimented his richly tanned skin, I sat on the edge of his bed and watched for any sign of hope. But his open eyes just drifted aimlessly in their sockets. He was very obviously blind, but I had no way of knowing if he was asleep or awake. Since being admitted to the hospital, he had not indicated any awareness of anything or anyone.

Robert came home early for his spring break, and he drove his brothers to the hospital every day to check on Joey. Their visits were brief, which was easier for me, since I could not think of anything too encouraging to say to them.

After they left one day, I allowed myself to be hypnotized by the movement of Joey's eyes and was not aware of the hospital's neurologist until she rattled the pages of Joey's chart.

"When will the medicine wear off?" I asked, praying for a different prognosis.

"This isn't a medicine effect. He...."

I had to cut in to remind her, "He's on a higher dose, and he was given tons of phenobarbital when he first arrived."

"The medication he was given the first day is completely out of his system. I'm sorry, I just don't know any better way to say this...what you see is what you get." Her expression revealed her realization that she could have sugar-coated it a little. So she continued in a more sympathetic tone, "After a two-week coma like his, it can take a year before all the brain swelling subsides. I wouldn't be too hopeful." Trying to sound a little more optimistic, she added, "He's totally blind now, but there is a good possibility that sight will return when the brain swelling diminishes."

"How long will he be hospitalized?"

"We'll keep him on I.V. until you feel comfortable taking him home."

I didn't realize that Robbie had walked in during this conversation. But when the neurologist left, he rejected her verdict with, "Let's see what Cokely has to say when we get him home."

"Home!" I whispered just in case Joey could hear. "How can I take him home? Liquid just dribbles out of his mouth. He can't eat! I can't even lift him!"

Neither of us wanted to discuss the future, so Robbie consoled me by saying, "I'll spend the night here; you can get some sleep."

I was gathering my things to leave when a nurse informed us that she had a call on hold from the Marina Hospital emergency room. The same doctor who had treated Joey and then transferred him here to Children's Hospital informed Robbie that the paramedics had just brought him our three other sons!

The car had been totaled on their way home from visiting Joey. Except for the concussion Marty might have suffered, amazingly they had only sustained minor bruises. I stayed with Joey while Robbie left to claim our other boys. We never could isolate our traumas!

Sherry's visit the next morning was shorter and less chatty than usual. Everyone, including VISA, knew we shared the same excessive-

compulsive traits, but I was sure she topped me in generosity as well as sensitivity. I was glad she left before the tears became noticeable. Neither of us could tolerate the other's sorrow.

Before long, my younger brother, Jack, phoned from Florida to encourage me to start planning another trip to the Universal Studio amusement park, which he had been responsible for building and which was located conveniently close to Joey's favorite, Disney World.

Since the coma, countless relatives had called and expressed their concern. Unable to discuss the situation, we said "we're fine" so many times that we thought we were. One relative who came to the hospital tried to console us by saying, "He looks just like he always did!" That hurt; she had no idea how much was missing. But then, I had also needed to learn how close you have to be to see the child beneath the problems.

That same afternoon, Robbie's older brother, Rony, dropped by. He avoided telling me his thoughts, but he was able to capture Joey's essence in a poem he had written that was worth treasuring. I found it on the night stand after he left:

Eyes that sparkle with compassion and love
Allow our hearts to soar like doves.

A smile that fills our mind with joy turns
Our complicated lives into obscure playful toys.

The sweet innocence of a struggling life
Fills our senses and eliminates personal strife.

It's a boy named Joey who's life will be filled
With struggles and glory, a special life that
has meaning…just by being.

A life with an accumulation of memories
That burst into vivid colors of light and
Sound as he passes through time and space.

After we were released from intensive care, Dollie was the first to visit, but Joey's face remained expressionless, even after her enthusiastic greeting.

To avoid a difficult conversation with me, Dollie decided to have a one-sided session with Joey, asking and answering herself as she talked about his current situation. When she came to a word that she knew Joey could easily spell, she purposely misspelled it, hoping for a reaction.

We both thought the first smile was just a coincidental reflex; but then he smiled every time she randomly injected an incorrect letter into one of his familiar words!

Undoubtedly, the Joey we knew and loved was alive within this shell! In spite of this, I did not feel that happiness was appropriate.

There was hope...but not enough to stand by while Joey struggled to escape! Escape was impossible. The scale of thoughts which I had juggled for years now swayed to the heavier side. This time, continuing to live might be worse for my precious child, and it would surely be too painful for me to watch!

Hours after Dollie left, I was still intensely studying Joey for answers. Then, suddenly, he stopped breathing! Not wanting to be alone when the final curtain fell, I only spent a few seconds shaking him before I ran to the door and bellowed, "I need help!"

The three nurses at the central station looked startled. I assumed they were on their way, and so I returned to Joey to start mouth-to-mouth resuscitation. I was unwilling to shoulder the responsibility of his death, even though it might be a blessing. Since I could not risk leaving Joey again, after every breath of air into his lungs I screamed again for help. Before long I alarmed a mother in an adjacent room, who made sure my message was understood. The nurses appeared, and after several more puffs, Joey resumed breathing on his own.

When the scene was over, a doctor finally arrived and nonchalantly informed me, "Occasional apnea is to be expected after being on a respirator for two weeks." Before he could get away, he mistakenly added that the nurses had assumed that my plea for help had been only an hysterical outburst. When I heard this, I was convinced that someone had just sucked all of the air out of the room—and then they saw real hysteria!

The hospital staff summoned Robbie from the set of *The Betty Ford Story*, and he convinced me that my vigil might be easier at home with night nurses. My friend Francia had already called and recommended "a wonderful nurse who specializes in children with eating problems." We arranged for Jannelle Pearson to spend this last night in the hospital

with Joey, so that she could acquaint herself with the case while we prepared our house for the transfer.

The next day we drove Joey home. But when we arrived we did not have enough hands to move his tonelessly slippery body from the car to his bedroom until his brothers ran out to help. We positioned Joey on the bed and duplicated the hospital's elevation and pillow support. His room had never looked so immaculate, but whenever I approached his bed to adjust the pillows, there did not seem to be enough oxygen in the room for both of us. But no one made a comment about Joey's condition, or about my wheezing. As usual, we all tried to protect each other with a phony positive attitude.

The boys took shifts with Joey, and Robbie answered an urgent phone call from the set while I talked to Jannelle, who had stopped by to help organize our routine. In the past, I had always delivered the plan and instructions for implementing it. Now, however, I was awed as Jannelle stressed the importance of monitoring Joey's food intake, liquefying nutritional food in the blender, and stimulating him to consume as much as possible. I just nodded my approval and wondered where this lady had been eleven years ago!

Before Jannelle left, she assured me that she would return for the night shift, and she suggested we buy large syringes and a supportive chair to facilitate feeding Joey. I failed to mention that I already had this equipment, and more, stored in our garage. I was far too shaky to go back to the beginning.

Shortly after Jannelle left, Dr. Malphus surprised us with a housecall on the way to his office. With an amiable smile he announced, "I'm here because I knew you couldn't come to me." He was a thin, gentle man who had taken over our retired pediatrician's practice, and he was always able to instill confidence with his casual manner and colorful bowties. I loved his sense of humor and the way he seemed to enjoy my long-winded tales about my sons' harrowing adventures. A laughing audience always calms nerves and cures sadness!

After checking Joey, Dr. Malphus offered, "Tell me your concerns so I can find a way to help."

"Dehydration." I had only enough wind for short sentences.

He suggested moving my scale to Joey's bathroom in order to monitor his weight. Then he gave me a jar of dip-sticks and instructions for daily testing of the concentration of Joey's urine. He promised to intervene with intravenous feeding if we ran into trouble.

I tightly grasped Dr. Malphus's gift, knowing that this tiny bottle of dip-sticks contained a way to save me from lots of unnecessary worry about how much Joey consumed.

Not long after Dr. Malphus left, we opened the door for Dr. Cokely. When we told her what the other neurologist had said, she raised our hopes with a straightforward shrug as she walked past me to examine Joey, saying, "Well, they don't know this kid."

Dr. Cokely sensed our problem of getting Joey to a lab for routine monitoring of his drug levels, and brought me kits with the needles, tubes, and instructions necessary for pricking Joey's finger for blood and calculating the levels of his current medications, Dilantin and phenobarbital. Before she left she demonstrated the procedure and reminded, "You know where I am if you need me."

Feeling like someone had given me a shot of B-12, I was ready to receive the swarm of aides, teachers, therapists, and friends that filed past me throughout the rest of the day, visiting Joey and making it possible for me to avoid entering his room. They each bombarded Joey with their own special things they did and said, which always made him smile.

Clarine Higgs had been my extra hands since Joey was seven. She was the matriarch of her own large family, and to Joey's delight, she usually arrived with a different set of nieces and nephews trailing behind her. This godsend rarely missed a day or a chance to firmly state her rule, "It's whatever Joey wants!" We did not agree with this as much as Joey did, but she had the willingness and energy to make it happen, and she enabled us to leave the house with the secure knowledge that Joey was happy.

Clarine had always taken Joey to his karate class every Saturday morning without fail. These lessons were open to anyone with any degree of disability who was willing to wear a uniform and follow instructions. After going to the first class, I preferred to stay at home, since it was too easy for me to pick up all the disgruntled feelings of the other students as Joey wildly maneuvered his walker on the mat. Everyone in the large group had been taught that this nicely padded area was worthy of respectful bows before they entered. The mat was reserved only for students, a rule that excluded Clarine and me but left Joey free to do as he pleased—which *never* included standing still or waiting in any line! Joey ignored all the other devout followers, and refused to leave the instructor's side. While teaching the karate moves, Tony Johnson,

the teacher, would calmly brush off any complaints about Joey with, "It's okay. There must be a reason he needs to do this."

One memorable morning a pupil accidentally dropped one of his crutches. According to Clarine, within seconds every one of the stunned spectators were gasping as Joey whizzed from the opposite side of the room, released his walker for its crash landing into the wall, dropped to his knees, and swiftly snatched the crutch. But then, with a clumsy crawl he continued to drag this cumbersome bounty until he was able to hoist it directly into the hands of its owner. It was obvious from that moment that everyone saw my misfit in a different light.

I always dressed Joey in color-coordinated outfits, but our Sunday aide, Eileen McKenna, would sneak fancy striped pants and flowered shirts into his drawers so that he could wear something "rad" on her shift. Food had always been shoved into Joey's mouth; Eileen was probably the first person to ever ask Joey what he wanted to eat. Then she solicited his help in cooking the assorted things he pulled out of the refrigerator. I would never taste the conglomeration of ingredients they mixed in every pot I owned. The outfits never matched, and the kitchen was a mess...but Joey loved Eileen!

Fortunately, there was little time to dwell on the past before Dollie and Linda also dropped in on us and coordinated their own plan to spur more smiles out of Joey. Joey never had much interest in television shows, but he was mesmerized by reruns of the videos Dollie had made of him working at the computer. Before saying goodbye, the girls positioned the television and these tapes close to Joey, where they were easy for us to play continuously throughout each day, supplying Joey with constant stimulation.

The first video was still playing when Joey's schoolteacher, Katie Webb, made a short visit and added as she was leaving, "We'll save his place and keep his aide on staff. He'll be back!"

Before I had time to express my appreciation, Francia Bailey arrived with fresh hot bagels. For weeks I had had difficulty swallowing even yogurt, but Francia's bagels were so good that large, ferociously chewed bites slid easily down my throat. I thanked her for Jannelle and we casually talked about everything—everything, that is, but Joey. Her son, Michael, had also been in the UCLA Intervention Program, and we had been together for years of Nancy Miller's meetings for moms. When we graduated from the program, a small group of us continued to have breakfast whenever we had time—or had a breakdown. Before

she left, Francia relayed that the other moms had been calling her for updates about Joey and were available whenever I was ready to talk. Only someone who has shared years of ideas, laughter, and common heartache could understand!

The visits were short and the messages were simple, but the effect was monumental. I headed for the garage to retrieve the feeding gadgets and handicapped equipment Joey had grown out of years ago. Since there had been a time when they helped us survive, they had too much sentimental value for me to discard them, even though I had convinced myself over the years that the nightmare of needing them again would never become a reality.

Marty was carrying some of the stuff inside for me when he said, "You know, Mom, I've never felt sorry for Joey because he's never felt sorry for himself. I'm not sad. I'm sure he'll come back!"

I wasn't sure who he was trying to convince, but my posture improved as I headed toward Joey. On the way, I overheard Robbie yelling at someone on the phone. My husband had hugged me whenever we passed each other on the stairs that day. I had expected him to leave for work, but by late afternoon I realized that he was ensconced in a makeshift office upstairs. He must have noticed that I hyperventilated whenever I was unsure of his location.

Now when I entered Joey's room, I felt like I had an army of support behind me. I could even smell the honeysuckle blooming outside the window! Then Shawn, who had been sitting beside Joey while I visited with Francia, startled me with a sudden, "Hey, Mom, look at this!" Joey's arm, bent at the elbow, was slowly moving up and down, and the fingers alternately fanning out and making a fist.

"Oh, the doctor said that's just a reflex."

Shawn had an expression of doubt that caused me to move closer, and I realized that when the fingers folded, the thumb was almost in between them. It looked like the correct sign language one would use to convey a need to go to the bathroom.

Shawn saw the recognition on my face, so I only had time to grab Joey's head before Shawn, his arms muscular from years of surfing, hoisted his brother, and the two of them headed for the toilet. We had to call for help from the other boys to stabilize Joey in a sitting position, but within seconds we heard the tinkling proof that his gesture had been more than a reflex!

Now, with a doctor who made house calls and another next door,

strong-armed sons and a supportive staff, bagels in the morning and someone to hug me at night—all in addition to the sign for toilet—now I had more than enough hope to start over!

Sounding like an annoying parrot as I force-fed Joey each day, I repeated over and over, "Joey, you can control this arm. Show me another part of your body you can move. We can make one mean yes and the other no, so you can tell us what you want." I loved repetitious chants. They always inhibited ugly thoughts.

Two weeks later, on the day Robert was scheduled to return to school, he stopped by Joey's room and plugged the right spark into my words! "Joey, you've gotta have a yes and no so that I know if you want to drive the car."

The second Robert said the word "car," Joey's left knee bent, and became our sign for "no." After several tests with questions we were sure would get a "no" answer, Robert asked about the car ride, and without hesitation, Joey's right arm rose.

Before Joey's coma, one of the most stimulating events of his day had been sitting on someone's lap in the car and controlling the wheel while they drove around the block. Even now, the improvement in his muscle tone was obvious as Robert carried him to the car. Since Joey was still sightless, I preferred not to watch how they managed their drive, but Joey's smiles came much more readily after that ride.

When Joey's near-drowning occurred, I was relieved to realize that his repeated comebacks were beyond my control. But at this moment, as he rebounded once again, there was a gleam that told me that the meaning of this child's chaotic life was much more than what I originally thought his surname—"He will add"—indicated. When people called or came to visit, I heard in their voices and saw in their faces that Joey added inspiration not only to our family, but also to the lives of the many people who tried to help him do everything in his own way.

Together we broke the shell, and within months, although Joey's speech lagged, his sight returned, and ninety percent of our Joey came back for his twelfth birthday party. The road looked almost the same as it had in the beginning, but this time I was not alone. I had the strength and courage that comes from being part of a group.

Chapter 21

Now What Do I Do?

And when your sorrow is comforted (time soothes all sorrows) you will be content that you have known me…You will want to laugh with me.

MONTHS of holding Joey up while his brothers crawled on opposite sides of his body to pattern the movement of his legs had helped to pave the way for Joey's comeback. Unfortunately, it had also pinched several of my nerves. I wish I had been smart enough to incorporate proper weight training into my exercise program.

The years of lifting beyond my capacity had already led to bilateral carpal tunnel syndrome, but now the problem had moved up my arms and became thoracic outlet syndrome, in which the nerves and arteries are squeezed by the muscles of the neck. In the midst of a series of surgeries to release these compressions, it finally became obvious that Joey's need for a full-time aide was permanent. I had interviewed countless applicants, but hadn't found the right person. Then one day Robbie made an unexpected announcement.

"I've found the perfect person! I was talking to him while he changed the light bulb in my office; he helps out our maintenance man."

When my questions revealed that this man had never even seen a handicapped child, I vehemently rejected Robbie's proposal and reminded him that we needed somebody with more than personality. But he waited until he was halfway out the door on his way to work before adding, "I hired him. He starts today."

By now I was very accustomed to training new aides, but when charming Armando Rangel arrived, I abbreviated the course. While I was hitting a few highlights of why this kid was slightly more complicated than a typical light bulb, I noticed that Armando's eyes kept

shifting to Joey, until he shyly interrupted, "Excuse me. I...I think he's trying to tell me something."

"Oh...that's just his sign for toilet. Shawn already took him, but..." I began to explain that Joey enjoyed throwing little kinks into my indoctrination. But before I could finish, Armando had asked Joey where the bathroom was, getting Joey to point the way, and was pushing the wheelchair down the hall. I lingered outside to listen for the chaos that comes with inexperience, but instead I heard Armando sweetly whisper, "I want this job very much! If you help me, I promise to help you an awful lot. How do you do this?"

Joey was able to interpret Armando's heavy Spanish accent, and when I peeked around the door, he demonstrated for the first time since his coma how he could grab his support bar and transfer himself from the chair to the toilet. And I saw that Armando would work.

The bond that formed between Joey and A.R., as Joey came to call him, was far beyond anyone's expectation. The two seemed to be able to communicate without an exchange of words. A.R. approached and accepted Joey as another adult who had both needs and feelings that required assistance and respect.

Armando always grinned gleefully whenever I suggested that my son could use another uplifting trip to Disneyland, and he never missed an opportunity to let Joey experience the joy of giving. After hospital stays, the patient and A.R. always returned with thank-you flowers for the nurses. Soon, on holidays Joey was as excited to see our reaction to his gifts as we were to see his reaction to ours. In time I became certain that Armando enjoyed triggering Joey's smile as much as I did.

Armando seemed to be able to fix any machine or person, and perpetually tried, even when I thought fixing wasn't necessary. He was a perfect point guard for our team of helpers. Thus, Joey acquired an aide as well as a best friend, and I was blessed with an exhilarating sense of freedom from sustaining Joey's world single-handedly.

Sometimes blessings come in bundles. The same year Armando entered our family, my greatest wish for Joey came within his grasp. Deliverance occurred on the day perceptive Dollie presented my son with a Liberator Speech Synthesizer she had borrowed for several trial sessions. This newly developed tool for emancipating speech had a portable keyboard and the highest quality speech synthesis program available. It offered the non-verbal lots of shortcuts for faster output, as well as all the benefits of a computer with a compact printer attached. When

Joey's hands first touched this machine, our eyes met and we both knew that here was a potential to control his own future in communication.

With Armando's competence in caring for Joey, Dollie's fortitude in liberating Joey's voice, and my trapped nerves making me incapable of compulsive cleaning, my need to be at home was greatly reduced. So I was vulnerable when Marty made a comment that indirectly spurred my desire to explore another occupation. I do not recall what he said; but I heard it as an opening to give him some parental guidance.

I snatched a fresh bottle of Evian as I prepared to lecture Marty, but I was startled when both of his hands rose in a halting gesture. "Mom, before you get started, I just want to know first...."

His tone was very respectful, but when he paused I prepared myself for one of those profound observations that occasionally left me unsure if I should praise him or punch him. "...Is this going to be one of those lectures where you start off nice and then go crazy?"

I lost wind for the talk, but more important thoughts blew my way. Maybe this was a clue that my sons were already saturated with whatever wisdom I possessed. The look on my face was probably similar to the one worn by the chick in the poster that hangs in Joey's room. The chick is standing beside his broken shell with an expression that shows that he has fought like hell to free himself and has proudly fluffed his feathers before being stunned by the question, "Now what do I do?"

It was around that time that I was reading a magazine in a doctor's waiting room and came upon a movie idea that Robbie was able to sell to a network on my behalf. Thus I became the associate producer of *Best Interests of the Child*, a film about child abuse. It was a captivating learning experience. Best of all, because I was married to the boss, I could take time to step back into my Mom role whenever an emergency occurred, whenever Joey needed an advocate, or whenever someone was still willing to listen to a lecture.

Robbie seemed to enjoy teaching me his trade. I enjoyed it, too, and I worked on two other projects during the next couple of years. Robbie, also, was searching for some new spice to his life; but it was more profitable for him to spend extra time on a boat rather than on a movie set. After finding a place on the mantel for his Best Picture Emmy for *Inherit the Wind*, a remake of the famous trial debate about the origin of man, Robbie lowered his expectations of himself and became content with the apex of his career. He discovered that water sports and skiing made parental bonding easier for his growing sons.

These exhilarating activities became accessible to Joey too, after we discovered the Handicapped Ski School on the slopes of Bear Mountain. They had equipment to accommodate almost any physical problem. So our future looked brighter than ever as our Joey zoomed over the snowy hills, sitting in something similar to a toddler's car seat with attached skis and a hand-controlled lever for steering. As the rest of the family shooshed alongside, Joey's face clearly revealed that his sense of freedom was uninhibited by the security rope and ski instructors that trailed his every move.

Regrettably, Joey had rebounded from his coma with increased leg spasticity, which worsened as he started the rapid growth of puberty. We were soon hearing recommendations for surgery, which we stalled for a while with heavy metal braces. Then, in the nick of time, a friend introduced us to Janet Anderson. She is an innovative and endearing physical therapist, and had mastered the use of creative fun, supportive straps, and foam night braces to manipulate stubborn tendons and straighten limbs. Her assistance enabled Joey to continue to use his walker and skis without surgery.

Joey's snow equipment was very versatile, so one day while our older sons were involved in their own Saturday choices, Robbie, Joey, and I piled into our new little truck for an afternoon of water skiing. As always, we stopped first at the marine store for some supplies, and just as soon as Robbie vacated the driver's seat, Joey squirmed to get his legs over the gear shift so that he could take control. Instinctively, before entering the store, Robbie turned around to leave us with a warning, "Now, don't let him turn that key."

I answered with cheery sarcasm, "Don't worry. We'll be here when you get back."

Actually, I always resented anyone implying that Joey was not safe behind a steering wheel. Anyone who made such a suggestion could not have witnessed the tremendous joy and physical progress Joey got from driving, and I was completely confident in my own quick reflexes if anything should get out of hand.

I had never been able to comprehend the mechanics of a stick shift, so I made sure that Joey's hands stayed on the wheel. My arm was slung over the back of his seat, and I had only sung a few lines of an Irish ballad when Joey suddenly combined a powerful back arch with a twist of the key and a hefty stomp on the accelerator. This caused the truck

to pop up onto the sidewalk and coast toward the storefront's plate-glass window. Without intervention, we would certainly have cracked the glass, but I swiftly flipped my foot over the gear shift toward the brake—and accidentally engaged the accelerator again!

We literally flew into the store, spraying glass all over the numerous bolts and inflatable boats displayed inside. Thankfully, nothing human was harmed.

Robbie was in the check-out line, but he later described hearing the bomb hit and watching people duck flying glass and nautical supplies as he pushed to the front of the line, saying, "Here! Take my money...I think that's my wife and child."

I only remember the piercing noise, people pulling Joey and me out of the truck, and a nice man gently blocking my attempts to stand up; but I'll never forget how casually Robbie forced his way through the crowd, strolled over to where we were sitting in the midst of all the debris, and calmly asked, "Are you two all right?"

Any stranger observing him would have assumed this was a familiar family stunt. Feeling like I was leaning against a vibrator, I was too awed by his aloof attitude to answer. After seeing that neither of us was broken or bleeding, Robbie politely asked a salesperson to bring him a broom, and then while sweeping he nonchalantly gave our insurance information to the manager.

As my head bogged around, taking in the situation, the man squatting behind me and stabilizing me in a sitting position with his hands on my shoulders, whispered his concern into my ear, "Lady...your son?"

"Oh, he's all right."

He repeated the question two more times, and after each I stuttered the same assurance as I gawked in disbelief at the disaster. Then I felt his patience slipping as he tightened his pressure on my shoulders to soften the blow and said more loudly, "Lady, he's not all right!"

Certainly, the surprise had significantly sobered Joey; but I could tell that he was not even slightly scared. Nevertheless, at that moment I heard the sirens and read on the faces around me that everyone assumed that Joey's obvious brain injury had occurred during the crash.

The police arrived, followed by lots of firemen and three different paramedic units. Each newcomer needed explanations, so Robbie directed them with arm signals and melodious words.

"She's over here!"

I mumbled medical justification for my son's condition several

times, then I heard the embarrassing question being passed around the surrounding crowd. Fortunately, however, no one specifically asked me to explain how the accident had happened.

My mate's coolness completely fooled even me until my last interrogator stepped aside and Robbie stared sharply down at me with a knuckle-bulging grip on his broom. I thought his teeth were going to crack, his jaw was clenched so tightly, and I knew the grin was phony as he projected his voice like a ventriloquist and emphasized each word. "Sandra, did you *have* to do this?"

Maybe I just needed a way out from under the stress, but I thought this was the funniest thing he had ever said to me! At first my sudden burst of laughter embarrassed him, but then I could see his fury subsiding. To avoid joining my hysteria, he turned to sweeping the glass off the truck and clearing traffic before he backed outside.

As we drove away from the growing mob of rescuers and inquisitive passersby, I looked forward to an extended bathtub session. But I noticed we were not heading in that direction.

"Where are we going?"

"Well…to the beach!" Robbie's tone clearly communicated that it had not even occurred to him that we should do anything other than pick up and move on as planned.

Often during the past years with four teenage boys, we had only been able to fasten our seat belts and hold on. None of our sons was the type who could sit on the sidelines and watch. With their frequent delinquent pranks, stitches, and speeding tickets, they were well-known by the police department, and their insurance had been canceled by several medical and automobile insurance companies. But most of the time things had happened too fast to worry about.

Ultimately, after walking away from a couple of automobile accidents and abandoning his bungee-cord and Rambo tendencies, Robert allowed his artistic talents to blossom by taking acting classes. Then he channeled his excess energy and directorial aspirations into a starting career as a second assistant director on the *Hart to Hart* series of movies Robbie's company was producing. He spent his first paycheck on a sleek Armani suit and a fitting thank-you card to his father for the mutual respect they were developing.

As an adult, Robert's instincts and charm easily compensated for any lacking reading skills. He had also become more able to express his feelings, and when we discussed the effect that Joey had had on him, he

revealed, "Because of Joey I have more respect for people with prob-
lems. A person in that situation is emotionally very strong; but I find
myself avoiding close relationships with other people because of the
fear of losing them."

I could see how hard it was for him to continue. "Everyone deals
with Joey differently. I love Joey, but I can't talk to him without crying.
It frustrates me. I can't read Joey from his eyes. I don't have patience, so
I ignore him a lot, which makes me feel sad. I plan to sit down with
him and fix this one of these days."

Robert has dexterous hands, but words are sometimes difficult for
him. I don't doubt that is why he can identify with the frustration of
someone whose speech is affected by both verbal and motor problems.
Like his dad, Robert was too covertly sensitive to cut through personal
emotional scenes in order to see the meaning beneath them. Maybe
that is why they both excelled in analyzing movies.

Shawn, on the other hand, competed in lots of surfing contests
during his teens. Then, after several years of slacking grades, shoddy
goals, and a shoulder reconstruction from pushing a snow-boarding
maneuver to a disastrous 180-degree flip, he settled down to catching
morning waves and struggling into a solid course at Loyola Marymount
University's film school. With his extracurricular ventures of distribut-
ing a line of clothing and promoting a couple of bands, and in view of
his oversized fifties-style slacks, heavy-duty shoes, and his sense of hu-
mor, we were certain he was on his way to becoming an entrepreneur. I
saved the essay he wrote for one of his college applications.

> I will always remember a day when I was six years of age. My
> mother was in the hospital, not for a bad reason but for a very
> exciting one; she was going into labor with my soon to be baby
> brother. I remember the day especially well because we had
> almost arrived home from a trip to Marineland when my dad
> had to make a U-turn and go back to the hospital. Everyone in
> the car was yelling and screaming, not knowing that my
> mother was in intense pain. When we arrived at the hospital
> my dad went with my mother while my two anxious brothers
> and I wrestled around in the waiting room, expecting to hear
> the good news.
>
> Hours later the news arrived; it was not very pleasant. The
> doctor told us that Joey had complications during his birth; he

suffered severe brain damage and might not live. Right there and then it hit me that we were not going to be the sought after All-American family. I did not know what to do or how to feel. I can remember my body went numb and it felt like my heart had stopped. I felt hopeless. At that time I did not know anything about what a handicapped person is like, all I knew was that they acted funny and were weird; I guess this was God's way for me to learn.

After weeks of visits to the hospital, we were able to take Joey home. When we got home everything was really strange and quiet. My parents' eyes were bloodshot from all of the crying that they had gone through. I think they were worried about how my brothers and I would react to Joey. You might say that we were weird, but we took a look at him and he looked normal to us, so we were happy and started to play with him. While this playing was going on I had glanced up to see what my parents' reactions were. At that moment I saw the first smile I had seen either of them make since the trip home from Marineland.

As the years went on, Joey was constantly in and out of the hospital, but our family got more relaxed about the situation. Joey has severe cerebral palsy, which means that he has very little muscle control throughout his body. He is also epileptic, and stops breathing after every seizure. Sure, Joey would have many near-death experiences, but I would always tell myself that he would pull through and I would always make a promise to God that if He let Joey live I would try to be a better person.

Joey's problems were a learning experience for my whole family. Through him I have learned that life is really precious, and it can change in the blink of an eye. I realized that a simple little "hi" or "goodbye" was something that I had taken for granted, but for Joey or any other handicapped person it could take several years to accomplish—if they were lucky.

Every day it is a challenge for Joey to learn something; you could almost see the struggle in his eyes. I can remember the first time that Joey said "hi." It was a couple of years ago when my family was eating dinner. He had crawled in from his room with a half smirk on his face. We all were expecting something

and when my dad put him on his lap Joey took a breath and said "hi." It did not come out the way I would say it, but it came out. Everyone at the table smiled and my mom shed a couple of tears. Learning how to live our life with Joey is like a puzzle, and every day is a challenge to solve it.

And then there was our Marty, who sometimes could not recognize his own abilities but had already mastered an ability to motivate others. He was the homecoming prince, captain of his high school's football team, and recipient of two athletic trophies for "most inspirational," and we were not worried about his talent for tackling obstacles in any field he might eventually choose. He had always been our completely perfect child, with too much potential to ever have a problem.

But then one morning I heard a radio disc jockey forecast that "Life is what happens while you're making other plans." And sure enough, one week after his eighteenth birthday, Marty was arrested! As a former probation officer, I certainly thought I had covered crime in my children's upbringing. But Marty must have tuned out those lectures.

After aimlessly twirling through the typical denial, anger, and depression, we discovered that the real culprit was the alcohol that this "silent sufferer" had used as an escape. Looking back, we had to admit that the symptoms of Marty's affliction had started years earlier, but they had been too easy to overlook in our stressful home. Marty was a good actor, and we were too willing to be gullible parents.

Fortunately, a close friend wisely pushed us into applying for treatment at the Betty Ford Center—something we had never expected to have to do when Robbie was producing Mrs. Ford's life story as a television presentation.

Thanks to a week of in-depth family counseling at the Ford Clinic, we were able to more fully understand the disease that had temporarily transformed our son into a stranger. During group therapy, neither my workaholic husband nor I had trouble pinpointing where Marty got the obsessive-compulsive genes characteristic of an alcoholic. Still, as we sat in an oversized circle of diverse families and listened to other stories, it dawned on me that I would never again have to ponder what anyone meant by "problems." They're *terrible!* And we've *all* got them! What matters is what we decide to do about them. They may disguise themselves differently—from alcoholism to loss of health, job, loved ones, money, self-esteem, or zeal—but they all boil down to just a loss of

control over one's own life. It is immaterial what disguise a problem wears, because no one really gets away with hiding their problems. Confronting them is the first necessary step in learning how to live with them. I hope that by now all the members of my family have learned to focus on themselves and take "one day at a time," to accept what they can't change, change what they can, and pray for the wisdom to know the difference.

Actually, I already knew this answer! For years it had been wrapped in a assemblage of analogous words and attached to my refrigerator door. But sometimes solutions are just not that easy to digest immediately.

Being a believer in pet therapy, I spent days canvassing Southern California for the most charismatic Himalayan feline I could find. Knowing how difficult the road back can be, when I drove home with the perfect catch curled on my lap, I petted it and prayed that this kitten would be a suitable companion and pacifier for Marty while he stabilized his dominoes. But when the entire family lavished the kitten with affection and rallied around to watch him romp with the dogs, I knew Marty's intended diversion had inadvertently color-coordinated everyone's Rubik cube.

Marty continued to follow the necessary steps to become a theater arts major at the University of Arizona. He also became my closest confidant, and he spontaneously adopted a topic similar to Shawn's for his own college application:

> Often, people ask me who is the one person who has made a substantial impact on my life and whom I admire the most. This question instinctively triggers an old memory of a very ordinary but enlightening experience when I was 13 years old and my brother Joey was 12.
>
> It was a mid Sunday afternoon when Joey and I were playing around like always. We had a usual routine of wrestling around on the floor and every once in a while I would pick him up, throw him into the air, and onto his bed. I enjoyed making him laugh, with the realization that laughter and smiles were some of the few precious things he had going for him. After several times of this tiresome routine, I made a lazy excuse that my elbow hurt and that I could not play for a while. We lay next to each other catching our breaths and I immediately

began to daydream. The sudden break in my dream was my brother kissing my elbow. Not realizing my sarcasm, Joey's only knowledge of response was one of kindness and love. My younger brother has cerebral palsy and a severe case of epilepsy; he is now 17 years old.

With this experience I did not learn anything new about my brother, but it made me realize the true innocence and purity of his character. While struggling with his own life, he always sends warm smiles in hope that the future would take a turn for the better for others.

Society has placed a mental image in our heads that in order to obtain happiness we need to have a successful career, to possess wealth and material things, etc. Despite these perceptions of life, Joey radiates true, unselfish, and uncondi-tional love for others. Ironically this unique world view is what society and this world really need and lack.

Watching Joey struggle to do the simple things in life helps me to realize the significance of my talents and virtues. Ever since I can remember I thought that because I was Joey's older brother, I would have to carry him through life. Ironically he has carried me through life with his display of courage and love which inspires me to take advantage of my opportunities.

In Joey's early years, his surviving for another birthday always seemed like a monumental accomplishment. Hence, I started mailing out invitations to everyone we loved, and the Fourth of July became our family's traditional chance to celebrate life itself.

On Joey's seventeenth birthday we ate goodies loaded with calories, swam, danced, and jumped on moon bounces throughout the day. No matter how sick Joey was at any time during the year, we could always stimulate a smile by discussing plans for his next party. This year, how-ever, the cake had to be substituted with sugar-free jello and whipped cream, to comply with the rules of Joey's current ketogenic diet.

Recently popularized, the ketogenic diet is an old remedy for epi-lepsy, which mysteriously switches the body's chemistry into ketosis (the excessive production of ketones such as acetone) to burn a precisely measured and balanced diet of ninety percent fat and negligible carbo-hydrates. Tasty menus had been difficult for me to concoct, but easy to toss to Armando for strict regimentation—and Joey hasn't seen a respi-

rator since he started eating them.

Each year we seemed to have additional reasons for joy—or was it anticipation of recapturing the memories that turned us all around to joy?

Two weeks after Joey's seventeenth birthday, we were all looking forward to recuperating from the party with a weekend on Catalina Island. Joey preferred to drive a golf cart around the island with A.R., while Marty, Robbie, his brother Rony, and I decided to test our new hard-bottom inflatable boat. Spontaneously, we voted to beach on one of the island's deserted coves which was encircled by a steep cliff. It was a gorgeous day, and we were unaware of the South American storm that had caused unusual turbulence in the water until after our boat had landed on the rocky beach. We had to watch the waves swirling around our ankles for a while before we recognized the growing swell of water crashing behind us.

When the four of us tried to push the boat far enough back through the surf to start the engine and escape our blunder, we were swallowed by an enormous wave, and my body was whipped into a somersault. With my legs still jackknifed over my head, I was powerless as the boat rolled onto its side and crashed back down on top of me.

Even though I was underwater, I was certain I could hear my bones smashing as my back slammed into the sand. The blow forced my body to bend above the waist, and one vertebra crushed another beneath it.

Trapped by the strength of the surf, we were stranded for over five hours before a brief lull enabled Robbie to start the engine in shallow water after Rony and Marty shoved him under a wave. The boat had taken in a lot of water, and its propellers had been damaged by the rocks on the beach, so Robbie looked as though he were sitting on a dolphin spouting smoke as he putted for help. I watched him go, fearing how this stress would affect his heart, which now required medication, and I was forced to forget that I could only roll on the rocks toward the mountain to avoid the rising tide.

When the rescue helicopter arrived, there was not enough ground left for them to land on, so they dropped a basket from the air above the mountain ridge. My entire body was immobilized before I remembered that I had never been brave enough for any Disneyland ride that left the ground...and my face started to itch.

The noise of the helicopter was deafening, and the whirling wind made attaching ropes to my basket difficult for the strong, serious

Coast Guards. I didn't want to be a burden to them, so I decided to relieve my itching chin by rubbing it against the inside of my neck brace. Faster than the original accident, my lower jaw was sucked into the metal collar, cutting off my airway. My rescuers, assuming my gargled whining was just panic, patted my head but concentrated on their knots. I was deliriously grateful when they discovered my entrapment before hoisting the basket.

I marveled at how smoothly I wqas hoisted into the sky, and I stopped praying when I saw the man above reaching to grab me. But just then a brisk gust of wind blew my basket underneath the helicopter, entangling the ropes in the helicopter's wheels. I am not sure how many times I was jerked and twisted, but Marty told me later that the ground crew had all extended their arms to catch me if I fell. When I was finally pulled inside the helicopter, I was certain I was watching all of this in a movie theater.

By the time I reached the hospital, I was so happy to be alive that I couldn't feel the pain or worry about the future. Fascinated with the portable box of tools the brace man used to customize my hardware, I was back on my feet before I faced the doctors' serious doubts.

Back at home I got upstairs all right with my new commode and walker; but it took a month to get back down. Too bad we cannot understand the difficulties that confront the handicapped until we experience them ourselves. It is annoying to hear "one day at a time" when you are the one who is doing it, even though it works.

When I was at last able to attempt my first outing, I pictured that chicken poster and felt an overwhelming need to visit my mom. As fate would have it, she required twenty-four-hour nursing care and was living in a nearby convalescent hospital. As her mind deteriorated over the last several years, I had often been saddened by my inability to communicate with her and my uncertainty of when exactly I had lost her. We first recognized the slip when she would sit through family meals, just sipping her hot milk and toasting too many times with her Irish twinkle, "Here's to those who wish us well, and those who don't can go to hell!"

Fully braced on this particular day, I waddled down the hall and found my mom vegetating in a wheelchair outside her room. Her sparse little curls of hair were much more flaming this month than they should have been. On the tray in front of her was a stack of her favorite oatmeal cookies, a telltale sign that my dad had recently been there.

She had helped him switch his addictions to sweets and golf, but unfortunately she was never fully aware of the model husband and father her work-in-progress had become.

As I approached and cheerfully asked her how she was, I expected her to snap, "Who are you?" But miraculously she shrugged and smiled, "Well...I'm doing the best I can with what I've got."

Later, after we had giggled and hugged, I left with her inspiring shove. Once more she had forced me to remember that there were still a lot more special memories I wanted to reach for.

In the past, whenever I was due a gift, I had always hinted for pre-paid retreat time. Now with a need to use my accumulated reserve, I called Vicki Hobart. She was the soul mate I had met on a Mother's Day escape to a Palm Springs "fat farm." We had instantly bonded over veggies, and soon found that together we could shop through any sorrow.

Fate had given me a few more deuces than I had expected, but I could still control my destiny. Luckily, I had already been taught that no matter how many debits you face in life, if you look carefully, you can find stashed assets to cover them. I had an excellent seventeen-year-old role model for making stubborn muscles work, and an inborn ability to hide from any unpleasant prognosis. Combining these assets with invigorating exercise and eliminating salt would naturally make the next day better. Gradually, all those years invested in a treadmill paid off, and I recovered to the point were only I could see my shortcomings.

It was generally hard to suppress a laugh whenever I recalled the treasured supply of gimmicks in my personal survival kit—the bathtub, the beans, the bells, piercing my ears, discovering my colors, workouts with Jane, cover-ups with blush, hours of needlepoint, and collections of quotations. I constantly had to refix my Rubik's cube to fit the times.

During my rehabilitation I realized that I had definitely reached the age of wanting to give back, and that perhaps in some medical capacity I could help the homeless. Thus I began by enrolling in a premed biology class at UCLA. I also joined a local health club, started to read a book with movie potential, and scheduled blocks of time for writing.

Writing had long been an effective therapy for me. While providing a ladder to climb, it had also helped me live with an insurmountable problem by learning how to use a childlike blueprint to maneuver

around the immovable obstacles that can drop onto *anyone's* path through life. Hopefully the tricks I stumbled upon for surviving assorted traumas could help others traveling a similar road. In addition to the help it could give them, it would also *add* an even more special meaning to Joey's life—and, thus, to mine.

I really did not know what career I would ultimately settle into, but I knew the general direction I was heading, and I was certain I would find the answers along the way. I would probably "munch it" a lot in the beginning, but if I did I could just slide back onto the track and get excellent again. Succeeding, or even deciding on a suitable occupation, was not a problem, because I was only determined to do lots and enjoy the struggle.

The emotional rollercoaster that came with a life of constant emergencies clearly took its toll on our family. But then, we could have chosen to sit on the beach and watch the waves; instead, we all felt the need to be out there riding the surf. By now we know that the cumulative fun has been worth the falls, and that we will probably continue to have more consequences to face. On the other hand, by taking advantage of any chance for laughter, we have already found more than enough happiness along the way to help carry the extra burdens.

Joey's brothers, his dad, and I have all been well trained through helping him. Whenever our attention becomes too centered on a trauma, one of us can always play the distracting clown. Between us, we know the answer to any problem: it is controlling your own life, flushing your own toilet, and opening your own doors. It is taking whatever is given and making it work—not through major upheavals, but by controlling all the simple little things you can control. Because eventually, as all those little things accumulate, growth always appears and overshadows the negative aspects of your life. So you simply supply your own gimmicks for incentive, stare at the ground, and keep moving forward with lots of involvement until the life in front of you looks better than the life you left behind.

Nothing ever seems to end as I originally expect, but at fifty I have finally matured enough to let *all* of my sons have their problems, and to focus on making the most out of the rest of my own life.

It took me years of teaching my children before I learned that they have the answers adults have lost. They don't worry about the top of the hill until they get there. Instead, they stop to smell the flowers and

poke the bugs along the way. If a problem is too big, they sneak around it to a solution, or they just don't think about it. They always see the simple answers to which adults are blind; and they don't waste time on the unanswerable questions. They move the stickers to make the moments work, and then talk themselves into a feeling of excellence.

If we can relearn to be as clever as children, we cannot be burdened by any cross we have to carry. Time soothes all sorrows, and life compensates if we give it a chance!

921
Pap

Papazian, Sandy,
1944-

Growing up with
Joey.

DATE			